PIONEER & MILITARY
MEMORIAL PARK
of PHOENIX

PIONEER & MILITARY
MEMORIAL PARK
of PHOENIX

DEREK D. HORN & THE PIONEERS' CEMETERY ASSOCIATION

Contributing Authors: Debe Branning, Donna Carr, Bob Cox,
Patricia Gault, Jan Huber, Dean Isaac, Mark Lamm, Jason O'Neil,
Vivia Strang, Diane Sumrall and Val Wilson

THE
History
PRESS

Published by The History Press
Charleston, SC
www.historypress.com

Front cover, top left: Margaret Loring. *Courtesy Sharlot Hall Museum Library and Archives, Sharlot Hall Museum Collection, Call no.1700.0274.0000*
Front cover, bottom: A view of the cemeteries in 1940 that shows their condition as the first PCA began its work. *Courtesy Arizona State Libraries, Archives and Public Records, History and Archives Division, Phoenix, No. 96-4248.*
Back cover, inset: An advertisement for monuments and tombstones. *Courtesy Library of Congress, Weekly Phoenix Herald, April 2, 1885, vol. XII, no. 5, page 3.*

First published 2018

Manufactured in the United States

ISBN 9781467138031

Library of Congress Control Number: 2018936077

The Mission of the Pioneers' Cemetery Association, Inc. (PCA), a Section 501(c)(3) organization, is to: conserve and protect the historic physical remains, grave markers, artifacts and buildings of the Phoenix Pioneer and Military Memorial Park (PMMP); provide a safe and accessible community resource for present and future generations; and acknowledge, celebrate and promote Arizona's Pioneer history represented by those interred in Arizona's historic cemeteries through research, education, conservation and community engagement.

The PCA also strives to preserve, interpret and promote, through active fundraising and volunteerism, the understanding of archaeological resources as exemplified by the prehistoric, historic and contemporary cultures of the Southwest. Such cultures include, but are not limited to, the prehistoric Hohokam, historic Hispanic, African American, Chinese and European groups.

This book is dedicated to the many PCA members who tirelessly give their time and talents to restore and maintain the PMMP in Phoenix. For decades, these volunteers, utilizing public and private records as well as other governmental and historical resources, have built an archive that provides the basis of information in this book and a historical perspective of early Phoenix, Maricopa County and the state of Arizona.

There is no vision but by Faith
There is no life except by Death
Life's race well run Life's work well done
Life's victory won now cometh rest
Build on and make thy castle high and fair rising and reaching upward to the skies
—epitaph inscribed on the Tovrea monument at Greenwood Memory Lawn Cemetery in Phoenix

CONTENTS

Contents

ACKNOWLEDGEMENTS

During the preparation of this manuscript, I was very fortunate to work with individuals dedicated to the preservation of the Phoenix Pioneer and Military Memorial Park and the memory of Phoenix's early settlers. First, I want to thank Pioneers' Cemetery Association, Inc. (PCA) Book Committee members Frank Barrios, Donna Carr, Dean Isaac, Mark Lamm, Jason O'Neil and Val Wilson for their articles, research, suggestions and support. Members Debe Branning, Bob Cox, Patricia Gault, Jan Huber, Vivia Strang and Diane Sumrall provided pioneer biographical material and contributed articles. I also thank Diane and PCA charter member Daniel Craig for kindly sharing their photograph collections, stories and assistance.

In addition, the PCA wishes to acknowledge the following individuals for their many years of hard work in researching, compiling, digitizing and updating PCA files on the early pioneers who are buried in historic cemeteries throughout Arizona, including the PMMP and Cementerio Lindo: Donna, Patricia and Diane, along with Denise Foster, Dava Eastwood and the late Algona Winslow and Marge West. Their years of research greatly facilitated the preparation of this book.

The following archivists, librarians and other individuals generously shared their time and provided access to their collections: Wendi Goen and Jennifer Merry, Arizona State Library; Robert Spindler and Renee James, Arizona State University Libraries; Lindsey Vogel-Teeter, Pueblo Grande Museum; Brenda Taylor, Sharlot Hall Museum; Leah Harrison, Salt River Project; Dr. Lawrence Bell, Arizona Jewish Heritage Center; Michelle Reid,

Phoenix Heritage Square; Michael Nikolin, Phoenix Police Museum; Lisa Bartlow; and Irving Chew. Readers G.G. George, Karen Heck and Barbara Horn provided valuable input on the manuscript. Travys Harvey offered constructive advice on how to structure this project.

We greatly appreciate the support and guidance of our acquisitions editor, Laurie Krill, throughout this project. We also thank Hilary Parrish and the rest of the Arcadia–History Press team for their efforts.

Finally, without the support of President Vivia Strang and the PCA Board of Directors, this work would not have been possible.

Derek D. Horn
January 2018

Introduction

The Pioneers' Cemetery Association

Phoenix's Pioneer Military and Memorial Park (PMMP) has an amazing history. The park is a collection of seven separate cemeteries established in the 1880s and 1890s to serve the new and rapidly growing community of Phoenix in the Arizona Territory. For about thirty years, the cemeteries became the final resting place of thousands of the city's first residents: miners, merchants, farmers and pioneers who helped establish the territory and town. Some of them were entrepreneurs who saw opportunity in the West. Others were "just folks" who moved to the Salt River Valley for opportunity, their health or a new start in life. Many Phoenicians familiar with such names as Isaac, Osborn, Cartright, Balsz, Broadway and Churchill will find them carved on the headstones in the PMMP.

After being closed to new burials in 1914, the cemeteries deteriorated. In the late 1930s, citizens concerned about their neglect banded together to form the Pioneers' Cemetery Association to improve the condition of the burial grounds. Their efforts yielded results, but World War II interrupted, the restoration work halted and the cemeteries were again forgotten and fell into disarray. The Pioneers' Cemetery Association faded away.

Soon after the celebration of the nation's bicentennial in 1976, a group of concerned citizens took it upon itself to renew the cemeteries. These efforts gained momentum, and today, a dedicated group of volunteers, a new Pioneers' Cemetery Association (PCA), in partnership with the City of Phoenix, not only lovingly maintains the grounds but also organizes events that celebrate the history of our nation, state and city. The PMMP

frequently comes alive with groups of children and adults absorbing some history while participating in events held amid Phoenix's first residents. They may even learn about an ancestor or two buried there. The historic Smurthwaite House serves as the PMMP visitors' and research center and provides a glimpse into everyday life in early Phoenix.

The saga of the PMMP is closely linked to the early history of the Arizona Territory and the city of Phoenix. This story begins with the American Indian civilization that inhabited, flourished and then abandoned the Salt River Valley centuries ago. It continues with the establishment of a settlement along the river; life in its early days; the history of the first Phoenix cemeteries; and the development of the PCA, its current events and activities. Included are biographies of some of Phoenix's first residents whose stories emerge from beneath the headstones.

LA VILLA AND EARLY PHOENIX

LA VILLA

The Hohokam settled Arizona's Salt River Valley first. They moved there about AD 300 and over the centuries established villages, dug irrigation canals and planted crops until they disappeared around 1450. No one knows for sure what happened to them. Their name is said to mean "those who have vanished."

The Hohokam were unique among North American Indians in that they engaged in irrigation farming as well as hunting and gathering. They lived in pit houses and created pottery, carved petroglyphs into stone and made turquoise and shell jewelry and figurines. They were knowledgeable about hydrology. Over the centuries, the Hohokam dug a network of canals that extended for miles both north and south of the Salt River. These canals supplied water for their crops, primarily corn, and for everyday living. The Hohokam learned, as did future white settlers, that a reliable supply of water was crucial to permanent settlement and growth in the desert.

The Hohokam village that occupied the current site of the PMMP is called "La Villa" by modern archaeologists. Excavations indicate its establishment about 450.[1] La Villa was one of the largest villages in the prehistoric valley. It covered about eighty acres, from Sixth Avenue on the east to Sixteenth Avenue on the west and between Grant and Washington Streets, a prime location one and a half miles north of the Salt River and

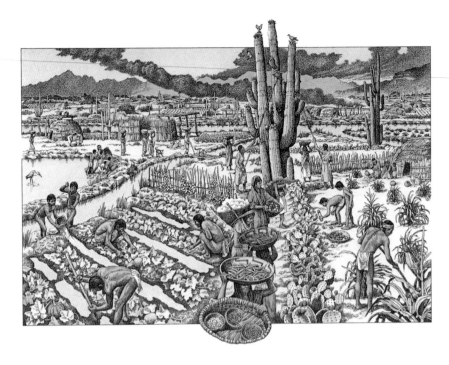

A Hohokam village in the Salt River Valley. *Artist's rendition by Michael Hampshire, courtesy Pueblo Grande Museum, City of Phoenix.*

just on the edge of the floodplain, which allowed a village with little risk of flooding. A canal that drew its waters from the Salt passed through the village and provided it with water. Little is known about the villagers' everyday life, but they would have engaged in agriculture, hunting small game, creating ornaments, manufacturing axes and playing some sports and games. La Villa may have been part of a network of villages. Its size indicates its importance. Modern archaeological excavations uncovered pit houses, mortuary features and two plazas.

About AD 900, the villagers abandoned La Villa, possibly due to flood damage to the canals and a general decline in the Hohokam civilization that started about that time. They likely combined with a nearby village. By 1450, the Hohokam had disappeared from the Salt River Valley.

After the Hohokam left, the valley remained largely uninhabited. The Pima and Maricopa Indians lived along the Gila River to the south. The Yavapai and Apaches occupied the lands to the north. Spanish explorers likely passed through the valley, but they were looking for gold and, finding none, moved on. It was not until the late 1860s that anyone took an interest.

Today, La Villa is within the urban core of Phoenix. The town expanded into La Villa in the 1880s, and the historic cemeteries that became the PMMP cover much of its western portion. The rest of the La Villa site is covered by warehouses, the Union Pacific Railroad tracks, the Maricopa County Human Services Campus, city streets and other modern structures. While historic and modern development obscured many of the surface features of the former Indian village, some investigators in the 1920s and 1940s recorded these remnants before they succumbed to modern development. With the support of the City of Phoenix and the PCA, archaeological excavations that occurred in 1990s uncovered many features of La Villa. Their discoveries and other archaeological work around the area create some understanding of the civilization that flourished before it vanished mysteriously centuries ago.

EARLY PHOENIX

Some time in the latter part of the year 1867 a company was organized in Wickenburg and named the Swilling Irrigating Canal Company for the purpose of digging an irrigating canal near the head of the Salt River Valley in which is now situated the town and settlement of Phoenix.... Soon after their organization was completed the company commenced the work of digging their ditch....The ditch was completed in 1868 and corn crops were raised in the summer of that year the water for irrigation being obtained through the ditch. At that time there was about 30 inhabitants in the Phoenix Settlement.[2]

So wrote pioneer John Alsap about the humble beginnings of what became, one hundred years later, a major American metropolis. In 1867, a group of settlers led by former Confederate soldier and miner John W. "Jack" Swilling of Wickenburg, Arizona, founded a settlement in the Salt River Valley. While Swilling is credited with establishing the first non–American Indian community that became modern-day Phoenix, he was likely not the first to exploit the fertile land along the river. That distinction belongs to John Y.T. Smith.

While the Spanish had settled the southern part of Arizona beginning about 1650, the north part of the territory only became attractive to settlers in the 1860s, as miners moved into the regions around modern-day Prescott

and Wickenburg looking for gold and silver. The army established Fort Whipple and Fort McDowell to protect the miners, ranchers and settlers and keep the lines of communication open. Both needed a constant supply of hay and grain. Smith, an army veteran and one of the suppliers for Fort McDowell, is credited with establishing a camp in 1866 along the Salt near present-day Fortieth Street and overseeing a civilian force that harvested the wild hay growing along the riverbank. Smith's camp was not permanent. Later in the year, he went back to the fort, but he would return and make his imprint on the valley.

Swilling, inspired by the fertile lands of the Salt River Valley, formed the Swilling Irrigating and Canal Company in 1867. He may have appreciated the area's potential during his forays around the state, or maybe he worked for Smith during his encampment the previous year. Whatever the motivation, Swilling, along with his party of settlers, moved into the valley. They dug irrigation canals along the courses of the ancient Hohokam ditches to tap the river, planted crops and quickly established a thriving farming community near present-day Sky Harbor International Airport. Swilling and his company, which included Bryan Philip Darell Duppa, were soon followed by John Alsap, Columbus Gray, James Monihon, John Osborn, William Hancock and others.

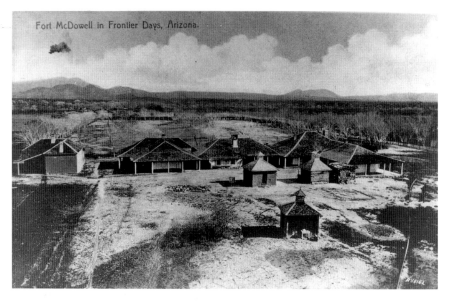

Fort McDowell about 1877. Its need for fodder catalyzed agriculture along the Salt River. *Courtesy Sharlot Hall Museum Library and Archives, Sharlot Hall Museum Collection, Call no. 1650.0156.0000.*

As the community along the Salt prospered and grew, the settlers realized that a town was needed to provide a center of commerce and support for the area. They formed the Salt River Valley Town Association to further that goal. By 1870, two factions were vying for their favorite sites. A group led by Jack Swilling favored a location close to his ranch near Thirty-Second and Van Buren Streets. Another group, led by John Alsap, favored a location farther to the west and closer to land claimed by Duppa, Osborn and Gray. A selection committee appointed by Alsap in October 1870 recommended a 320-acre parcel of land bounded by present-day Seventh Avenue, Seventh Street, Van Buren Street and Harrison Street. It was unfarmed and far enough north of the river to escape flooding. The larger community accepted the proposal. Alsap led the land patent process while Hancock surveyed the site into streets, blocks and lots. Though stories vary about who named the town "Phoenix" after the mythical bird that rises from its own ashes, many historians credit Duppa.

The Swilling group was still in the game, however, and the rivalry further intensified when, in 1871, the territorial legislature and governor approved a bill to create a new county and name Phoenix as the county seat, subject to voter approval. Alsap, as a member of the legislature, ran the bill. The vote occurred on May 1, 1871, and the Phoenix Townsite was chosen as the permanent county seat for the newly created Maricopa County.[3] The vote ensured Phoenix's preeminence in the area and its future. Swilling left the valley soon after for other ventures.

During the early years of the valley settlement, the pioneers' hard work and commitment, not to mention water from the Salt delivered by the canals, soon had the land producing a variety of crops. According to Alsap, by 1870, about two thousand acres were under cultivation. The principal crops included barley, wheat, corn, sorghum, potatoes and peanuts. Alsap believed about fifty thousand acres were ultimately suitable for farming.[4] He far underestimated the potential.

Soon after the establishment of the town, businesses sprang up and people started to move in. Hancock's survey created a grid of eight streets running east–west and fifteen streets running north–south. The principal business district centered on Washington Street east of Central Avenue, and the town generally developed on its east side first. The Salt River Irrigation Canal, or "Swilling's Ditch," ran along the north side of town. From it, water flowed into open ditches that ran along the sides of the streets. The water flowed west and south to match the general contour of the land. The ditches provided a rudimentary water supply, but their maintenance was

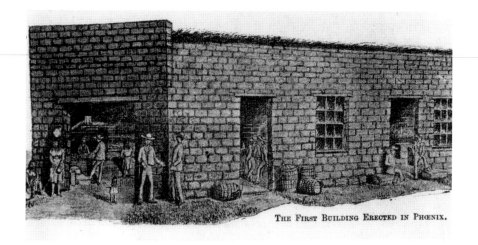

THE FIRST BUILDING ERECTED IN PHŒNIX.

William Hancock's store, the first building in Phoenix. *Courtesy Herb and Dorothy McLaughlin Collection, Greater Arizona Collection, Arizona State University Libraries.*

usually a concern, especially when they were used for disposal of wastewater or dead animals.

Because wood for construction was scarce, the first buildings were one-story adobe structures utilizing soil from the surrounding area and cottonwood or saguaro ribs for roof framing. William Hancock built the first permanent structure, a post office and general store on the north side of Washington Street at First Street. Other businesses soon followed. A public school was established in 1871. By April 1872, the town had four stores, two saloons, a bakery, a brewery, blacksmiths, carpenters, restaurants, butchers, a law office, a doctor's office and drugstore, a courtroom and a post office but, curiously, no church building.[5]

In 1870, Phoenix had a diverse population about evenly split between Anglos and Mexicans. There were few women, and the men were mostly farmers or farm laborers. The settlers from states of the former Confederacy outnumbered those from northern states and other countries.[6] Ten years later, there was a major increase in families, a stronger presence of foreign-born settlers and northerners outnumbered southerners. Mexicans accounted for almost half of the town's population.[7] The first Chinese settlers arrived in 1872, and soon there was a thriving Chinatown at Adams and First Streets.

In 1878, the town's first newspaper, the *Phoenix Herald*, began publication. The first bank, the Bank of Arizona, began operations, and a brick factory opened its doors. The Southern Pacific Railroad's transcontinental line

reached Maricopa, twenty-eight miles south of Phoenix, in 1879, which greatly shortened the distance wagon teams had to haul goods. A spur rail line would connect Phoenix with the Southern Pacific in 1887.

By 1880, the town's population numbered nearly 1,800. The availability of bricks and lumber, accessibility of consumer goods and need for additional commercial space doomed the one-story adobe structures. Over the next decade, multistory wood and masonry buildings rapidly rose in the town's commercial district.

In February 1881, Phoenix became a formally incorporated town. John Alsap won election over James Monihon as the first mayor. While desert life was still hard and summers harsh, things had greatly improved since the early days of Jack Swilling's first settlement, and by 1881, Phoenix was well established as a center of commerce, banking and law.

THE CEMETERIES OF THE PHOENIX PIONEER AND MILITARY MEMORIAL PARK

B y the mid-1870s, Phoenix had come a long way since its beginnings as a bare patch in the desert. It had most of the amenities one would expect in a thriving frontier town, but it was not long before the community realized it needed another amenity: a cemetery. Subsequently, a parcel of land bounded by Seventh and Fifth Avenues and Jackson and Madison Streets became the first city cemetery. One of the first to be interred there was Cassandra Smith, a little girl who died in October 1872. She was joined by others, including pioneer and miner King Woolsey and Luke Monihon, murdered by John Keller. Also buried there were two men lynched in August 1879 from cottonwood trees on the town plaza, Keller for Monihon's murder and another murderer. Demetrio Dominguez, the only man legally executed in Phoenix, in November 1880 for armed robbery and murder, also ended his days in the first cemetery.

When first established, the cemetery was out in the very southwestern corner of the town, a good distance from the business center and homes to the east—out of sight unless one had business there. As the town grew, development moved west, and soon some were voicing concern about the cemetery and the need to relocate it. According to the *Phoenix Herald* on April 16, 1879:

> *There is already an evil making itself painfully and obnoxiously apparent. We refer to the cemetery. Already buildings are going up about it. The time will come not long hence when it will be in the very midst of our town unless*

removed. A well-filled grave yard is highly productive of disease, poisoning the water of wells in its immediate vicinity and loading the atmosphere, to some extent, with its deathly vapors.

The *Herald* went on to recommend the cemetery should be two miles beyond its current location. Later that year, prisoners were used to clear the cemetery grounds, and the July 30, 1879 edition of the *Herald* noted that the cemetery presented a "decent appearance."

In March 1880, while this debate continued, Yuma businessman David Neahr subdivided a large parcel of land on the western border of Phoenix. Called Neahr's Addition, it extended the Phoenix street grid between Van Buren and Harrison Streets to the west and was one of the earliest expansions of the community, even though it was not officially annexed into Phoenix until 1896.

After Phoenix incorporated in 1881, agitation to move the cemetery grew. In March 1881, in response to a request in the *Phoenix Herald*, a group of the town's prominent citizens convened to discuss the matter. The *Herald* related the following: "A.D. Lemon spoke of the necessity of a suitable and decent place of interment and the shameful place of depositing the dead of this city at the present. A place about one mile from town should be secured and laid off with avenues and walks."[8]

Committees were formed to plan the effort and seek a site, but apparently little was accomplished. The *Weekly Phoenix Herald* expressed concern about the lack of action on December 15, 1882, by writing that it would take Phoenix several years to act on the "bad judgement" of locating the cemetery within the city.

Finally, the city council acted. In August 1883, it resolved to find a new cemetery outside the city limits and requested that provision be made to remove the bodies in the old cemetery to the new one and a maintenance plan established. A possible location was the recently recorded Neahr's Addition just west of the town border.

In June 1884, the council appointed a subcommittee to consider establishing a new cemetery for the city. One of the members was Councilman John Loosley. On July 7, 1884, the council accepted a proposal from attorney Jerry Millay. Millay soon recorded a deed on a half block in Neahr's Addition between Madison and Harrison Streets and east of Fifteenth Avenue, well outside the town at the time. This parcel became the new city cemetery. Millay then began the grim work of relocating bodies from the potter's field in the old cemetery to the new one. He completed

work in October and was paid $300 for the task. On October 8, with his work complete, Millay conveyed his new cemetery to Loosley for $600. In the meantime, surveyor Thomas Hine recorded the cemetery plot on Millay's land on September 3, 1884.[9]

Concurrently with Millay's relocation work, the city council appointed another subcommittee to consider the relocation of all the other bodies. Loosley submitted a proposition, which the council accepted. Because this removal included known burials, some of whom had family members still living in the area, he took out advertisements in local newspapers promising liberal terms on cemetery plots so families and friends could lie together eternally. The relocation began in early 1885. Graves that could be identified received plots in the new cemetery. Those who could not be identified were buried in common graves. This first cemetery became known as the Loosley or City Cemetery. The city paid Loosley $600 for his efforts, but he retained the right to sell lots.

Also in 1884, just to the east of the Loosley Cemetery, the Free and Accepted Masons, Independent Order of Odd Fellows, the Knights of Pythias and the Ancient Order of United Workmen laid out their own burial

Locations of the Early Cemeteries of Phoenix

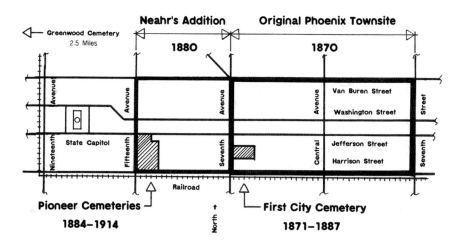

The location of the early cemeteries of Phoenix. *Drawing by Derek Horn.*

Notice.

IN VIEW OF THE CONTEMPLATED removal of the occupants of the old cemetery to the city Potter's field, very liberal terms are offered to purchasers of cemetery lots until January 1st, 1885. For terms apply to Millay & Hine, agents; J. M. Gregory, undertaker; or to
J. R. LOOSLEY, Proprietor.

A notice about plot availability in the new cemetery. *Courtesy Library of Congress,* Weekly Phoenix Herald, *December 4, 1884, vol. XI, No. 46, page 2.*

grounds. William Hancock prepared the survey map. These became known as the Masons, Odd Fellows, Knights of Pythias and Workmen Cemeteries. By 1885 the Loosley Cemetery and the fraternal society cemeteries took up the city block bounded by Madison and Harrison Streets and Thirteenth to Fifteenth Avenues.

In March 1891, Lulu Porter, the widow of former district judge and Phoenix mayor DeForest Porter, established the Porter Cemetery on the half block just north of the fraternal cemeteries.

In 1888, Phoenix businessman George Loring sold the block north of the Loosley Cemetery to Hine. The document was witnessed by Millay. In April 1898, J.W. Walker, a builder and developer, laid out and dedicated the Rosedale cemetery on the half block just north of the Loosley Cemetery. Rosedale later expanded over the rest of the block north to Jefferson Street. While no plat of the north half of Rosedale has been discovered, there was an agreement in 1899 between Walker and Loring to develop the north half of the block in accordance with the south half. For a few years, the north side of Rosedale was known as the Loring Cemetery. With the establishment of the Rosedale Cemetery, all the seven cemeteries that compose the present-day Phoenix Military and Memorial Park were established.

And what became of the old cemetery at Jackson Street and Seventh Avenue? In April 1888, the City of Phoenix deeded the land to the local school district, and in 1889, the West End School was constructed there. Despite the best efforts of Millay, Loosley and others to remove bodies,

The Cemeteries
of the
Phoenix Pioneer & Military Memorial Park

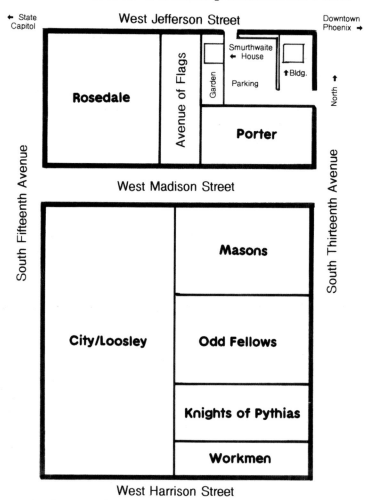

This schematic shows the location of the seven individual cemeteries that constitute the Phoenix Military and Memorial Park. *Drawing by Derek Horn.*

it was reported that workmen digging trenches for the school building foundations discovered some old graves. The remains were reinterred in the new cemetery. In November 1944, during excavation for a new building at Fifth Avenue and Madison, the site of the original cemetery, workers discovered additional graves and human remains overlooked in 1885. In 2012, excavations for a new Maricopa County sheriff's office uncovered additional grave sites and unidentifiable human remains that were later interred in the Loosley Cemetery.

For twenty-five years, the seven cemeteries became the final resting place for most of Phoenix's citizens. They became part of Phoenix in an 1896 annexation, and the same concerns expressed about the old cemetery then arose about the current ones. Many did not like a cemetery in the city. Maintenance, or lack thereof, also generated concern. The *Arizona Republican* on July 26, 1895, wrote:

> *The condition of the city cemetery is deplorable, but as steps must soon be taken to remove it to a distance of at least five or six miles from the city, it would hardly warrant the labor and eupense [sic] of repairing it now. The cemetery should be removed to a convenient distance and beautified with shrubs, flowers and grass. Now it is indeed a dismal looking place.*

The *Republican* would have to wait almost ten years for this hope to become reality.

Greenwood Cemetery opened in early 1906. Located on a large parcel at the northeast corner of Van Buren Street and Twenty-Seventh Avenue, it was well outside the town limits. Greenwood boasted landscape designed by the state capitol's gardener, a full-time gardener to care for the grounds and its own pumping facility for irrigation. The sales of plots included perpetual care. The cemeteries on Jefferson and Madison lacked all these amenities, so as soon as it opened, Greenwood became the preferred place for eternal rest.

In the meantime, the area surrounding the seven smaller pioneer cemeteries began to develop. Phoenix became the territorial capital in 1889. The legislature met in Phoenix City Hall until construction on a new capitol building about one and a half miles west of the city center was completed in 1901. The land around the new capitol complex became a prime area for development. The Phoenix Street Railway system began serving the capitol by 1893, which further encouraged growth along the Washington-Jefferson Corridor. In 1908, Phoenix opened a new public library, the Phoenix Carnegie Public Library, in a park between Washington and Jefferson Streets

This page: Overview of grave sites at the location of the new Maricopa County sheriff's office in 2012. *Courtesy Pueblo Grande Museum, City of Phoenix.*

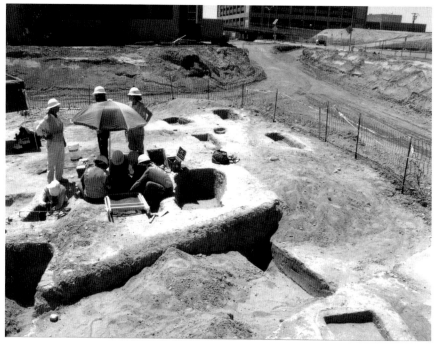

just northeast of the cemeteries. Once outside the city, the cemeteries soon became surrounded by new residences, and the same concerns that led to the demise of the old city cemetery caught up with them.

Property owners from the surrounding neighborhoods wanted the cemeteries moved. On January 8, 1912, the Phoenix City Council directed the city attorney to investigate the feasibility of acquiring Rosedale Cemetery for a park. Later, the council appointed a committee to consider ways and means to remove Rosedale. It reported back to the council in November 1915, with the recommendation to sell the cemetery's potter's field, use the proceeds to buy plots in another cemetery, move the bodies there and turn Rosedale into a park.

During a city council meeting in May 1914, the city's sanitation officer recommended that no further burials be permitted within the city limits. The council agreed, and on June 29, it passed Ordinance Number 15, which prohibited the burial of human bodies within the corporate limits of the city. This effectively closed the seven cemeteries to most new burials. Occasional exceptions occurred for individuals who died after that date to be buried in family plots or with family members, but almost two hundred exhumations occurred to move bodies to other cemeteries. For the next twenty-five years, except for an occasional interment or disinterment, the cemeteries that held Phoenix's first residents lay abandoned and largely forgotten.

PHOENIX'S FIRST RESIDENTS

B y 1914, when the cemeteries closed to new burials, many of Phoenix's first residents occupied graves in the PMMP cemeteries, their lives and stories forever linked with the new desert town, its growth and prosperity. Some were movers and shakers, others just plain folks. Many had multiple careers and simultaneous professions. Some engaged in practices that would be criticized today. Whether prominent or humble, each played a role in his or her community's establishment, survival and prosperity. These early settlers shared the vision, courage and tenacity needed to create a thriving town in a harsh and arid desert. In the beginning, they had scarcely more than the Hohokam had before them, namely ingenuity and natural resources, yet they created what became a major American metropolis.

The following sections contain short biographies of some pioneers who were buried in the PMMP.

MOVERS AND SHAKERS

John T. Alsap (Contributing Authors Donna Carr and Jason O'Neil)

John Tabor Alsap was a true Renaissance man. An early resident of Arizona and the Salt River Valley, he engaged in several professions and led the effort to establish the original Phoenix Townsite. Details of Alsap's early life are

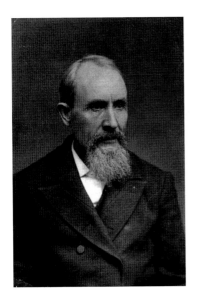

John Alsap. *Courtesy Arizona State Library, Archives and Public Records, History and Archives Division, Phoenix, #97-6451.*

sketchy and inconsistent. He was born in February 1830 or 1832 in Frankfort, Kentucky. His family soon moved to Ohio and later to Indiana. Some biographies have him either graduating from the New York College of Medicine with degrees in medicine and law or, more likely, studying medicine in Ohio. Alsap practiced medicine in Indiana before migrating to California in 1853 or 1854. For the next ten years, he also practiced medicine there and engaged in farming, mining and stock trading.[10]

The opportunities of the new Arizona Territory attracted Alsap, and he moved there in 1863. He arrived at the Walker diggings near Prescott in Yavapai County in November of that year and started mining for gold. Early the next year, Apache Indians raided the miners in the area, and Alsap was a member of a committee that, in March 1864, urged Governor John Noble Goodwin to have soldiers stationed in the area to protect the miners. Soon after, Alsap joined a punitive expedition, led by King Woolsey (see later entry), against the Apaches. His medical skill came in handy as he dressed the wounds of the injured. Alsap's reputation established, Governor Goodwin appointed him as the first territorial treasurer in December 1864, a post he held until December 1867.[11]

Alsap opened the first saloon in Prescott, a shrewd business move that brought him into contact with much of Prescott's electorate. On June 6, 1866, he married Louisa Osborn, daughter of pioneer John Preston Osborn. Tragically, she died barely a year later. Alsap became a member of the territorial legislature in 1868, and in his terms in office during the next decade, he served as Speaker of the House and president of the council (the Senate). His larger political ambitions were not fulfilled in Prescott, however, possibly because he was still a relative newcomer to an established community.

In 1869, Alsap moved to the Salt River Valley with his brother-in-law John Osborn and took up farming near the Swilling Party settlement. The new community grew rapidly, and by 1870, it was apparent that a business center

was needed for the exchange of goods and services.[12] Various members of the community had different ideas where the new town site should be located, mainly so it could benefit them. At a public meeting of 130 citizens on October 20, 1870, Alsap proposed a location that had not been yet been homesteaded or owned by any individual or group. Six days later, a committee created to recommend a location endorsed Alsap's proposed site. The citizens approved it, and the 320 acres that are now bounded by Van Buren Street, Seventh Avenue, Seventh Street and Harrison Street became the town of Phoenix. Alsap managed its land patent development.

Alsap turned his attention from the practice of medicine, mining and farming to the practice of law. As the fledgling community along the Salt River gained a foothold, he successfully led the effort to have a new county created, with Phoenix as its seat. Following the creation of Maricopa County in 1871, Governor Safford appointed Alsap its first probate judge. In his capacity as judge, he sometimes officiated at civil weddings when no minister was available. He also served as superintendent of public education.

On September 7, 1876, Alsap wed Anna Dugan Murray, and together they had five children. Between 1873 and 1879, Alsap continued service in the territorial legislature. He was also elected to a two-year term as Maricopa County district attorney in 1877 and filled a vacancy on the Maricopa County Board of Supervisors between August 1879 and December 1880. Alsap's contributions to the city of Phoenix were recognized when it incorporated in 1881, and he became its first mayor. He served only a few months, however, before resigning.

Alsap was an ardent Mason throughout his life. He was the founder and first master of the Aztlán Masonic Lodge in Prescott and of the Arizona Masonic Lodge in Phoenix. He chartered the Royal Arch Masonic Lodge. In early August 1886, Alsap announced his candidacy for Maricopa County treasurer. Later that month, however, he became unwell with an unknown illness and died on September 10, 1886. His age was given as fifty-six years. Upon his death, he was buried in the Masonic Cemetery in Phoenix. Alsap's wife, Anna, survived him by sixteen years and is buried next to him.

Robert E. Lee Brown (Contributing Authors Jason O'Neil and Donna Carr)

Though a resident of Phoenix for just a few days before he died, Robert E. Lee Brown may be one of the most unique characters in the PMMP and maybe the West. Known as a genial companion and entertaining

conversationalist with a striking and picturesque personality, he traveled extensively and earned two nicknames: "Barbarian Brown" and "Marc Antony."

Brown was born on May 31, 1865, in Philadelphia, Pennsylvania, to Laurence and Martha Brown. He trained as a mining engineer, speculated in mines and was well regarded internationally for his expertise. He was also a newspaperman and owned several publications. His ventures took him from the Pacific Northwest to South Africa.

In 1889, Brown began surveying potential mining claims in Washington. During a violent labor strike in Coeur d'Alene, Idaho, in 1892, he started a newspaper called the *Barbarian*. A newspaper account later noted that Brown "wielded a scathing, reckless and ruthless pen."[13] He took the side of the mine owners versus the unionized miners. His emphatic articles earned him the nickname "Barbarian Brown." Threatened frequently with death, he wheeled a cannon into the street outside his office and stopped rioters from assaulting those who were distributing copies of the *Barbarian*. In 1893, Brown went to Chicago and, with William "Coin" Harvey, launched a publication called the *Coin*.

Brown later journeyed to South Africa, where he secured a position with a prominent mining company. He is reported to have acted as a mediator between Transvaal president Paul Krueger and the raiders during the Jamison Raid in South Africa. He earned his other nickname, "Marc Antony," by warning workmen of Johannesburg against siding with revolutionaries plotting to overthrow Krueger's government.[14]

In September 1895, Brown participated in a land rush when the Transvaal government opened a large tract for mining. He gathered a group of four hundred men to form a "flying wedge" around him so he could reach a government land office ahead of his competitors where an agent was waiting to sell licenses for mining claims. The first ones there would get the best territory. Twelve thousand miners gathered on the day sales commenced. During a violent race to the land office, Brown's wedge held, and he, though injured, got there first and demanded a license. The Pretoria government did not honor Brown's claims, so he sued and later secured a settlement estimated at $500,000.

Brown returned to the United States and spent time in Washington before traveling to London, where he engaged in mine stock brokering. By 1901, he was back in Washington and then later moved to New York City, where he lodged at one of its premier hotels, the historic Hoffman House. During the last year of his life, Brown contracted tuberculosis and traveled to Phoenix

in a vain attempt at recovery. He died on October 3, 1902, at the age of thirty-seven. Despite his wealth and fame, he was buried under a simple wood headboard in the Rosedale Cemetery. Because he was in Phoenix but a short time, his death rated only a few lines in the *Arizona Republican*, despite his far-ranging adventures.

Benjamin Joseph Franklin (Contributing Author Donna Carr)

Many biographies of Benjamin Joseph Franklin assert that he was born in Maysville, Mason County, Kentucky, in 1839 to Charles and Elizabeth Franklin. This is unlikely given the time frames of his early career and because *their* son Benjamin was listed in the federal census of 1850 as being only seven years old. It seems more likely he was the son of John and Mary Franklin, also of Mason County, Kentucky, and was born in 1833. As an adult, B.J., as he was known, sometimes claimed to be a namesake and direct descendant of the signer of the Declaration of Independence. It was certainly good political capital, but there is no evidence to support this claim.[15]

It is believed that Franklin attended Bethany College in what is now West Virginia and then taught in public schools. He later studied law, was admitted to the bar in 1859 and settled in Leavenworth, Kansas, where he began his practice.[16]

Franklin arrived in the Kansas Territory at the end of a violent time as settlers from northern and southern states battled over whether Kansas would be a free or slave state. Elected to the Kansas State Senate in 1860, Franklin did not take his seat the following year. A Southerner, he instead joined up with the Confederacy when the Civil War broke out in April 1861 and enlisted in its army as a private. Some sources say that he served under General Braxton Bragg and rose to the rank of captain, but the regiment in which he served is not mentioned.[17]

Since Franklin had been a Confederate officer and taken up arms against the United States, he was forbidden to practice law or hold public office after the war until he took an oath of allegiance. From 1865 to 1868, he farmed in Columbia, Missouri, and was recorded as paying taxes there.[18] He finally took the oath in 1868.

Sometime during or immediately following the war, Franklin married Anne Johnson. She was the stepdaughter of Alfred Morrison, the treasurer of the state of Missouri. Morrison had resigned his office in August 1861

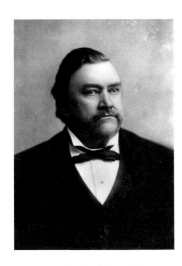

Governor Benjamin Joseph Franklin. *Courtesy Arizona State Library, Archives and Public Records, History and Archives Division, Phoenix, #96-1380.*

rather than take a loyalty oath to the United States and the state of Missouri, which remained in the Union.[19] Franklin may have been attracted not only to Anne but also to her stepfather's connections, and Morrison may have helped him with his political career. The couple had three children.

About 1868, Franklin started a law practice in Kansas City, Missouri. From 1871 to 1875, he was the prosecuting attorney for Jackson County. In 1874, he was elected to the United States House of Representatives as a Democrat and served two consecutive terms. He was nominated for a third term but withdrew his name and returned to private practice in 1879. A photograph of Franklin taken by Mathew Brady during his time in Congress shows him with a head of wavy hair and a mustache. A press description later in his career described him as a "man of ponderous physique and hearty manners."[20]

In 1885, Franklin, an admirer of newly elected President Grover Cleveland, a fellow Democrat, went to Washington, D.C., to request an appointment as U.S. consul to Hangchow (now Hangzhou), China. As related by Arizona senator Henry Ashurst years later, during Franklin's interview with the president, Cleveland told him that while he had a high regard for his abilities, the administration's policy was to appoint only those who spoke the language of the country where they were assigned. As the story goes, Franklin replied, "Mr. President, ask me any question you wish in Chinese and I will answer you in that language." Cleveland reportedly bristled and then said, "You will be appointed tomorrow, Mr. Franklin, very possibly this afternoon."[21] Whether he was bluffing or truthful, Franklin got the job.

The Franklins did go to China, but with the electoral defeat of the first Cleveland administration in 1888 and a Republican president again in the White House, they returned to the United States and settled in California in 1890. Soon, however, Franklin saw the business potential of Arizona, and by 1892, the family had moved to Phoenix, where he once more took up the practice of law.

Franklin soon reentered the political arena. As a relative newcomer to Arizona, he was not aligned with any faction within the local Democratic Party. In 1895, aware of efforts to have territorial governor Henry Hughes removed from office, Franklin persuaded several prominent local men to send letters of recommendation on his behalf to his old patron President Cleveland, who had returned to the White House in 1893. Cleveland responded by appointing him the twelfth territorial governor of Arizona on April 18, 1896. Franklin's son Alfred served as his personal secretary.

Franklin advocated for statehood. Believing that many businesses and individuals were not paying their fair share of taxes, he pushed for tax reform. As a fiscal conservative, he was averse to soliciting funds from Congress, but he realized that only the federal government had the wherewithal to build the dams and irrigation systems that Arizona needed to grow. He advocated for federal support for dams and reservoirs to make the desert "bloom as a garden." He also simplified the livestock laws. Of the 320 pieces of legislation presented to him, however, he signed only 88 bills. Among the bills he refused to sign was one in support of compulsory school attendance. Franklin thought this impractical in a territory as rural as Arizona at the time.[22]

Franklin's governorship did not last long. Cleveland did not run for president in 1896, and the White House switched parties again. After Republican William McKinley became president, he replaced Franklin with a man of his own party, Myron Hawley McCord. On July 22, 1897, Franklin left office and returned to his private law practice with son Alfred as his partner. Franklin was generally regarded as being personally honest and competent although not particularly effective as a governor given his short tenure.

In January 1897, Franklin suffered a near-fatal heart attack but recovered through "sheer force of will." His health declined thereafter. When he did not wake from a nap on May 19, 1898, it was determined that he had died of a recurrence of his heart trouble. Franklin was buried in Rosedale Cemetery following an Episcopalian funeral service. Given his political career, his headstone is rather modest. The inscription includes the initial "J" written backward.

Franklin's son Alfred went on to have a career as eminent as his father's. He served as assistant United States attorney for Arizona from 1895 to 1897. In 1910, he was a delegate to the Arizona state constitutional convention. Upon statehood in 1912, Alfred became chief justice of the Arizona State Supreme Court, a post he held until 1918. After the death

of his wife from the Spanish flu in 1919 and the deaths of his mother and brother soon after, Alfred became a recluse and sought solitude in the desert. He was last seen alive in 1948. When and where he died, no one knows.[23]

John J. Gardiner (Contributing Author Derek Horn)

John J. Gardiner, an enterprising businessman, built the first hotel in Phoenix, established several businesses and was instrumental in creating the city's first municipal waterworks and electric utility. He was born in Gloucestershire, England, in June 1841 to George and Mary Gardiner, who named him Jehoida John. At the age of sixteen, Gardiner went to work in a flour mill, but he also engaged in grain speculation. By the age of twenty-two, he had amassed enough money to marry and immigrate to the United States. He married Elizabeth Mason in 1862, and fifteen days after their wedding, he sailed for America. There was an understanding that he would eventually send for Elizabeth once he was established.

Gardiner traveled to Salt Lake City, purchased mules and wagons and began hauling freight throughout the West. He corresponded with Elizabeth, who remained in England, but after a few years, correspondence ceased. He later attested that around 1868, he received word that Elizabeth had died. Gardiner subsequently married again in 1869. He and his second wife, also named Elizabeth, moved to Phoenix in 1870 and established a new life.

Gardiner purchased most of Block 19, at the northwest corner of Washington and Third Streets, and built one of the first buildings in town, the Phoenix Hotel, also known as Gardiner's Hotel. The one-story adobe building had a courtyard with a unique feature. A channel intersected an irrigation ditch on Third Street and conveyed water into a pool in the courtyard. Hotels guests could take a dip in the pool, which must have been a welcome relief on a summer day. The hotel quickly became a popular gathering spot for the community and special events. Gardiner continued to develop his property and prospered over the next decade.

In 1882, Gardiner returned to England for a visit and, with what must have been total shock, discovered that his first wife, Elizabeth, was still very much alive. Not only that, he learned he had a son, named John Mason Gardiner, by then about twenty years old. Coincidentally, about the time Gardiner heard that Elizabeth had died, Elizabeth also received word that John was dead, so there was no mystery as to why their correspondence had

Right: John Gardiner. *Courtesy Arizona State Library, Archives and Public Records, History and Archives Division, Phoenix, #97-8333.*

Below: An early view of Gardiner's Hotel. Note the water in the ditch along Washington Street. *Courtesy Arizona State Library, Archives and Public Records, History and Archives Division, Phoenix, #97-2132.*

ceased. It is unknown if she had ever mentioned their son in her letters to him in America.

Gardiner now found himself in an awkward predicament with two wives. He explained the situation to (the first) Elizabeth, took her and John back to America and left them in Salt Lake City while he traveled to Phoenix to sort out the situation with his second wife. It was agreed that the second Mrs. Gardiner would obtain a divorce and receive a settlement of $5,000 (about $116,000 in today's currency), payment of which would be secured by Block 19. Gardiner also obtained from the first Mrs. Gardiner any rights she could have to his Phoenix property, particularly Block 19, for a consideration of $1,000. In 1885, Elizabeth Mason Gardiner journeyed to Phoenix, where she and Gardiner lived together as husband and wife. Elizabeth O. Gardiner remained in the community for a few years before moving to California.

During the 1880s, Gardiner continued to build his enterprises and profile in the community. He built a water supply and delivery system for his businesses on his Washington Street property. A municipal source of water safe for drinking, sanitation and firefighting did not then exist, so in 1886, Gardiner began expanding his system to surrounding businesses, and soon his firm, the Phoenix Works Company, had a franchise to provide water to the town. He set up a plant at Polk and Ninth Streets that included a one-hundred-foot-tall water tower and machinery with a pumping capacity of two million gallons a day. Gardiner's son John Mason Gardiner joined him in the enterprise, and when he sold it in 1889, the system included twelve miles of water mains.

Gardiner branched out into other enterprises. He engaged in building construction, built the first lumber mill in Phoenix and created an electric lighting company. Returning to his roots, he established a large flour mill. Gardiner became a naturalized citizen on October 24, 1890.

First wife Elizabeth Mason Gardiner died on April 13, 1895, from asthma at the age of fifty-four and was buried in the Porter Cemetery. Before she passed away, she and Gardiner put most of their assets into a holding corporation known as the Farmers and Merchants Manufacturing Company, capitalized with five thousand shares of stock valued at $100 each. Gardiner married Laurabel Squires later that year in October. They had three children, but one died in infancy and was buried in the Masons' Cemetery.

Soon after his mother's death, Gardiner's son John Mason Gardiner sued his father to obtain half the assets, or 2,500 shares, of the holding company. Territorial law provided that half of the community property of a

The waterworks built by John Gardiner. *Courtesy Herb and Dorothy McLaughlin Collection, Greater Arizona Collection, Arizona State University Libraries.*

husband and wife passed to the surviving children upon the death of one if the other spouse remained alive, so John Mason claimed half of the couple's property. After a trial, the judge granted him only 585 shares by reasoning that Elizabeth had not contributed to the development of Block 19, which constituted the bulk of the estate, and she may have renounced her rights in 1885.[24]

John Gardiner continued to run his businesses, but on February 9, 1903, he died of heart disease at the age of sixty-two. He joined his first wife, Elizabeth, in the Porter Cemetery. Despite his wealth and prominence, he lies under a simple wooden headboard.

The Phoenix Hotel, expanded and improved over the years, became the Capital Hotel. It operated as a rooming house until demolished in 1959. The Gardiner family still owned property on Block 19 until it was acquired by the City of Phoenix in 1969 for a new civic center. It is now the location of Phoenix Symphony Hall.

Henry Garfias (Contributing Author Derek Horn)

A prominent Hispanic man in a primarily Anglo town, Henry Garfias gained distinction as a courageous and diligent lawman, as well as a popular citizen. Born in California in 1849 as Enrique Garfias, he migrated to Arizona about 1871. He hauled freight between Phoenix and Wickenburg and then settled in Phoenix in 1874. His first jobs were court interpreter and occasional grave digger.[25] In 1878, he ran for and was elected a Phoenix constable. He may have begun ranching, as he recorded a brand for his livestock that same year.

As a center of commerce, banking and law for the surrounding agricultural community, Phoenix was usually an orderly town, but there were times of violence. Garfias's first major incident as a lawman occurred in 1879. On June 1, a man named Jesus Romero rode his horse through a crowd on Washington Street, slashing three men with a sword before escaping into Pima County. Garfias and a deputy sheriff pursued, captured and returned him to Phoenix, where he was jailed. On August 21, Garfias picked up rumors that a mob intended to lynch Romero and one other prisoner, John Keller, who had recently murdered Luke Monihon. Despite his efforts to protect the prisoners, Romero was shot that evening. The next morning, vigilantes took Keller and another murderer, William McCluskey, and hanged them in the city Plaza located between Washington and Jefferson Streets and First and Second Streets.

After Phoenix incorporated in 1881, the town held an election for its first mayor, treasurer, councilmen and marshal. Garfias ran for marshal as an outsider against two Anglo candidates and won. He served as marshal while keeping his position as Phoenix precinct constable.

The duties of the town marshal in the 1880s involved not only being the chief law enforcement officer but also such odd jobs as killing stray dogs, filling holes, repairing street crossings, managing chain gangs, removing stumps, cleaning irrigation ditches, collecting license fees and taxes and whatever else the mayor and city council asked him to do. His pay was based, in part, on performing these tasks.

The new Phoenix government got off to a rocky start. In 1882, the *Phoenix Gazette* noted the poor conditions of the town streets and irrigation ditches. Despite revenues of nearly $3,000 in the past year, no funds seemed available for repairs. Many blamed the hardworking town marshal. Garfias fought back against the allegations of corruption and neglect of duties with an editorial in the *Phoenix Herald* in which he laid out his case and blamed "malicious obstructionists" for the town's plight. He was reelected in the city's only contested election and soon won over his critics with his work on street and irrigation canal repairs, as well as utilizing chain gangs to trim trees and clean up the city Plaza.[26]

Phoenix peace officers in the 1880s. Henry Garfias is on the left. *Courtesy Phoenix Police Museum.*

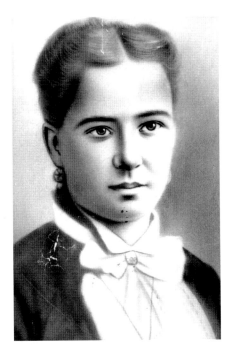

Left: Elena Garfias. *Courtesy Arizona Historical Society, Y-PC-100.*

Below: The first Maricopa County Courthouse. *Courtesy McCulloch Brothers Photographs, Herb and Dorothy McLaughlin Collection, Greater Arizona Collection, Arizona State University Libraries.*

On August 2, 1882, Garfias received a report that some cowboys were shooting pistols randomly along Washington Street. He formed and led a posse that confronted the three men and demanded their surrender. The cowboys responded by firing on Garfias, who returned fire, hitting one of them. The cowboys then rode off with the posse in hot pursuit while exchanging gunfire. When it was over, one of the cowboys was dead and two others were captured.

This incident sealed Garfias's reputation for courage. Past concerns forgotten, the community expressed its appreciation to Garfias with speeches and a check for $167 collected from local businessmen. He also became deputy U.S. marshal for Maricopa County, and for the next four years Garfias continued to perform his various law enforcement and other civic duties.

In April 1883, Garfias married Elena Redondo, daughter of a prominent Yuma family, and in 1885, they moved into "an elegant brick residence" at the northwest corner of Third Avenue and Jefferson Street.[27] He also started a Spanish-language newspaper, *El Progresso*, with his brother-in-law. Garfias and Elena had three children. Soon after the birth and death of their third child, Elena Garfias died in 1890 and was buried in the Loosley Cemetery.

Garfias lost a bid for reelection as marshal in 1886. He then ranched, served as a court interpreter and continued to perform various contract projects for the city, which included relocating graves from the old city cemetery to the new cemeteries in 1888. He ran for and won a constable position in November 1892 but lost a reelection bid two years later.

While no longer marshal or constable, Garfias continued to perform various law enforcement assignments. On the evening of August 16, 1892, he was waiting with a couple of horses beside a railroad track near Tempe at a prearranged time and location. As the train to Phoenix passed by Garfias, it slowed down, and the Maricopa County sheriff dropped Ed Tewksbury, the alleged murderer of Tempe resident Tom Graham, off the train. Garfias then slipped Tewksbury into a Phoenix jail. Tewksbury was held in Tucson after capture, and the sheriff was returning him to Phoenix to stand trial. Feelings ran high over Graham's murder earlier that month, and the ruse ensured Tewksbury avoided a lynch mob.[28]

In June 1891, Garfias married Dolores Ferreira, but their life together was not smooth. They lost their infant son in 1893. That same year, Garfias fought an indictment for filing false reimbursement claims related to his

constable position. He won his case. Garfias filed for divorce but later withdrew his petition. He and Dolores remained separated, however, for the remainder of his life.[29]

Henry Garfias died on May 8, 1896, after suffering injuries in a horseback riding accident and was buried in the Loosley Cemetery. While the exact location of Garfias's final resting place is not known, his epitaph could have been written by a fellow frontiersman who said, "Henry isn't entitled to any credit for his sand [grit], for he doesn't know any better."[30]

Columbus Gray (Contributing Author Donna Carr)

Columbus Gray was born on August 29, 1833, in Gadsden County, Florida, to Thomas Gray and his first wife, Temperance Kersey. The Grays moved to Alabama and then to Union County, Arkansas, where Temperance died in 1845 and Thomas remarried. Columbus grew up in a boisterous household with eight brothers and three sisters. Although the family may have had hard times in the beginning, by the eve of the Civil War, the Grays were relatively prosperous and owned sixteen slaves.

News of the discovery of gold in California enticed Columbus to leave home with his older brother Josiah in 1850, cross the Isthmus of Panama and journey to the gold fields. Like so many others, however, he did not strike it rich as a miner. After a brief stint on the Fraser River in British Columbia, Gray gave up and went home to Arkansas in 1859.

When the Civil War commenced, Gray enlisted in an Arkansas unit of the Confederate army. He was present at the Battle of Prairie Grove on December 7, 1862, and saw his younger brother James fall in battle. Columbus was later captured and spent nine months in a Union prison camp near Alton, Illinois, before making his escape from a prison train bound for Fort Delaware.

Shortly after the war ended, Gray married Mary Norris, the twenty-year-old niece of his stepmother. Mary's delicate health and the depressed postwar economic conditions in Arkansas encouraged him to take his new wife west, to the California he remembered from his mining days.

They set out in February 1868 as part of a small train of fifteen mule-drawn wagons. The party included Columbus's older brother Josiah and his family. It took them more than six months to reach the Salt River Valley, where they stopped on August 18, intending to rest before continuing their journey.

By that time, the settlement started by the Swilling Company was established and enjoying some early success. The first of several irrigation canals or ditches was already in use, and crops of corn, beans and pumpkins were nearly ready for harvest. The hot, dry climate seemed to alleviate Mary's ailments. Seeing that the soil was fertile and, with irrigation, crops could be grown, the Grays decided to stay.[31]

Life in the valley then was primitive. The Grays' first home was no more than a brush shanty, but a year later, they constructed an adobe dwelling and a corral. Mary was the only Anglo woman in the small settlement, though not the first woman. Trinidad Swilling, the wife of Jack Swilling, was Spanish.

Columbus Gray. *Courtesy Arizona State Library, Archives and Public Records, History and Archives Division, Phoenix, #97-8589.*

Mary's cook and housekeeper, Mary Green, was the only black woman.

In 1868, the year the Grays arrived in the valley, only 250 acres were under cultivation. Four years later, as more canals were dug and fields planted, this number jumped to 8,100 thanks to the industry of the settlers. The Grays became influential citizens of the area, and Columbus was one of the original signers of the Articles of Incorporation for the Salt River Valley Town Association on October 20, 1870. When Maricopa County was created in 1871, Gray was appointed to the county's first board of supervisors. In 1879, he was elected to the territorial legislature.[32]

From farming, Gray's business interests expanded to include mining. At one time, he was a part owner of the Harquahala Mine but later sold it. Gray also constructed a building in downtown Phoenix that was intended to be the first Masonic Hall, but he sold it instead to two enterprising brothers named Goldwater.

A catastrophic flood of the Salt River in 1891, followed by a severe drought the next year, wreaked havoc on the Grays' fortunes. Although they had a windmill pump and a hand pump, the drought killed all fifty of the Grays' cattle.[33] But better days followed, and eventually the Grays moved into a fine mansion at Seventh Street and Mohave, presided over by housekeeper Mary Green.

Columbus Gray died on August 30, 1905, of stomach and liver cancer and was buried in the Masons Cemetery. Mary Gray continued to live in their mansion until her death in 1936.

William Augustus Hancock (Contributing Author Jason O'Neil)

William Augustus Hancock made two significant contributions to the city of Phoenix. An early settler in the Salt River Valley, he surveyed and laid out the original town site. As an entrepreneur and attorney, he advocated stalwartly for irrigation and reclamation projects vital to the growth of the area. Hancock was born on May 17, 1831, in Barre, Massachusetts. In 1853, he and his brothers drove a herd of livestock from Iowa to California to feed the miners in the gold fields and then took up ranching and mining.

He enlisted in the Union army and went to Yuma in 1864 as a member of the Seventh California Infantry. He later served in Company C of the First Arizona Volunteers and was stationed at Fort McDowell, where he mustered out in 1866 with the rank of lieutenant. He held the honorary title of captain for the rest of his life. Hancock became the superintendent of the government farm at Fort McDowell and then moved to the valley about 1870.

Little is known about Hancock's education, but he must have received some training in surveying and instruction in the law. After he moved to the valley, he became the secretary of the Salt River Valley Town Association and surveyed the town site. He also surveyed the Salt River Irrigation Canal or "Swilling's Ditch," the Grand Canal through the valley and the fraternal cemeteries in the PMMP. His law office, an adobe structure at the northeast corner of First and Washington Streets, was the first permanent building erected in Phoenix. It also served as a grocery and dry goods store, courthouse, jail, public school and central meeting place. Hancock received most of his legal fees in wheat and barley.

Upon the organization of Maricopa County, Hancock was appointed the first sheriff by territorial governor Safford but was replaced a few months later by an elected sheriff. He was appointed district attorney in 1871, became probate judge in 1875 and served as superintendent of schools and postmaster in the 1870s.

In 1873, Hancock married Lillie Kellogg, who was twenty-five years his junior. The couple had two children, but their marriage was troubled. In 1886, Hancock had Lillie committed to the Insane Asylum of Phoenix (now

William Hancock. *Courtesy Arizona State Library, Archives and Public Records, History and Archives Division, Phoenix, #97-8662.*

the Arizona State Hospital) soon after it opened. She would be in and out of mental institutions for many years.

In 1892, Hancock successfully represented his friend, landowner Michael Wormser, in a landmark Arizona water rights case that established the principles that water was not a commodity, belonged to the land and early users of water had priority over later users. In 1900, Hancock proposed the creation of a cooperative venture to create dams along the Salt and Verde Rivers to ensure a reliable supply of water for the farms in the valley. He encouraged congressional action to support reclamation.

Hancock died of pneumonia on August 24, 1902, and was buried in the Knights of Pythias Cemetery. A few months later, President Theodore Roosevelt signed into law the National Reclamation Act of 1902, which provided the means for valley landowners to finance and construct dams on the Salt River. Hancock's cooperative venture idea became reality with the formation of the Salt River Valley Water Users Association in 1903 and completion of Roosevelt Dam in 1911.

Samuel Korrick (Contributing Author Derek Horn)

Sam Korrick settled in Phoenix in 1895, perhaps on a whim. On his way to California from Texas, he stopped in the valley and decided it held opportunity. He was born in April 1871 in Grodno, Belarus, then part of tsarist Russia. About 1890, he immigrated to America, perhaps to escape anti-Semitism and compulsory army service, as well as for a chance to make his fortune in America. Korrick worked as a dry goods clerk in New York for a few years before moving on to El Paso, Texas, where he worked for a merchant family, the Diamond Brothers. He then moved to Phoenix.

Despite his relative youth, he combined his experience in the dry goods business with a flair for merchandising, determination and hard work. He set up his first store in a narrow space in the 200 block of East Washington

Street. In a brilliant piece of branding, he called his shop the "New York Store" to generate some glamor. Enjoying early success, he signed a lease in 1897 for more space in the same block and employed sixteen people.

Korrick was a fierce competitor. Prominent newspaper advertisements for his store promoted quality merchandise, low prices and seasonal and annual clearance sales. They noted his buying trips to eastern markets and goods imported from New York, which must have created a certain cachet for his customers in the desert city. Other merchants eventually adopted his methods.

In 1899, with continued success, Korrick brought his brother Charles over from Russia to join him in the business. He became involved with the Masons and the Elks and was active in the local Jewish community. Korrick was a founding member of the Commercial Club, formed to promote Phoenix in the East, and became a subscriber to St. Joseph's Hospital.

Korrick's health started to decline in 1901, and he died on March 23, 1903, at the age of thirty-two. His death certificate lists "cerebral softening" as the cause of death. Korrick's services were an ecumenical affair. After the reading of Jewish rites, a Methodist minister gave a eulogy. Masons, Elks and members of the Eastern Star and Ladies Aide Society

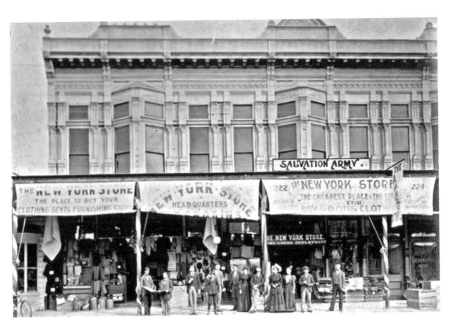

The New York Store. *Courtesy Korrick family/PCA files.*

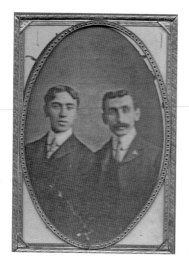

Charles and Samuel Korrick.
Courtesy Korrick family/PCA files.

of the Methodist Episcopal Church attended, as well as fellow merchants and members of the Jewish community. The six pallbearers represented the Jewish community, Elks and Masons. After a long cortege that accompanied him to the Masonic Cemetery, Korrick was interred in accordance with Masonic rites. During his services, many local merchants closed their stores out of personal regard.

Charles Korrick carried on with the store and proved to be as good a businessman as Sam. He brought his brother Abraham into the business, and in 1914, they built a new upscale department store at the northeast corner of Washington and First Streets. They soon simplified the name to Korrick's. The business lasted well into the twentieth century, when it eventually became part of Macy's. The original New York Store was demolished long ago, and Phoenix Symphony Hall occupies the site, but the 1914 Korrick's building in downtown Phoenix, though heavily altered, still stands.

James D. Monihon (Contributing Author Donna Carr)

James Davidson Monihon was born on November 6, 1837, in Oneida County, New York, to Irish immigrant parents. After growing up there, in 1854 he journeyed to California, where he became a miner. When the Civil War broke out, he enlisted on August 16, 1861, as a private in Company F, First California Infantry. Monihon's unit was sent to Arizona to stop the Confederate drive west from Texas into New Mexico and Arizona.

For the next several years, the regiment ranged throughout the Arizona and New Mexico territories not only keeping the Confederates away but also engaging in skirmishes with the Indians. Monihon was wounded during a skirmish at Sand Creek in the Tonto Basin on June 18, 1864. He was discharged with the rank of corporal on August 29, 1864, at Fort Whipple near present-day Prescott. Monihon settled in the area, where he mined and carried mail through Indian country. In November 1868, as a civilian, he

participated with the army in an Indian raid. He also sold hay, grain and other agricultural commodities.

By 1872, Monihon had relocated to Phoenix, where he homesteaded 160 acres at the southwest corner of present-day Van Buren Street and Twenty-Seventh Avenue. Soon his brother Luke joined him in the area with a homestead of his own. Monihon quickly established himself in the community. He became a member of the Salt River Valley Town Association, which coordinated the process of setting up, surveying and patenting the new Phoenix town site.

Monihon constructed a stable on Washington Street between Central and First Avenues for Jake and Andrew Starar and received a third interest as payment. He eventually bought them out, and the Phoenix Livery, Feed and Sale Stable and Corral became his enterprise. He is reputed to have planted the first cottonwood trees in Phoenix along Washington Street, the main business thoroughfare, and had one of only three wells in the town site with drinkable water. He also engaged in road construction and mail delivery.

On July 2, 1873, Monihon's corral was the site of a lynching. Mario Tisnado, who had stolen a cow, was being held in the courthouse jail pending trial. In an example of swift frontier justice, a vigilante group broke into the jail, seized Tisnado and dragged him to the corral across Washington Street, where they hanged him from one of the beams.

It is not known if Monihon had anything to do with this event, but it did not hinder his rise in the community. In addition to his homestead and business, Monihon acquired more property. At a meeting of the town association in October 1875, he proposed a motion, seconded by John Alsap, for incorporation. The motion was defeated, but six years later, in 1881, Phoenix did incorporate. Monihon ran for mayor but was defeated by Alsap.[34] That same year Monihon, along with other landowners, donated property for the Catholic church at Third and Monroe Streets, the present location of St. Mary's Basilica.

On March 15, 1877, Monihon married Josephine "Josie" Linville. He was thirty-nine and she was nineteen at the time. They had one daughter. By 1880, the couple was living in Phoenix, where Monihon worked as a real estate agent.

Tragedy struck the Monihon family in August 1879. Luke Monihon, while returning to his farm after running errands in town, was murdered by John Keller on the nineteenth of the month. A posse led by Henry Garfias swiftly tracked down the murderer and jailed him. Believing

Monihon Block. *Courtesy McCulloch Brothers Photographs, Herb and Dorothy McLaughlin Collection, Greater Arizona Collection, Arizona State University Libraries.*

justice was too slow, a citizens' committee nabbed both Keller and another accused murderer on the morning of August 22, took them to the city Plaza and hanged them from a cottonwood tree. Later, the grand jury empaneled to hear the case could not reach a verdict because too many people had been involved.[35] Monihon's murderer was buried in the first city cemetery.

In 1889, Monihon built the three-story Monihon Building on the site of his old corral. An impressive example of Victorian architecture, it survived until the 1930s, when it was torn down. Monihon was active in the local chapter of the Masonic Order, rising to the office of grand marshal of the grand lodge. His wife was a member of the Order of the Eastern Star. Monihon also joined the local GAR post and eventually became a post commander. One of the most influential citizens of the community, he successfully ran for Phoenix mayor in 1894 and served a one-year term. He ran again in 1896 and served another term. By the time he tried for a third term in 1899, he had lost much of his support and was defeated.

Monihon was eventually awarded an invalid pension for his military service. Early in the new century, his health started to fail, and he died on September 2, 1904, of pulmonary tuberculosis at the age of sixty-seven. After a Masonic service and funeral attended by over five hundred people, Monihon was interred in the Masons' Cemetery. In 1921, Josie had his remains reburied at Greenwood Cemetery. His murdered brother Luke still rests in Loosley Cemetery.

Frank Moss (Contributing Author Mark Lamm)

Frank Moss has the distinction of being one of seven individuals who served nonconsecutive stints as mayor of Phoenix. Born in Kenosha County, Wisconsin, on September 15, 1852, to Francis and Carrie Moss, he grew up in Wheatland, Wisconsin, and began learning the blacksmith trade when he was sixteen years old. He apprenticed in Kenosha and then moved to Virginia City, Nevada, where he worked as a blacksmith and ran a lumberyard. In 1878, he moved to Tombstone, where, while driving a wagon, he was reportedly shot at twice by Indians. He traveled mostly at night to avoid them.

Moss opened a blacksmith shop in Harshaw, a mining town south of Tucson. About 1880, he relocated to Phoenix, where he eventually set up a blacksmith and wagon-making shop at the northeast corner of First Avenue and Adams Street. Over the years, he also invested in real estate, ranched, mined and participated in Republican Party politics. He owned and trained racehorses.

On May 31, 1885, Moss married Ida Harmon. They had three boys together: Earl, born in 1886, and twins Ralph and Earnst, born in 1895. He also joined several fraternal organizations, including the Odd Fellows, Elks and the Workmen of the World.

Sometime before 1890, Moss joined the volunteer Phoenix Fire Department. By 1890, he was an assistant chief, and in 1892, he was the chief. The job had its hazards. In November 1890, he and another person were severely burned on their faces and hands when they extinguished the flames on a young servant girl who, while lighting a stove, had become covered with burning coal oil. In January 1894, while on the way with his crew to fight a fire, he was thrown from the engine and dislocated his right shoulder. Despite quick treatment from Dr. Scott Helm, the injury left him unable to lift his right arm, and he had to give up his position as fire chief.

Frank Moss in his firefighter uniform. *PCA files.*

Undaunted by this setback, by the middle of 1894, Moss ran for and won a seat on the Phoenix City Council. He also continued his trade as a blacksmith. In August 1895, he built a new shop at the southwest corner of Washington Street and Fourth Avenue.

During early 1896, the city council was dealing with a high-profile community issue: whether to continue allowing prostitution in Block 41 of the city. At its meeting on April 6, 1896, Mayor Roland Rosson, reportedly tired of the burdens of office, resigned. The council then selected councilman Allyn Lewis as acting mayor. At the following council meeting on April 30, acting mayor Lewis resigned, and the remaining council members appointed Moss as acting mayor. He served as mayor pro tempore until James Monihon won the office for a second time in a special election on June 2, 1896.

After the election, Moss continued his service on the city council and worked at his shop on Fourth Avenue. He won another term in 1898, but his life was soon upended. On December 4, 1898, for unknown reasons, Moss moved out of his home and separated from his wife, Ida. She filed for divorce on June 14, 1899, which was granted on July 1. Ida remarried a month later, on August 5, to Orrin Lawrence, a Phoenix policeman. There is no record of Moss remarrying, but curiously, his 1900 census record shows his marital status as widowed.

Moss became acting mayor again on July 10, 1905, when Mayor John Adams resigned over a dispute with the other members of the city council on appointments to the Water Works Commission. This time, Moss held the seat for almost a year. During his stint as acting mayor, and perhaps due to his experience as a firefighter, the city council passed ordinances that prohibited the construction of buildings of paper, canvas or cloth and restricted the storage of some combustible materials. The council also passed an ordinance that created a speed limit of six miles per hour for automobiles, bicycles and horse-drawn vehicles.

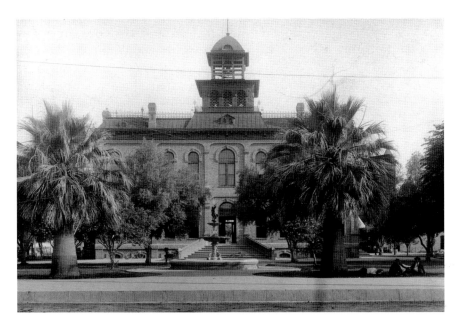

Phoenix City Hall about the time of Moss's death. *Horn Collection.*

On the evening of March 19, 1906, Mayor Moss rode his bicycle to city hall. Not feeling well, he lay down while medical help was summoned. A doctor gave him some medicine for indigestion, but Moss died between 9:00 and 10:00 p.m., likely of a heart attack. He was fifty-three years old.

He lay in state at city hall. After his service, he was laid to rest in the Odd Fellows Cemetery. Soon after his death, his handwritten will dated June 17, 1903, was found among his effects. Ida, by now remarried to J.F. Harriman, filed probate on behalf of her sons. Moss had made provision for them but left his business to Belle McDonald, a friend and possible fiancée from years back. Ironically, in November 1909, Ida, *now* married to James Collyer, purchased Moss's blacksmith shop from Belle for twins Ralph and Earnst.

Lindley Hogue Orme (Contributing Author Val Wilson)

Lindley Hogue Orme was born in Maryland on December 19, 1848, to Charles and Deborah Orme. Orme served in Company B, Thirty-Fifth Virginia Cavalry Regiment, in the Confederate army as a private and was admitted to the hospital for measles at one point. In the years after the war,

IN MEMORY OF
MARICOPA COUNTY TERRITORIAL SHERIFFS

LINDLEY H. ORME
1848 — 1900

WILLIAM A. HANCOCK
1831 — 1902

NOAH M. BROADWAY
1833 — 1905

THOMAS BARNUM
1832 — 1909

WILLIAM THOMAS GRAY
1852 — 1911

Sheriff Monument honoring the service of Maricopa County sheriffs interred in the PMMP. *Photograph by Derek Horn.*

he lived in California and then moved to Arizona and Maricopa County in 1870. In March 1876, he married Mary Greenhaw. Mary died in March 1883. Orme married again in November 1884, to Mary Jeffries. They had one son.

Orme became a well-known Phoenix citizen and served the area in an official capacity for several years. In 1880, he was elected sheriff and served two terms until 1885. From there, he served in the territorial legislature and was elected again as sheriff in 1891, serving two more terms. During his service to the community, he built the first Phoenix jail with incandescent lamps, conducted quarantines for smallpox, assisted in securing the state capital for Phoenix and served justice on civil and criminal offenses alike. In 1895, he foiled the plan of a conspirator who aimed to commit a triple murder due to a family vendetta. Orme staked out at the intended victims' location and surprised the assailant and accomplice. The story made the papers, and Sheriff Orme became a hero.

Orme's health deteriorated in his later years, and he died at the age of fifty-two on September 24, 1900, of meningitis. As a member of the Odd Fellows and the Elks, his services were conducted per their rites, and he was buried in the Odd Fellows Cemetery. It was reported that the flag at the state capitol flew at half-mast to honor his service.

DeForest Porter (Contributing Author Derek Horn)

DeForest Porter arrived in Arizona as an associate territorial supreme court justice in 1872 and spent the next ten years on the bench, yet it was perhaps as an elected official and legislator where he exercised his greatest influence. Born on February 2, 1840, in Albion, New York, he attended St. Lawrence University and graduated from its theological school. Rather than enter the ministry, he apprenticed at a law office. Some sources indicate he was admitted to the bar in 1862. He enlisted in the Union army and was severely

wounded during the Battle of Gettysburg in 1863. In 1865, he married Julia Trowbridge. The couple made their way west and settled in Brownville, Nebraska, where Porter established a law practice. They had a son, DeForest Jr., and adopted a daughter.

In 1869, Porter was elected city attorney for Brownville. He later became the assistant assessor. In January 1871, he won a special election as a representative to the Nebraska territorial legislature, where he served on a committee to draft articles of impeachment on Governor David Butler for mishandling state funds.

Seeing opportunity in Arizona, Porter obtained a commission as an associate justice on the Arizona Territorial Supreme Court from President Ulysses Grant in February 1872. He and his young family moved to Yuma to take up his duties. As an associate justice, he presided over the Second Judicial District, which covered central Arizona. He was reappointed in 1876 and again in 1880. During his tenure, Maricopa County was added to his district, and about 1877, he moved to Phoenix. Julia Porter died in November 1878, and Porter married Lois "Lulu" Cotton in June 1880. They had one daughter.

Little is known of Porter's judicial record, but the newspapers of the time indicate that he was well regarded. The *Phoenix Herald* noted in its April 16, 1879 edition that "Judge Porter is a general favorite in this valley." It was Porter who presided over the grand jury that could not reach a verdict in the lynching of Luke Monihon's murderer, John Keller, in 1879.

During his time as district judge, Porter acquired mines throughout the state, as well as land in and around Phoenix. The family of his second wife also had significant landholdings. Mentioned in 1878 as someone who would make a good territorial representative to Congress, Porter ran in 1882 but was defeated. Sensing opportunity in mining and perhaps bored after ten years as a judge, he resigned in 1882 and became the resident manager of Excursion Mining Company. He also ran for territorial delegate to Congress. Neither worked out, but undaunted, he soon returned to Phoenix and established a law practice.

Porter successfully ran for Phoenix mayor in May 1883 and served a one-year term. His primary goal was to create a rail connection from Phoenix to Maricopa Wells, a station on the Southern Pacific Railroad's transcontinental line. In those days, freight was hauled in and out of the valley in wagons pulled by horses or mules. Lack of a rail link to national markets put the valley at a competitive disadvantage. A spur line to Maricopa would allow the community to efficiently ship its goods to markets

throughout the country and facilitate the import of commodities. To that end, as a newly elected representative to the territorial legislature, Porter journeyed to San Francisco in December 1884, met with the president of the railroad and obtained a commitment to support the connection between Phoenix and Maricopa. The community, though, had to finance the enterprise.

As a member of the Thirteenth Territorial Legislature in early 1885, Porter introduced an enabling law to allow Phoenix to raise funds to construct the line. The bill was approved, funds were raised and the line eventually opened on July 4, 1887. The opening of this rail line and, in 1895, another rail spur to the Atchison, Topeka and Santa

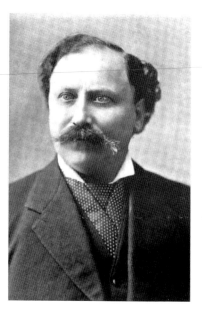

Deforest Porter.

Fe transcontinental route across northern Arizona provided reliable access to interstate markets. These rail connections spurred the growth of Phoenix and the Salt River Valley for decades.

Porter sought and won two more terms as Phoenix mayor in 1886 and 1887, but by this time, his health had started to deteriorate. For years, Porter suffered from heart trouble, and the Arizona summers were hard on him. He took breaks from his judicial duties and business interests to spend summers in cool climes. Nevertheless, he worked hard in his professions and service to the community. In March 1887, he suffered an attack of erysipelas but recovered. Two years later, in February 1889, he had another attack and died of a stroke on February 17, 1889, at the age of forty-nine. Initially interred in one of the PMMP cemeteries, his remains were later moved to Greenwood Cemetery, where he rests among his second wife's family.

Charles Poston (Contributing Author Derek Horn)

Poor Charles Poston! A half century ago he was regarded as the undisputed "Father of Arizona Territory." Now he seems more like a person whose death would have been welcomed if only it had happened thirty years before

it did. The story of his career does make interesting reading for the first forty years of his life. After that it was all down hill.[36]

So wrote John Goff, Poston's biographer, about the man who at one time was known as the Father of Arizona. He was born on April 20, 1825, near Elizabethtown, Kentucky. Young Poston enjoyed traveling. At the age of seven, he started work for his father's newspaper as a carrier and printers "devil" (apprentice and errand boy) before beginning his extensive lifetime travels in his early twenties. Before his death, his travels had taken him from North America to Europe and Asia.

Poston married Margaret Haycraft in 1848. In November 1850, he left his pregnant wife in Kentucky to seek his fortune in the California gold rush. Poston made his way to New Orleans, where he boarded a steamer for the Isthmus of Panama. After crossing to the Pacific, he took another steamer to San Francisco, where he found work as the chief clerk in the surveying office of the customs house for the Port of San Francisco. In 1853, after being demoted, Poston decided to explore northern Mexico and the new Gadsden Purchase area of the United States for mining opportunities. He joined with mining engineer Herman Ehrenburg and departed in early 1854. After their ship ran aground near Guaymas, Sonora, Mexico, Poston and his party were detained by the Mexican authorities. Released after it was determined they were not dangerous, they spent the next few months looking for mining and other opportunities near Tucson and Ajo before heading down the Gila River to the Yuma area. There, Poston met Fort Yuma commander Major Samuel Heintzelman, who would later become his business partner. Before he returned to San Francisco, Poston laid out the town site of Colorado City, a land speculation near the fort and present-day Yuma, which he later sold for $20,000 (over half a million dollars today).

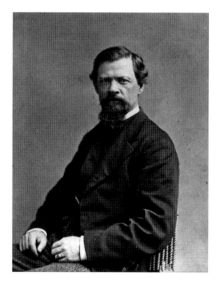

Charles Poston in his prime. *Courtesy Sharlot Hall Museum Library and Archives, Sharlot Hall Museum Collection, Call no. po-2092ph.*

Needing capital for a mining operation, Poston traveled east and raised $2 million from Cincinnati, Ohio investors introduced to him by Heintzelman. With capital secured, Poston formed the Sonora Exploring and Mining Company with himself as "military commandant" and the title of colonel. Heintzelman was president. The mining party set out from San Antonio, Texas, in May 1856 and made its way west along the Rio Grande into New Mexico. It then proceeded into southern Arizona before settling in an abandoned Spanish presidio near the settlement of Tubac.

Once established, the operation got down to business. Sonora purchased the seventeen-thousand-acre Arivaca Rancho for its mining potential and found silver yielding $7,000 per ton of ore in the Santa Rita Mountains.[37] During this time, Poston, as managing supervisor in charge of daily company operations, took on the role of *alcalde*, or magistrate, for the Tubac settlement. He printed money and presided over marriages, divorces and baptisms until the Catholic church in Santa Fe got wind of these events and sent a vicar to investigate. As the story goes, after a $700 donation to the church, the vicar was mollified.

Despite its success in producing ore, Poston's company experienced financial difficulties, and the shareholders did not see major profits from the operation. The Panic of 1857, a depression caused by a stock market decline along with bank and railroad failures, added to their problems. Profits from July 1858 through April 1859 amounted to $10,000. The company reorganized with gun manufacturer Samuel Colt as president. Poston soon left the mine for his health but returned in 1860 to take over operations.

Mining operations were producing $3,000 per day in silver by 1861. The onset of the Civil War, however, and subsequent withdrawal of the army garrisons left the settlers with little protection from the Apache Indians, who began to assert control over the area. Tubac had to be abandoned, and Poston eventually made his way back to New York.

After Union troops left the area at the beginning of the Civil War, Confederate soldiers marched in and declared Arizona as their territory. Union troops then returned and retook it. Spurred by Confederate interest in Arizona and other Southwest territories during the Civil War, the United States Congress approved legislation in 1862 that created the Arizona Territory. President Abraham Lincoln signed the bill on February 24, 1863.

By this time, Poston was in Washington, D.C., as an aide to now General Heintzelman. In his later writings, Poston took a great deal of credit for establishing the Arizona Territory, which is how he became known for a time

as the "Father of Arizona." Poston related his story, which appeared in the *Arizona Weekly Citizen* on April 12, 1884:

> *At the meeting of Congress in December 1862 I returned to Washington, made friends with Lincoln, and proposed the organization of the Territory of Arizona....There was no other person in Washington (save General Heintzelman) who took any interest in Arizona affairs, they had something else to occupy their attention, and did not know where Arizona was.* [38]

The article continues with Poston relating how Senator Benjamin Wade of Ohio and Representative James Ashley of Ohio told him how to accomplish the task. Poston went on to report that he was told that many members of Congress wanted to head west for both political and financial opportunities after their terms expired. "Consequently an oyster supper was organized for which the lame ducks were invited, and there and then the slate was made and the territory virtually organized." [39]

While Poston gave himself considerable credit for establishing the territory, strong political and economic forces were the real drivers behind its creation. There is no doubt, though, that Poston lobbied strongly and played a significant role.

Soon after President Lincoln signed the Arizona Organic Act creating the Arizona Territory, Poston landed a federal job as the superintendent of Indian Affairs in Arizona and headed west again. In 1864, he was elected as the first territorial delegate to Congress but lost the next election. His term ended in March 1865.

Nearly forty years old and out of a job, Poston traveled extensively for the next ten years. He spent time in Europe, delivered a copy of the Burlingame Treaty of 1868 to China, went to the Far East and lived for a while in London. [40] While traveling in India, he developed an interest in the Parsi people and Zoroastrianism. Poston returned to the United States in 1876, and President Ulysses Grant appointed him registrar of the land office in Arizona. While managing the office in Florence, he started construction on a Parsi fire temple on a nearby hill. He ran out of funds, however, and the project was never completed. Poston resigned from the land office in 1879 and went to work for the *Arizona Star* newspaper in Tucson.

During the 1880s, Poston endured a series of disappointments and reverses. In 1882, he shot at the editor of his newspaper, but the charges were dropped. The title to his landholdings in southern Arizona was invalidated by a series of court decisions, cases he should have won. [41] His estranged wife

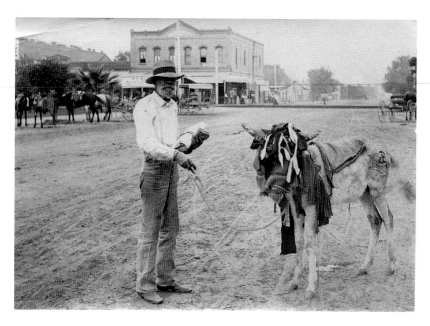

Charles Poston at Second and Washington Streets in Phoenix with the Fry Building in the background. The donkey wears a fly bonnet. *Courtesy Sharlot Hall Museum Library and Archives, Sharlot Hall Museum Collection, Call no. po-2092pf.*

died in 1884. He remarried a much younger woman in 1885, but he and his second wife lived together for only a few months before separating. By mid-decade, he was drinking heavily.

While Poston had ambitions and lobbied to be appointed territorial governor, instead he was appointed a statistical agent with the Department of Agriculture. In this capacity, Poston took up residence and his new duties in Phoenix, where he quickly established himself in the community. During the years that remained to him, Poston embarked on a series of grand ventures, but none materialized. He died in June 1902, of an apparent heart attack, and was buried in the Porter Cemetery.

Since he was regarded by many as the Father of the Arizona Territory, influential Phoenicians arranged for Poston to be granted his last wish to be buried on the hill near Florence where he planned his fire temple. On April 26, 1925, Poston was reinterred on newly renamed Poston's Butte with Governor George W.P. Hunt presiding.

Tallman Trask (Contributing Author Val Wilson)

Tallman Jacob "T.J." Trask was born in 1852 in Vassalboro, Maine, to William and Sophia Trask. The family later moved to Illinois. When he was twenty, Trask was living with Abel Gurn and his family and working as the clerk in Gurn's sizable dry goods store in Concord, Illinois. Trask learned the ins and outs of the trade while selling and stocking the products. He traveled west to Pueblo, Colorado, and became the head clerk in the grocery store of J.D. Miller. There, Trask met Laura Cooper and married her in July 1877. They had two children who died in infancy.

In March 1879, it was announced in the *Colorado Weekly Chieftain* that Trask was opening a store in Otero, Colorado.[42] He and Laura soon moved to Albuquerque, New Mexico, to start a new store with Lyman Putney, a businessman from Lawrence, Kansas. They specialized in wholesale groceries and exotic fruits from California. Their store was located right next to the tracks in downtown Albuquerque on Railroad Avenue opposite the depot. Native Americans who went there to trade could sleep near the store at night. Putney would sleep in a hammock by the ceiling beams to avoid the stray bullets from the town's rowdy night life.[43]

Trask and Laura had a tumultuous relationship, with Laura often spending time with family in Pueblo and Kansas. In the spring of 1884, Trask filed for divorce based on desertion and was granted one in October 1884. In December of that year, he married Lizzie Strother of Ohio, dissolved his business interests with Putney and opened a new store in Phoenix with his brother-in-law Emory Kays. In addition to their store, they also bred Galloway cattle on Trask's alfalfa farm near the present-day fairgrounds on West McDowell Road.

In 1892, Trask opened another store in Phoenix with his brother Alonzo and Charles Kessler. The Trask-Kessler wholesale grocery became one of the largest stores in town. It was located on Washington Street between Central and First Avenues near Trask's home on Adams Street between Second and Third Streets.

Trask became involved with many civic activities. He was president of the territorial fair and oversaw the exhibits. His own most notable exhibit contributions included a pagoda made from grains grown on his farm and a display of hanging teacups and saucers from his wholesale grocery store that spelled "Trask-Kessler." He also served as president of the Arizona Industrial Exposition Association, president of the Immigration Union, vice

Tallman Trask's elaborate monument. *Photograph by Derek Horn.*

president of the Business Chamber of Commerce in Phoenix and on the board of the Phoenix and Prescott Toll Road Company.

In the last year of his life, Trask's health began to fail. Despite treatment, he died on December 8, 1894, from complications of muco-enteritis. He was laid to rest in Porter cemetery under a marble monument of unusual Moorish design that proclaimed him as an "upright businessman."

Michael Wormser (Contributing Author Derek Horn)

As a young immigrant, Michael Wormser arrived in New York City with fifteen dollars. When he died in Phoenix forty-eight years later, he left an estate valued in the millions in today's currency. He was a merchant, miner and farmer, but he made his biggest mark on Phoenix by engaging in aggressive land speculation and water rights acquisition. As described by a twentieth-century biographer:

> *Michael Wormser was a French Jew and a capitalist, and he helped build Arizona. Above all, he embodied the spirit of frontier materialism. He never married. He kept largely to himself. If he enjoyed himself, it was by accident during a business trip. Yet when it came to business enterprise, his creative energy was unlimited.*[44]

Wormser was born in France on June 27, 1827. He immigrated to the United States in 1858. After working in New York for a few months, he sailed around the tip of South America to join his cousin Benjamin Block in San Luis Obispo, California. Block paid for his steerage ticket.

Block brought Wormser into his business, a livery stable. Block was a poor businessman, and the stable failed, but Wormser's experience in court claims following the demise of the business impressed upon him the effectiveness of seeking redress though the courtroom, a pattern he would follow the rest of his life.[45]

With $2,000 worth of goods purchased on credit, Wormser began selling to settlers in San Luis Obispo. By 1862, Block had moved to La Paz, Arizona, and attracted by the prospect of plentiful gold, Wormser followed him there. They went into business together again and operated a general store. Wormser soon moved on to the Wickenburg area, where he found more profit in merchandizing than mining. He then moved on to Prescott, where, in 1864, he opened the first general store in the town, called Wormser and Company, in an adobe building near the corner of Goodwin and Montezuma Streets. Wormser eventually partnered with Aaron Wertheimer, and it became Wormser and Wertheimer.

The store was successful, but Wormser, still allured by gold, filed some mining claims during the 1860s and 1870s but had little success. He also started a business pattern he would follow for the rest of his life. In lieu of cash purchases, Wormser would sell goods to ranchers in exchange for mortgages on their properties as collateral. If they could not pay, he acquired their property to satisfy the debts.[46]

Block eventually relocated to the new town of Phoenix in the early 1870s and started a general store in an adobe building at the southeast corner of Jefferson Street and Central Avenue. By 1873, this store had failed, and Wormser and Wertheimer, interested in expanding their operations, acquired it. In January 1874, Aaron Wertheimer died of stomach cancer. Wormser liquidated the Prescott operation at a loss and settled permanently in Phoenix. In addition to selling general merchandise, Wormser accepted grain as payment and sold it for profit. Then, in 1876, the price of grain dropped. This and unpaid accounts forced him out of business.

Approaching fifty and with debts to settle, Wormser turned to farming and began making money again. Also, as early as 1873, he began dealing with the Mexican farmers who worked land along the San Francisco Canal south of the Salt River. He advanced them seed and supplies, and in turn, they were obligated to give him a portion of their crops. This was an unreliable source of income, so Wormser encouraged the farmers to gain title to their lands. He then acquired their land and the water rights in the canal to eliminate their debts. Over the years, he obtained ownership or control of about nine thousand acres of farmland along the canal that he repaired and improved.[47]

Wormser was elected to the Maricopa County Board of Supervisors in November 1880 and served for four years. As a fiscal conservative, he pledged to focus on reducing the county's debt. At his first meeting, he was appointed superintendent of the poorhouse. He also came under fire for accusations that his land had received favorable tax breaks and that he sold inferior merchandise to the county. The board never acted on these accusations, and Wormer remained in office. He served as chairman from January 1883 until his term expired in December 1884.[48]

In 1892, the year after a great flood on the Salt River, its flow slowed drastically due to drought, and there was not enough water to fill all the canals. Wormser, concerned about his access to water, became a plaintiff in a landmark Arizona water case, *Michael Wormser et al. v. the Salt River Valley Canal Company et al.* Canals built after and upstream of the San Francisco Canal on the Salt River diverted water from the older canals downstream. This meant that Wormser could not furnish water to his tenant farmers or sell the excess. The suit was heard in district court before Judge Joseph Kibbey. William Hancock was one of the attorneys who represented Wormser. The case resulted in the "Kibbey Decision," which established the principle in Arizona that water belongs to the land, is not a commodity and that early users of water had priority over later users.

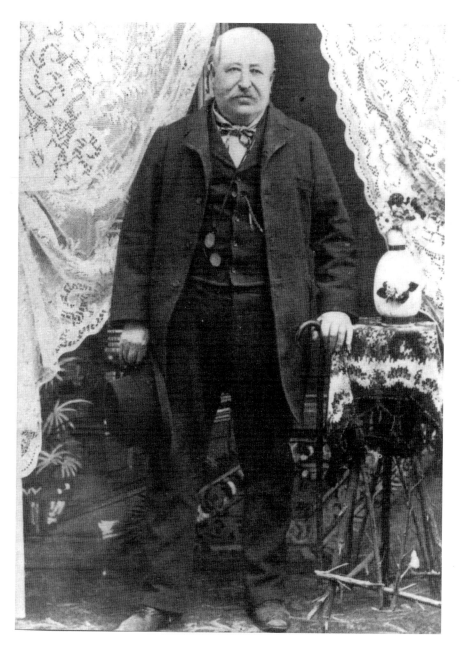

Michael Wormser. *Courtesy of the Pearl and Cecil Newmark Memorial Archives, Arizona Jewish Historical Society.*

Wormser continued operating his land empire, but he suffered a stroke in 1892, and his health slowly deteriorated. He died of heart disease on April 25, 1898, at the age of sixty-nine in modest lodgings that belied the fact he was the largest landowner in the valley. He was laid to rest in one of the city's cemeteries, probably Loosley.

Because Wormser did not believe in thoroughly documenting his business affairs and died intestate, it took some time to sort out his estate. Once his debts were settled and heirs given their inheritance, his body was exhumed in July 1903 and moved to his final resting place, property he owned on the east side of Thirty-Fifth Avenue at Jackson Street in Phoenix. His executor, who recognized the need for a Jewish cemetery in Phoenix, convinced Wormser's heirs to donate the property on which Wormser was buried for that purpose. The donation occurred in 1904, and it became the Beth Israel Memorial Cemetery in 1928.

Most of Wormser's land along the San Francisco Canal was purchased by Dwight Heard, who, along with his father-in-law, Augustus Bartlett, established a successful ranch on the property. Heard became a Phoenix mover and shaker as a rancher and land developer. As publisher of the *Arizona Republican* newspaper, he initiated annual pioneer reunions in Phoenix in the early 1920s that catalyzed interest in the abandoned city cemeteries. In 1929, shortly before his death, Heard and his wife, Maie Bartlett Heard, founded the renowned Heard Museum in Phoenix.

Just Folks

John Bolton (Contributing Author Derek Horn)

John Bolton arrived in Phoenix about 1890. He was born in Tennessee in March 1866, and during his short life of thirty-six years, he journeyed from Kansas to San Diego, California, before relocating to Phoenix for his health. He was one of the many people with lung ailments who sought a cure in the valley, where the dry desert air was considered therapeutic. He married his wife, Hattie, in 1893. They had two children, but one died young.

An African American barber, Bolton initially found employment in Frank Shirley's barbershop, an upscale establishment called The Fashion. He also became a member of a literary society. The future of Phoenix was a favorite topic at the shop, and Bolton soon became involved with local politics. He

was elected as a delegate to the Maricopa County Republican Convention in April 1896, an election year when William McKinley won his first term as president.

Bolton prospered in his profession and two years later established his own barbershop in a prestigious location, the new Adams Hotel in downtown Phoenix. About the same time, he also became one of the first black letter carriers in the city. Unfortunately, the desert air was not restorative for Bolton, and he died at his home on North Second Street of a lung hemorrhage on December 26, 1902, at the age of thirty-six, leaving behind Hattie and son Chauncey. He is buried in the Rosedale Cemetery.

Magdalena Mendivil Donnelly (Contributing Author Donna Carr)

Maria Magdalena Mendivil's surname and birthdate vary depending on the source consulted, but she was probably born sometime between 1832 and 1841 in Sonora, Mexico. She left home around 1857 and was living at Fort Yuma, San Diego County, California, when she gave birth in December 1860 to a son whom she named John Kippen. Delfina followed in 1864, George in 1867 and Amelia in 1869.

Just who was the father of Magdalena's children? No official record of any marriages or births has come to light; however, the 1860 federal census of Fort Yuma records a supply clerk named George Kippen residing in the same boardinghouse as Madalena Maldives [sic]. Magdalena would have been about three months pregnant at the time.

Born in 1819 in Bridgeport, Connecticut, George Kippen was the married father of three children. By 1854, he had left his family and moved to California, where he worked as a special messenger for the Arizona Mining & Trading Company. Between 1854 and 1862, he kept a diary while hauling supplies from California via Yuma to the mining camps in Arizona. The handwritten diary, which records his arduous trips across the desert and daily occurrences at the mines in Ajo, mentions him receiving letters from his wife.[49] Kippen was working as a civilian at Fort McDowell when he died suddenly on February 22, 1868. His diary eventually found its way into the hands of his daughter Mary Kippen of Bridgeport, Connecticut. She donated it to the Arizona State Archives.

If Kippen had been providing for Magdalena and her children, his unexpected death would have plunged the family into poverty. By 1870, Magdalena and her children had moved to Yuma, where they appear on the

Magdalena Donnelly's headstone.
Photograph by Derek Horn.

federal census that year under the surname "Kippin." It is not known what became of the two youngest children, but they are not found in any records after 1870.

About 1871, Magdalena met a wagon master, Frank Owen Donnelly, in Yuma. Donnelly was born around 1837 in Ireland. He immigrated to the United States and enlisted in the U.S. Army at Fort Leavenworth, Kansas, in June 1859. Donnelly was stationed in Missouri and Mississippi until May 1862, when he was discharged because of an injured knee. By 1870, he was a teamster living in Tucson.

As a teamster, Donnelly very likely passed through Yuma while hauling goods between California and Arizona. This may be how he, an Irish Catholic, met Magdalena, a Mexican Catholic with young children to support. Donnelly eventually bought a ranch in Pinal County and moved the family there. They had three children together. Amelia, named for her deceased half sister, was born in 1872, followed by Isabelle in 1874 and Catherine Inez in 1878.

In 1890, Donnelly was admitted to the Old Soldiers' Home in Sawtelle, near Los Angeles, California, where he died on September 21, 1894. Because there is no evidence that Magdalena received a widow's pension based on Donnelly's Civil War service, it is possible they were never formally married.

Per the 1900 federal census, Magdalena's household on the Donnelly ranch consisted of her son John Kippen, daughter Kate Donnelly and granddaughter Elsie Harrington. She eventually moved to Phoenix, where she died of pneumonia on February 11, 1905, and was buried in the Rosedale Cemetery. Later that year, one of Magdalena's grandsons, Charles Hardy, succumbed to laryngeal diphtheria and joined her in Rosedale.

Late in life, Magdalena may have become estranged from her two eldest children. When her will was probated, John refused the ten dollars she had left him, and Delfina, by then married, could not be located. Her estate was,

therefore, divided between her three youngest daughters. Throughout his life, John went by the name "Kippen," and the federal census records of 1900, 1910 and 1930 give his father's birthplace as Connecticut.

Sisto Lizarraga (Contributing Author Derek Horn)

On March 25, 1912, the headline on the front page of the *Arizona Republican* announced the passing of Sisto Lizarraga and the "Ending of Humble but Useful Life of Well Known Phoenix Man." Who was this man whose death rated a front-page article of the city's major newspaper? For over thirty years, "Old Sisto," as he was known, was the town's "official" grave digger.

He was born in Pitiquito, Sonora, Mexico, about 1852. During the short reign of Emperor Maximillian I, Sisto served in Maximillian's army as a soldier for about three months. During the war that forced Maximillian from his throne, Sisto was wounded and captured by the opposing forces, who then made him serve in *their* ranks for three months.[50]

Seeking a safe place to live and raise a family, in about 1882 Sisto made his way to Phoenix, where he served as a handyman who dug graves at the first city cemetery. He married Felipa Valencia, and they had eleven children, four of whom died in infancy. After years of service, he became known as the "official" grave digger in Phoenix, even though he never received a formal appointment.

A well-known and popular person in the community, Sisto made interesting copy for the local newspapers. On November 11, 1908, the *Arizona Republican* carried a feature story called "Sisto the Grave Digger," in which he discussed exhuming the remains of a woman buried in the Salt River and complained of the depression in his business because many bodies of the local deceased were being sent out of state for burial.

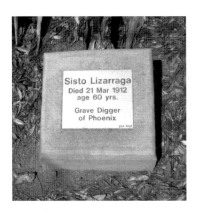

Sisto Lizarraga's headstone.
Photograph by Derek Horn.

Sisto's efforts to clean the cemetery, which had become a "jungle" of weeds, mesquite brush and other desert growth, were reported in the *Arizona Republican* on

December 3, 1910, along with Sisto's hope that he and his crew would receive some payment for their efforts by grateful members of the community. It is unknown if they ever did. On May 5, 1911, the *Arizona Republican* again reported on Sisto in its Of Local Interest column, where it described his war service in Mexico.

On March 21, 1912, at the age of sixty, Sisto died of a strangulated hernia at his home in the alley between Washington and Adams Streets and Third and Fourth Streets. The local undertakers donated a coffin, a hearse and carriages in recognition of the man who had served them and the community faithfully and honorably. He is buried in Porter Cemetery.

Cassandra Smith (Contributing Author Derek Horn)

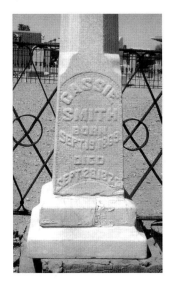

Cassandra Smith's headstone.
Photograph by Derek Horn.

"Cassandra was an interesting little girl, intelligent, pretty, and affectionate, and the first American who died a natural death in this town." This was how the obituary in the *Weekly Miner* edition of October 12, 1872, summed up the short three-year life of one of Phoenix's earliest and youngest residents, who had died on September 28. Cassandra was the daughter of William and Fanny Smith. Smith had opened a store in Phoenix in 1871. Though the first to die of natural causes in Phoenix, Cassandra did not have the distinction of being its first death. That dubious honor belonged to James Nelson, who was shot by James Smith, a member of the Swilling Party, on August 2, 1869.[51]

As she was one of the few children in Phoenix at the time, Cassandra's death saddened the community, which turned out at her graveside service at the first city cemetery at Jackson Street and Seventh Avenue. She rested there for thirteen years until she was exhumed and moved to the Loosley Cemetery, where she lies today. The cause of her death is unknown.

Blue, Gray and Khaki

James Broomell (Contributing Authors Donna Carr and Jan Huber)

James Henry Broomell was born on August 2, 1837, in Upper Oxford Township, Chester County, Pennsylvania, to John Broomell and Esther Moore Hambleton. His mother died in 1842, and his father remarried. Broomell attended school in Millersville, Pennsylvania, and then became a schoolteacher.

When the Civil War broke out in April 1861, Broomell, at the age of twenty-five, enlisted in the newly organized 124th Pennsylvania Infantry, Company C, on August 6, 1862, even though his mother was a Quaker. Six weeks later, he found himself in the Battle of Antietam in Maryland. In May 1863, he again found himself in battle, this time at Chancellorsville in Virginia. His nine-month enlistment came to an end when the 124th Pennsylvania was mustered out in May 1863 in Harrisburg, Pennsylvania, just after the Battle of Chancellorsville.[52]

Broomell's respite from war did not last long. Confederate general Robert E. Lee, commanding the Army of Northern Virginia, invaded Pennsylvania in June 1863, so Broomell reenlisted in Company A of the Twenty-Ninth Pennsylvania Militia. From July 1 through July 3, the Union and Confederate armies clashed at Gettysburg in an intense battle that is regarded as a turning point of the Civil War. Although the Twenty-Ninth did not see action at Gettysburg itself, it manned fortifications around nearby Harrisburg and, after the battle, helped transport the wounded to hospitals in Northern cities. On August 1, 1863, Broomell again mustered out of service at Harrisburg, his soldiering days over.[53]

In 1864, with the end of the war drawing near, Broomell tried cotton farming in Arkansas. He leased from the federal government a plantation near Helena that had been abandoned when its former owners fled the advancing Union armies. In addition to farming, Broomell and the newly freed black farmhands had to defend themselves from the guerrilla bands that infested the region. On one occasion, Broomell was captured by outlaws and held hostage for about three weeks, finally escaping one night while his captors slept. While in Arkansas, Broomell met Mary Wickersham, a Quaker schoolteacher who had gone south to teach the freedmen. He married her on July 11, 1867, in the Friends Meeting House in Rich Square, Henry County, Indiana.[54] They eventually had four children.

By 1870, James and Mary were living in Chicago with James's older half brother, George. George was an assistant superintendent of schools, and James was a school principal. During this time, James Broomell's health began to fail, and the family eventually moved to a farm in Aurora, Illinois. Unfortunately, his condition did not improve, and the Broomells lost their farm to bankruptcy. Then they moved to Phoenix in 1886, with just a few hundred dollars in savings to start a new life.

Mary's older brother William Wickersham helped the Broomells by purchasing 160 acres of undeveloped land on the southeast intersection of present-day Thomas Road and Forty-Third Avenue for $1,900 (nearly $50,000 in today's currency). The Broomells built a one-room house with curtains that separated the sleeping and the living areas. Broomell's teenage sons did most of the work because he was not able to do physical labor. Mary, the elder Broomell daughter, added to the family income by teaching in the local school. Younger daughter Alice, who was afflicted with a neurological ailment, helped her mother with housework and feeding the family.[55]

The Broomell sons fenced in the property, removed the scrub brush and cultivated the land. At first, they grew vegetables, alfalfa and grains. James Broomell took up beekeeping, an occupation at which he excelled. The Broomells expanded into the cattle business and rented about twenty more acres for pasture. As the ranch became successful, they sold some of their original property and purchased another eighty acres of undeveloped land.

In 1891, Broomell was granted an invalid pension that cited dyspepsia and a disease of the respiratory organs. He received the grand sum of $12 per month, a little over $300 in today's currency.

With his ranch a success, during the early 1890s Broomell became more involved in the community. He was instrumental in organizing the Bee Keepers' Association and became its secretary. He exhibited his bee products in local shows and won prizes. Broomell worked in organizations that promoted the Salt River Valley's agriculture and products. This included serving as president of the Farmers' Alliance and Industrial Union and being incorporator of the Farmer's Alliance Exchange.[56]

Acting Governor Nathan Oakes Murphy appointed Broomell as a delegate to the National Farmers' Congress in 1891. Broomell also worked with the chamber of commerce to have local products exhibited at the Chicago World's Fair in 1893. Such was his reputation that when he was appointed to the Territorial Normal School Board of Education, the *Arizona Republican* reported on May 21, 1891, "J.H. Broomell is a substantial viticulturist of substantial attainments."[57] Broomell became president of

the board in 1893. He also participated in Republican Party politics and joined the local post of the GAR.

James Broomell died in Phoenix on September 6, 1896, at the age of fifty-nine from complications of pulmonary tuberculosis. Prudent to the end, he deeded his land to his wife, Mary, before he died, thus avoiding probate, and left his family a paid-up life insurance policy. He is buried in the Porter Cemetery.

Clarence Proctor (Contributing Author Donna Carr)

Little is known about Clarence Proctor's life except for what appears in the public record. According to his military service records, he was born in Upperville, Virginia, about 1864. As a young black man working as a waiter, he must have decided the army promised a better or more exciting life, so he enlisted in December 1886. Shortly before enlisting, Proctor married Viola Jones, but she died less than a year later. They did not have children.

Proctor was assigned to the Tenth Regular U.S. Cavalry, an African American regiment stationed out west and known as the "Buffalo Soldiers." By 1886, the Indian wars were pretty much over, so the Tenth Cavalry's mission was to maintain order on the Indian reservations and assist the designated agents of the Federal Bureau of Indian Affairs in carrying out their tasks.

During the next twelve years while he served, Proctor saw duty at Jefferson Barracks, Missouri; Fort Thomas, Fort Grant and San Carlos in the Arizona Territory; and Fort Custer and Fort Assinniboine in Montana. He served in the Tenth Cavalry's F Troop and later L Troop, attaining the rank of sergeant.

When the Spanish-American War broke out early in 1898, the Tenth U.S. Cavalry was one of the regiments called up for duty in Cuba. The Tenth was composed of seasoned cavalrymen who needed no additional training, and it was thought that black troops would be immune to the malaria and yellow fever endemic in the Caribbean. Unfortunately, this proved not to be the case.[58]

The regiment assembled at Fort Assinniboine, Montana, and shipped by rail to Wisconsin, where it was greeted by cheering throngs, and then on to Lakeland, Florida, where it was to be equipped. The men of the Tenth Cavalry found Florida's Jim Crow restrictions particularly onerous, as they were not accustomed to the laws and mores of the segregated South.[59]

On June 14 and 15, 1898, the bulk of the Tenth Cavalry sailed from the port of Tampa, Florida, for Cuba. It is not known whether Proctor was among those who set foot on Cuban soil. The regiment took part in the Battle of Las Guasimas on June 24 and the Battle of San Juan Hill on July 1 alongside the First U.S. Volunteer Cavalry, known as the "Rough Riders." It was at this battle where a young colonel named Theodore Roosevelt, commanding the Rough Riders, gained fame for bravery and leadership. Roosevelt later singled out the Tenth as "brave men worthy of respect." The Tenth also participated in the siege of Santiago.[60]

Tropical diseases took a far greater toll than bullets. By the time the Spanish surrendered on July 17, 80 percent of the American forces had contracted some form of fever. To speed their recovery, Roosevelt had the men of the Tenth Cavalry sent to Camp Wikoff on Long Island, New York, to rest and recover.[61]

Following his discharge on December 20, 1898, at Camp Forse, Alabama, Proctor made his way to Phoenix. Unable to work because of poor health, he went to Los Angeles and filed for an invalid pension in March 1899. While there, he met a young woman named Nannie Goodwin and brought her back to Phoenix, where they were married on October 15, 1899.

Proctor probably intended to support himself and his new wife on his seventy-two-dollar-a-month invalid pension approved on April 3, 1899. Issuance of the pension, however, was delayed due to bureaucratic red tape and the fact that the U.S. military was now engaged in another overseas war in the Philippines. In December 1899, Dr. William Duffield examined Proctor and found him to be emaciated and suffering from an active case of tuberculosis.

Discouraged by his health and financial difficulties and possibly delirious from tubercular meningitis, Proctor hanged himself from the rafter of his house at 429 East Adams in Phoenix on March 27, 1900. At the coroner's inquest held the following day, Dr. Duffield testified that his patient had been in a despondent frame of mind during his last few months and had only a few more weeks to live at best. Proctor's death was ruled a suicide.[62]

Proctor's funeral was held at the African Methodist Episcopal church located at Second and Jefferson Streets on March 30, 1900. Local military commanders James H. McClintock and J.W. Crenshaw published a notice requesting all former members of the Rough Riders and First Territorial Volunteer Infantry appear in uniform to escort Proctor's remains through downtown Phoenix to his final resting place in the Porter Cemetery. His simple wooden grave marker declared him a Rough Rider.

Clarence Proctor's headboard in the 1930s. *Courtesy Senator Carl T. Hayden Photographs, Arizona Collection, Arizona State University Library.*

The headstone that replaced Clarence Proctor's headboard. *Photograph by Derek Horn.*

Ironically, a $794.40 check for Proctor's accrued pension payments arrived in Los Angeles the very day of his death. Opined the *Arizona Republican* on April 3, 1900:

> *If the clerks in the pension office had worked just a little faster, Sergeant Clarence L. Proctor of the Tenth cavalry, who committed suicide in this city by hanging last Thursday night, might still be living....He had reached the end of his financial rope, and as there was nothing else in site he attached himself to the end of another rope.*[63]

The money was awarded to his widow, but her later claims for a widow's pension were denied because Proctor's death was deemed a deliberate act and not service-related. Proctor's grave is now marked by a stone grave marker installed by the PCA.

Millard Lee Raymond (Contributing Author Donna Carr)

Another Rough Rider who rests in the PMMP is Millard Lee Raymond. Little is known about Raymond and his short life. He was born in Ottumwa, Iowa. Raymond listed his age as twenty-three and occupation as cowboy

on his recruitment form on May 4, 1898, when he enlisted in Santa Fe, New Mexico.

When the Spanish-American War broke out in April 1898, President William McKinley issued a call for volunteers to supplement the small regular army. Assistant Secretary of the Navy Theodore Roosevelt resigned his office and, with Colonel Leonard Wood, formed the First U.S. Volunteer Cavalry, known as the "Rough Riders." The volunteers came primarily from Arizona, New Mexico, Oklahoma and Texas. They were used to a hot climate, and the men selected from the many applicants had to know how to handle a horse and a gun.

Millard Raymond was assigned to Troop F, commanded by Captain Maximilian Luna. Luna had asked to serve because he wanted to demonstrate that Spanish-speaking native New Mexicans were solidly behind the American war effort. Owing to Luna's fluency in Spanish, he was eventually assigned to Colonel Wood's headquarters in Cuba, where he acted as an interpreter.[64]

Although nothing specific is known about Millard Raymond's war service, he probably took part in some of the Rough Riders' actions. They shipped out from Tampa, Florida, in May for Cuba. During the short conflict, the Rough Riders participated in the Battles of Las Guasimas and San Juan Hill and the Siege of Santiago. By August 1898, Spain had sued for peace.

The battles with Spanish soldiers were not the only challenges that faced the Rough Riders. Forced to abandon their horses for lack of navy vessels to transport them, they slogged through sugar cane fields during the humid tropical summer. What uniforms they had were made of scratchy wool and utterly unsuited to the tropics. Their rations consisted mostly of hardtack and canned goods. All the troops lost weight. Fresh meat was practically impossible to obtain and went bad overnight for lack of refrigeration. Disease took a great toll. Without mosquito nets, the men fell prey to malaria in droves. They also suffered from yellow fever, dysentery and other illnesses. Despite Roosevelt's best efforts, he estimated that at least half of his fighting force was down sick at any one time. Such must have been Millard Raymond's experience of the war.

It is not known how or why Raymond went to Arizona after he was mustered out. Perhaps he had formed a friendship with the Arizona men in his troop or planned to settle there. Recurrent bouts of malaria, however, prevented him from working. In January 1899, he decided to return to Ottumwa, Iowa, where he had relatives. He got as far as Maricopa before he fell ill again. Raymond died on January 11 at the age of about twenty-four.

Because his parents were too poor to have the body embalmed and shipped home, Raymond was buried in the Porter Cemetery with full military honors. The GAR veterans turned out for the funeral, and six of his companions from the Rough Riders acted as pallbearers. Despite his short time in Phoenix, many citizens attended his service as well. The original wooden headboard erected over his grave listed him incorrectly as "Raymond Miller." It deteriorated over time and was eventually replaced by a stone marker with the correct name but wrong military unit.

Edward O. Schwartz (Contributing Author Mark Lamm)

Edward Schwartz was born in New York on February 19, 1842. He became an engraver, but poor eyesight caused him to give it up. As the country entered the Civil War in 1861, Schwartz enlisted in the Eighth New York Militia in April and then mustered out in August. He next enlisted in the Fourth New York Cavalry in January 1862. Although he became ill with typhoid fever later that year, he recovered sufficiently to achieve the rank of lieutenant. A year later, he was promoted to captain, and in March 1864, he became a major.

Schwartz fought in several major battles, skirmishes and campaigns, including Cross Keys, Virginia; Second Bull Run (Manassas), Virginia; Chancellorsville, Virginia; and Gettysburg, Pennsylvania. He fought in General Philip Sheridan's Shenandoah Valley Campaign in 1864. Despite being wounded in June, he continued service but was hospitalized later that month to treat a primary syphilis chancre. Released from a Washington, D.C. hospital in July, he rejoined his unit and continued active duty until the end of the war. In March 1865, he was charged with being absent without leave for ten days when only three were approved, but in July, with the war over, he was honorably discharged.

Unable to give up military life completely, after the war Schwartz eventually went west and served in various frontier posts. He was part of a detachment that escorted engineer and geologist Clarence King through northern Arizona and other parts of the West in the Fortieth Parallel Survey of 1867–73. He later relocated to New Mexico, where he left service and married Angeline Flint in Santa Fe in 1880. They had one daughter.

In the early 1880s, the family moved to Phoenix, where Schwartz engaged in various business enterprises, held official military positions and served his community. In 1890, he was elected recorder of the city of Phoenix and held

the post for six years. He joined the GAR and became the commander of the Arizona post in March 1891. In April 1893, the new territorial governor Louis Cameron Hughes appointed Schwartz adjutant general of Arizona. He served for six years and was regarded as an able commander. Governor Hughes also established a nonpartisan board of control in March 1895 to oversee penal, charitable and reform institutions such as the Yuma Territorial Prison and the Insane Asylum of Phoenix. Schwartz served as the board's clerk until 1897.

For unknown reasons, Schwartz, his wife and their daughter left Phoenix in 1897 and moved to Seattle. A year and a half later, they moved to San Francisco before returning to Phoenix in 1899.

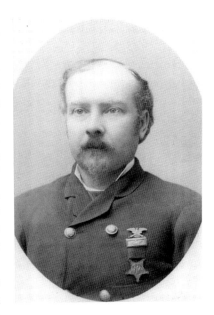

Edward Schwartz. *PCA files.*

The *Arizona Republican*, in a September 18, 1899 article on the Schwartz family's return, reported it was for Schwartz's health, but the ventures that took him to the Northwest and California must not have been successful. Schwartz is quoted in the article, declaring, "Not until one leaves Phoenix does he appreciate the business advantages it presents."

One of the last services Schwartz performed for his community was organizing the Memorial Day service for the GAR that took place on May 29, 1903. There was to be no march by the members because it was deemed too much of a strain for the old soldiers, but Major Schwartz encouraged veterans of the Confederacy to attend and participate in the ceremonies.

Schwartz suffered from chronic ailments during his last years and died on March 1, 1904, of hematuria at the family home in the Curio Building at the corner of Second Avenue and Jefferson Street in Phoenix. His funeral took place on March 3, 1904. Members of the GAR and uniformed soldiers of the National Guard of Arizona escorted his body as it was moved from the undertakers' parlor to the Presbyterian church. The national chaplain of the GAR presided over the service, and the soldiers fired a salute with their new Krag-Jorgensen rifles. Afterward, Major Edward Schwartz was interred in the Porter Cemetery with full military honors.

FAMILY CONNECTIONS

The Dorris Family (Contributing Author Derek Horn)

The Rosedale Cemetery is the resting place of five members of the Dorris family, successful merchants and businessmen in early Phoenix. Elias Marion Dorris was the first of four brothers and two sisters to move to Phoenix. He was born in November 1850 in Mississippi to Joseph and Jane Dorris. As a young man of nineteen, he went to Texas and then on to Nevada before returning to Mississippi about three years later. He farmed for about two years and then went back to Nevada and California for his health. He moved to Phoenix in 1885, started purchasing property and bought the half interest of W.W. Kunkle in Herrett and Kunkle, a secondhand business. Elias's brother Casswell Drake Dorris joined him a year later and purchased the other half of the business.

Robert Bennett Dorris and Joseph William Dorris followed their brothers to Phoenix and, in 1888, formed the Dorris Company Fruit, Confectionary, Oyster and Ice Cream Parlor. Joseph married Sallie Wilson that same year. They sold this concern three years later, and then Joseph promptly purchased a grocery store. Robert engaged in other businesses and became active in the Arizona National Guard. Meanwhile, Elias and Casswell formed Dorris Brothers and operated the secondhand store into the 1890s before going into the furniture business.

By the late 1890s, all four brothers, with varying degrees of success, were well established in business as well as in the community. The furniture store expanded into a large building on Washington Street between First and

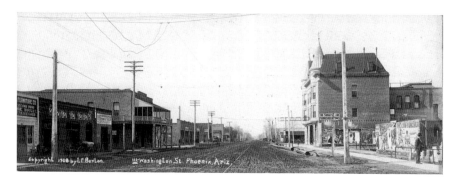

View west along Washington Street with the Dorris Theater and Gregory's monument yard on the right. *Photograph by L.C. Barton, courtesy Library of Congress.*

The Dorris-Heyman furniture store on Adams and First Streets was built on the site of the Holland family home. *Courtesy McCulloch Brothers Photographs, Herb and Dorothy McLaughlin Collection, Greater Arizona Collection, Arizona State University Libraries.*

Second Streets. Elias married Lizzie Maxwell in September 1895. They had one daughter. He also became a director of the First National Bank of Arizona. In 1898, Elias partnered with Samuel Patton to construct Patton's Grand Theater on the north side of Washington Street west of Third Avenue.

In early 1899, with his health deteriorating, Elias sold his interest in the furniture store to Casswell. Later that year, he purchased Patton's interest in the theater and renamed it the Dorris Opera House. At the age of fifty-two, he died of tuberculosis on May 9, 1902, and was laid to rest in the Rosedale Cemetery. Lizzie followed him to Rosedale in January 1903, also dying of tuberculosis, at the age of thirty-four.

Casswell married Hattie Weldon in 1891. They had a daughter, Frances, who died of pneumonia at the age of seventeen months on December 1, 1902. She joined her uncle Elias in Rosedale. In 1902, Dorris Brothers merged with Berman Heyman, and the furniture business became Dorris-Heyman. In 1908, it moved to the new Noble Building, a large four-story

81

structure at the southeast corner of First and Adams Streets constructed on the original site of Phoenix's Chinatown. Casswell died in an automobile accident on January 7, 1932, and was buried in Greenwood.

In the late 1890s, Robert was the baggage master for the Maricopa and Phoenix Railroad and then ran a restaurant and ice cream parlor called the Wave in the Ford Hotel at the northeast corner of Washington Street and Second Avenue. He married Gertrude Etter in February 1897, and they had one son. Robert closed the Wave in 1900 and went to work for brother Joseph. He died suddenly on February 21, 1904, of pneumonia and joined family members buried in Rosedale.

The Dorris brothers' father, Joseph, while visiting his family in Phoenix, died at seventy-eight on February 2, 1904. The cause of his death was listed as "old age." Soon to be followed by son Robert, he also was buried in the family plot.

The younger Joseph's grocery business, located at the southwest corner of First and Washington and Streets, prospered. He acquired a large tract of land northwest of Seventh Avenue and McDowell Road and set up the Dorris Ranch. In 1911, Joseph built a large home, known as Casa de Rosas, on the west side of Seventh Avenue south of Thomas Road. He closed his grocery business in May 1918 to pursue other ventures. He sold large tracts of his land to Dwight Heard and William Hartranft in the 1920s for development. Today, the Encanto-Palmcroft neighborhoods and Encanto Park occupy land he once owned. Joseph died on July 11, 1943, and was buried at Greenwood.

In the early twentieth century, the Dorris Theater hosted several meetings that resulted in the formation of the Salt River Valley Water Users Association, today's Salt River Project. The theater was demolished in the late 1990s. Dorris-Heyman Furniture became Coles Furniture in 1946. Its building at Adams and First Streets was demolished in the 1940s, and the site is now a parking lot. Casa de Rosas still stands and is the Parish House of Encanto Community Church.

William Thomas Gray (Contributing Author Donna Carr)

William Thomas Gray, younger half brother to Columbus Gray, was born on February 23, 1852, in Union County, Arkansas. He was the son of Thomas Gray and his second wife, Martha Jane Norris. Known familiarly as "Bud," Gray was too young to have participated in the Civil War, which took the life

of his older half brother James, nor did he go west with Columbus in 1868. The 1870 federal census records him at home in Arkansas with his parents and younger siblings.

Little is known about Gray's life and activities as a young man. The first documented evidence of his presence in Arizona is his purchase and sale of 160 acres of land at the northeast corner of Central Avenue and Seventh Street in 1882. He also purchased 160 acres at the southwest corner of Rural and Warner Roads in Tempe in 1887, near where brother Columbus had homesteaded in 1882. Gray may have engaged in mining and, at one time, managed a large property on the Colorado River along with Columbus.

Gray ran for Maricopa County sheriff four times, finally winning election as a Democrat in 1888 by one vote. His term in office was taken up by mostly mundane duties, including evictions, subpoenaing witnesses, transporting prisoners to the Territorial Prison in Yuma and taking insane persons to the newly built Arizona State Hospital near Phoenix for $2.50 a trip.[65] There were also the occasional thefts, murders and suicides to investigate.

It was not all mundane, though. In late March 1890, Sheriff Gray, deputy John Slankard and others formed a posse and pursued Frank and Billy Fox, two young horse thieves, across Arizona into California. They caught up with the Fox brothers at the Carrizo Wash east of San Diego on March 29. According to some accounts, Gray apprehended Billy, but Slankard shot and killed the unarmed Frank in the back as he was running away. Billy was returned to Maricopa County, tried, found guilty of forgery but not theft and spent a year in the territorial prison.[66]

Sheriff Gray's greatest challenge occurred on February 22, 1890, when the Walnut Grove Canyon Dam on the Hassayampa River north of Wickenburg collapsed. A huge wall of water roared down the river, destroying all in its path, including the camps of the construction workers who had been building additional dams downstream. At least forty people died. Other estimates place the death toll around one hundred. Sheriff Gray oversaw Maricopa County's rescue efforts and cleanup operations.

In September 1890, Gray was not nominated by his party for a second term, so after his term expired, he returned to private life. Perhaps anticipating his "retirement," in August 1890, he was granted a land patent for his 160 acres at the northeast corner of Ray and Kyrene Roads and another patent in December 1890 for an additional 160 acres at the southwest corner of Rural and Warner Roads.

In his later years, Gray's health declined, and he spent most of his time at his home on Thirty-Fifth Avenue north of Buckeye Road. He died on

March 19, 1911, of lymphosarcoma at the age of fifty-nine. Although his death certificate says that he was buried in Greenwood Cemetery, it has no record of him. Instead, records show he was interred in the Gray family plot in the Masons Cemetery.

Thomas Hayden (Contributing Author Donna Carr)

Unlike the others who are interred in the PMMP, Thomas Albert Hayden was neither a pioneer nor an early resident of Phoenix, yet his dedication to the cemeteries and happenstance earned him a final resting place among Phoenix's first citizens.

Hayden was born on June 2, 1880, in Nova Scotia, Canada, to Thomas and Elmyra Hayden. He attended Sheffield Scientific School at Yale, but in 1899, he went out west for his health before graduating. From 1906 to 1908, he was an engineer in private practice, and he oversaw the construction of the Urraca Dam in Colfax County, New Mexico, between 1908 and 1910. After the dam was completed, he worked in Florida on drainage projects before returning to New Mexico. From 1912 to 1915, Hayden was in private practice in Santa Fe, where he was also the city engineer. In 1915, he moved to Phoenix.[67] He may have been suffering from tuberculosis at the time. Hayden married Irene DuVal, and they had two sons. By 1918, he was a naturalized U.S. citizen and worked as a civil engineer in the Unites States Surveyor General's Office.

Hayden joined the Salt River Valley Water Users Association (now the Salt River Project) in 1918 as assistant chief engineer. Two years later, he became the assistant engineer of the association. Sometime between 1918 and 1924, Hayden and Irene divorced. He later married Anna Kessler, and they had five children together.

In response to growing concerns about the condition of the seven closed city cemeteries, Hayden joined Lin Orme, president of the Water Users Association, and other prominent citizens in 1939 to form the Pioneers' Cemetery Association (PCA). As its secretary treasurer, he worked with other community leaders toward the restoration of the historic burial grounds. Hayden is credited with surveying and creating maps that documented graves, plots and pathways forgotten by years of neglect. He also interviewed descendants and friends of those buried in the cemeteries. His efforts resulted in documenting a great deal of historic information that may otherwise have been lost.

Hayden died at his home on December 23, 1940, of a heart attack at the age of sixty. His body was cremated with the intention of having him buried in Greenwood Cemetery. Curiously, however, his cremains stayed at the J.T. Whitney Funeral Home for the next forty-eight years. It was not until 1988 that he was laid to rest, not in Greenwood, but on the Avenue of Flags in the PMMP.

The Rossons (Contributing Author Donna Carr)

At the southeast corner of Monroe and Sixth Streets stands a large Victorian house. Beautifully restored, it now anchors a block of historic structures that provide a glimpse of early Phoenix. For a short time, it was the home of prominent Phoenicians Dr. Roland Lee Rosson and his wife, Flora.

Born on August 28, 1851, in Culpeper County, Virginia, Dr. Rosson studied medicine at the University of Virginia. After graduation, he entered the army and was commissioned an assistant surgeon. After serving a short time in Virginia, he was transferred to the Arizona Territory, where he served at four different installations. Following a court-martial at Fort Yuma in early 1879, he was dismissed from the army, moved to Phoenix and established a medical practice.

Dr. Rosson married Flora Murray, the sister-in-law of Judge John Alsap, on August 11, 1880. They had seven children together, but two died as infants. One, a son born in 1883 and named after his father, lived only five weeks. Another, a daughter, was born in January 1896 and died at birth. Both were interred in the Knights of Pythias Cemetery.

As Dr. Rosson built his practice in Phoenix, he also engaged in local politics. In 1884, he won his first election and became Maricopa County coroner and public administrator. In April 1886, he was appointed the medical officer of the territorial prison in Yuma. By January of the following year, he had resigned his position and returned to his Phoenix practice.

Back in Phoenix, Dr. Rosson also resumed his political career. He ran for Maricopa County treasurer and won election in November 1890. He was reelected in 1892 and then ran, unsuccessfully, for Maricopa County sheriff in 1894. That same year, Dr. Rosson commissioned architect A.P. Petit to design a new residence to be built at the corner of Monroe and Sixth Streets. The house, which incorporated features of the popular Shingle style, had ten rooms with an office for Dr. Rosson on the first floor. It also had such modern conveniences as electricity, a telephone, hot

The Rosson House, circa 1895. *Courtesy of Heritage Square, Phoenix, heritagesquarephx.org.*

and cold running water and a second-floor bathroom. Construction was completed in 1895, and the Rossons moved in.

In 1895, Dr. Rosson won election as mayor of Phoenix. As a Democrat presiding over a Republican city council, he found his time as mayor stressful and resigned from office in April of the following year. According to the

April 7, 1896 edition of the *Arizona Republican*, he told a reporter that he was tired of the office. At that time, the city council was dealing with a contentious issue of whether to continue allowing prostitution to occur in Block 41 of the Phoenix town site, where it was legal at the time.[68] This may have been the last straw.

The Rossons also may have felt some financial strain from having constructed such a grand home. In the winters of 1895 and 1896, they rented the house to Whitelaw Reid, a prominent New York Republican politician and former vice presidential candidate. The Rossons sold the house to local merchant Aaron Goldberg in 1897 and moved to Los Angeles.

On May 12, 1898, Dr. Rosson became ill and died suddenly, but not before taking out about $33,000 in life insurance policies (nearly $950,000 in today's currency). There was speculation his death was suicide, but a coroner's jury ruled he died of gastroenteritis. He was forty-six years old. Flora outlived him by only thirteen years and died in 1911.

The house at Monroe and Sixth Streets changed hands several times and eventually became a rooming house. As the neighborhood that surrounded it deteriorated, the house fell into disrepair. When it was considered for demolition in the 1970s, Phoenix mayor John Driggs led the city's effort to acquire the house and restore it to its 1890s appearance. Today, the Rosson House is a museum and the centerpiece of Phoenix's Heritage Square.

Frederick Tovrea (Contributing Author Jason O'Neil)

Frederick "Freddie" Tovrea did not live beyond his tenth birthday. In July 1898, he became ill with appendicitis. Surgery to remove the inflamed appendix, dangerous in those days, was performed on July 16, but it was too late. The inflammation had spread, and Freddie died the next day. After his funeral at the family home on July 18, Freddie was interred in the Knights of Pythias Cemetery. While Freddie did not get a chance at a full life, one can imagine his potential, for he was part of an influential family whose impact on Phoenix is still felt to this day.

Freddie's father, Edward Ambrose Tovrea, or E.A., as he was known, like many of the early pioneers had a varied career. He was a freighter in New Mexico and Arizona in the 1870s and 1880s. He also worked in construction, mined in the Harquahala Mountains west of Phoenix and was a stockholder and the construction superintendent of the Buckeye Canal.

He married Lillian Richardson, and they had five sons. By the 1890s, the Tovrea family lived in Phoenix, and E.A. operated a meat market at 24 West Washington Street.

Shortly after the death of Freddie, E.A. sold his business and moved to Jerome. He served as its mayor in 1900. In 1901, he purchased a meatpacking operation in Bisbee, Arizona, and moved to Cochise County. By 1906, E.A. and Lillian were divorced, and that same year he married Della Gillespie. He founded the Arizona Packing Company in 1919, which created and operated the Tovrea Stockyards at East Van Buren and Forty-Eighth Streets in Phoenix.

The stockyards were a success. The operation grew to two hundred acres and became known as the largest feedlot in the world. E.A. died in February 1932, but Della and members of the Tovrea family continued to operate the stockyards and even opened a restaurant there in 1947. Della was very active in the Democratic Party in Arizona, and in 1936, she was the only female delegate to the Democratic National Convention from Arizona.

The year before E.A.'s death, he and Della purchased an unusual-looking structure just east of their stockyards. Originally constructed as a resort in 1930 by Alessio Carraro, the three-story building with a cupola and basement looked like a wedding cake. It became the Tovreas' home. After E.A.'s death, Della lived in the house for many years. On November 13, 1968, while Della, then eighty years old, was sleeping, burglars broke into the house and made off with cash and jewelry. Della's health declined rapidly after the burglary, and she died in January 1969.[69]

The Tovrea Stockyards no longer exist, but the Stockyards Restaurant continues to operate at its original location on East Washington Street. The City of Phoenix eventually acquired the Tovrea house and the grounds that surround it. It is now called the Tovrea Castle at Carraro Heights in honor of its builder and long-term owners.

Wooldridge Family (Contributing Authors Bob Cox and Debe Branning)

Julian Franklin Wooldridge was born on February 22, 1842, in Russell or Green County, Kentucky, to William and Agnes Wooldridge. In 1846, the Wooldridge family moved to Iowa, where young Julian attended school. Wooldridge married Mary Jane Pulliam on February 11, 1864, in Appanoose County, Iowa. A few years later, he went into business as a clothing merchant with his brother-in-law George Pulliam. The

Wooldridges became the parents of four daughters and a son. The Wooldridge children enjoyed every advantage that their parents' growing wealth could afford them.

About 1895, Wooldridge, who had contracted tuberculosis, moved his family to Phoenix. He eventually went into business selling shoes with Norman "Chip" Wilson. The mercantile firm of Wilson and Wooldridge, located in the Fleming Building at the northwest corner of Washington Street and First Avenue, was apparently quite successful.

An accomplished pianist, daughter Leona Wooldridge gave well-received recitals at community events. She married her father's business partner on March 24, 1897. The newlyweds moved into in a large house on Second Avenue north of Fillmore Street. Sadly, Leona and Norman were not to enjoy a long life together. About a year after their wedding, Leona fell gravely ill with tuberculosis. She was only twenty-four years old when she died on April 16, 1899. Her parents later acquired and moved into her home on Second Avenue.

Perhaps aware of their own mortality, sometime before Leona's illness and death Julian and Mary Jane constructed a family mausoleum, or vault, in the Rosedale Cemetery. The vault was designed with a "W" at roof-peak above the door and had shelves for eight caskets. Leona is the first interment there.

Life continued for the Wooldridge family. Wooldridge daughter Blanche married Alfred Firth in 1900, and her sister Charity married Theodore Powers. In January 1906, a daughter named Mary Theodora was born to Charity and Theodore. The infant succumbed to pneumonia on May 8, 1906, and was the next to be laid in the family vault.

Having been in ill health and retired since 1902, Julian Wooldridge died of tuberculosis on July 10, 1911, at the age of sixty-nine. A glowing, five-paragraph obituary appeared in the *Arizona Republican* newspaper the next day. The article stated that the funeral would be private, with immediate interment in the family vault. On July 13, however, a second obituary appeared, stating that "so many friends expressed a wish to pay a last mark of respect" that they were invited to a funeral service to be held on July 14. Following a Masonic service at the Rosedale Cemetery, Wooldridge was the next family member interred in the vault. On May 7, 1913, Charity Wooldridge Powers gave birth to a stillborn infant who became the fourth occupant.

While the City of Phoenix closed the Rosedale and the other adjacent cemeteries in June 1914, those with relatives buried there could still be

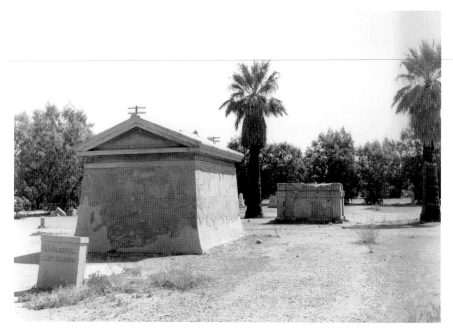

The Wooldridge Vault with B.J. Franklin's headstone in 1940. *Courtesy Arizona State Library, Archives and Public Records, History and Archives Division, Phoenix, #96-4251.*

Artisan Tony Fema restoring the Wooldridge Vault. *Photograph by Mark Lamm.*

interred in their family plots. When Wooldridge's widow, Mary, died on November 27, 1915, of pulmonary edema, she joined the others in the vault.

The cemeteries fell into neglect soon after they were closed. Vandals repeatedly damaged the metal door of the Wooldridge vault, so in 1927, the Wooldridge descendants had all five of their deceased relatives moved to the Greenwood Cemetery. The empty vault was then abandoned. The PCA restored the vault's structure in the 1990s, and its contents were documented. It is now used as a storehouse for broken monuments, supplies and equipment.

PIONEERS, SETTLERS AND EXPLORERS

"Lord" Bryan Philip Darell Duppa (Contributing Author Donna Carr)

Bryan Philip Darell Duppa, one of the first pioneers in the Salt River Valley, was instrumental in choosing the location of the Phoenix town site, and many credit him with providing its name. Born on October 9, 1832, in Paris, France, he was the son of Baldwin Francis Duppa and Catherine Darell. Although not a titled family, they were landed gentry, the family seat having been in Maidstone, Kent, England, since the 1680s.[70]

Duppa received a classical education at Cambridge University, where he learned French, Spanish, Italian and German in addition to Greek and Latin. He read Juvenal, Ovid and Homer in the original text and, in later life, was known to recite Shakespeare for hours from memory.[71]

Since Duppa had an older brother, Baldwin, who would inherit the family estate, he had to find some other occupation. Legend has it he bought a colonel's commission in the British army and was subsequently dismissed after killing an officer in a duel, but it was never substantiated. It seems more likely that he spent some time on his uncle George's sheep ranch in New Zealand, and this may have whetted his appetite for further adventure.

Duppa made his way to the United States and was known to have been in Prescott, Arizona, in December 1863. In January 1867, he was wounded twice in his right leg during a skirmish with Indians near Prescott. While dabbling in mining, he made friends with Jack Swilling and later became a stockholder in the Swilling Irrigation Company. It is likely that the two came to Phoenix together in December 1867, when the Swilling Party settled in the Salt River Valley and began digging canals and planting crops.

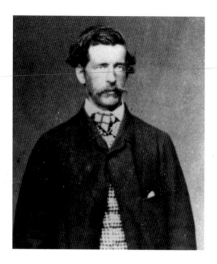

"Lord" Bryan Darell Duppa. *PCA files.*

Recognizing the area's potential for growth, Duppa homesteaded 160 acres at the southwest corner of Central Avenue and Harrison Street. He received one of the first land patents in the area in 1873. When the settlement grew to where it needed a center of commerce, Duppa was part of the committee that chose the location of the original Phoenix town site.

As the community began to thrive, it needed a name. Several versions exist of how "Phoenix" was chosen. Both Duppa and Swilling were much interested in the remains of the vanished Hohokam civilization, specifically its system of canals. Duppa is credited by some historians for proposing Phoenix, for it suggested a city rising from the ashes of a previous civilization. He is also credited with naming Tempe for the Vale of Tempe in Greece, although Duppa never made any such claim.

As one of the original settlers of the Salt River Valley, Duppa was well known to later inhabitants. Although he wasn't actually a lord, locals took to calling him that because of his impeccable English accent and classical education. Tall and thin, Duppa was an eccentric man with a flair for the dramatic. His troubling vice was drink. He also liked to gamble and, when in his cups, was as ready to brawl as to spout poetry. One historian wrote about Duppa: "A man of eccentric habits and impressive personality, he divided his time between farming and prospecting. A local newspaper later described him as 'a man of fine education, a voracious reader and a delightful conversationalist.' Others called him a 'foolhardy drunk.'"[72]

Duppa was a "remittance man" who received a generous allowance from his family in England. He got a check every four months for $3,000 (over $50,000 in today's currency), a tidy sum in those days, sent in care of his good friend Dr. O.J. Thibodo. Dr. Thibodo paid Duppa's bills and then handed over to him what was left. Duppa invariably spent it all on drink and gambling.

Although he never weighed more than 150 pounds, Duppa was quite ready to take on bigger men when he felt that he had been insulted. This willingness to scrap earned him a measure of respect in the saloons he frequented. His

courage when facing danger was never questioned. In March 1872, while cutting hay with John Alsap and some Mexican farmhands, the party was attacked by Apaches. Though wounded in the leg, Duppa fought them off.

In the 1870s, Duppa sold his homestead in Phoenix to John Montgomery and moved to New River north of the city, where, for some time thereafter, he ran a stage station. Asked why he chose to live in such a remote place, Duppa claimed that he wanted to prove to the Apaches that they could not run him off.[73]

The New River station itself was no more than a crude ramada with brush walls and hardly a stick of furniture. Passing through the area, Captain John G. Bourke described Duppa as "hospitable to a fault and not afraid of man or devil…or Apache Indian." Bourke was rather less enthusiastic about the accommodations.[74]

At times, Duppa seemed to prefer a hermit's existence, with only his books to keep him company. During these episodes, he became gaunt and unkempt. When Duppa's older brother died without heirs, the estate in England could have been his. He refused, however, to return to England and was reputed to have said: "It is useless at this time of life. To do so would require a radical change in my life, and I have lived so many years on the frontiers of civilization that I have no desire to again assume the life and the attendant

"Lord" Duppa on his way back to the PMMP in 1991. *PCA files.*

"Mourners'" procession following "Lord" Duppa during his reburial. *PCA files.*

responsibilities which would fall to my lot should I return to England."[75] All his other brothers predeceased him, and the estate eventually passed to one of his cousins.

In later life, Duppa returned to Phoenix, where he lived humbly on a farm near the Salt River. During the Great Flood of 1891, it was feared that he had drowned, but he and two other men survived by perching on the roof of a friend's house.[76]

Duppa died on January 30, 1892, at the home of his friend Dr. Thibodo. He was originally buried in either the Odd Fellows or Masonic Cemetery.[77] In April 1921, the Daughters of the American Revolution had his body moved to Greenwood Cemetery because the old cemetery was not being properly maintained. Once the PMMP was established, many citizens banded together and petitioned to have the remains of "Lord Duppa" returned. An elaborate solid copper burial vault and a new casket were provided, and on November 26, 1991, a procession of officials and historical reenactors accompanied the horse-drawn hearse that bore Duppa to his last (it is to be hoped) resting place.

William and Jennie Isaac (Contributing Author Dean Isaac)

The Isaacs were among the first families to settle in the Salt River Valley. William Isaac was born on April 14, 1827, in Cocke County, Tennessee, the first of nine children born to Smith and Mary Isaac. Shortly after William was born, the Isaacs left Tennessee, settling first in Ohio, then Indiana and eventually in Platte County, Missouri.

William married Jennie Netherton in Platte County on July 11, 1848. Jennie was born on December 19, 1827, in Cocke County, Tennessee, the second of eight children born to Daniel and Hannah Netherton. William and Jennie had eleven children in twenty-one years. Three children died young.

The Isaacs settled in about 1850 in Daviess County, Missouri, where they had their first five children: Eli, Alice, Mary, John and Clara. In 1853, William was appointed the first superintendent of schools for Daviess County. He also farmed and acquired approximately 590 acres of land under the Land Act of 1820.[78]

On May 5, 1848, Jennie's brothers, John and James Netherton, along with their father, Daniel, left Missouri to cross the plains to California to join the gold rush. Apparently, the Nethertons did not strike it rich. Daniel and James returned to Missouri, but John remained in California, married and settled in Contra Costa County. The Netherton and Isaac families had remained close since their days in Tennessee, and the Isaac family eventually joined the Nethertons in California. By July 1860, William, Jennie and their children were living in Contra Costa County with William's brother Richard and their mother, Mary Isaac, in a household of fourteen people. William farmed and had real estate valued at $150.

By 1870, the Isaacs were living in Gilroy Township, California. William listed his occupation on the 1870 federal census as surveyor. In September 1869, he surveyed an addition to the town of Gilroy. William was the proprietor of the Depot House Hotel, and in May 1870, he was elected to the Gilroy town council. The last three Isaac children, William, Edna and Alfred, were born in California.

In May 1875, William and Jennie and seven of their children loaded their belongings into two wagons, each pulled by four horses, and left California for Arizona. After crossing the Mojave Desert on the Mojave Trail, they arrived at present-day Bullhead City on July 1, 1875, and then crossed the Colorado River into Arizona. They arrived in Prescott on July 8 after traversing the 160 miles of the Hardyville-Prescott Toll Road.

On July 23, 1875, the *Arizona Weekly Miner* reported, "Mr. Isaacs [*sic*] and family, of Salinas City, Cal., have arrived here and are negotiating for a new cottage recently built by Mr. Wilson, at the corner of Gurley and Mariana streets, with a view to starting a private boarding house."[79] On November 5, 1875, Isaac's advertisement appeared in the *Miner*:

> *William Isaac, whose card appears in the MINER to-day, was formerly a resident of Salinas City, California, where the local paper speaks of him as a man of superior attainments, and perfectly reliable in every respect. He has settled with his estimable family in Peeples (or Antelope) Valley, where, in addition to his farming operations he is ready to answer calls for Surveying and Civil Engineering, and guarantee the correctness of his work.*[80]

In the fall of 1877, Isaac and his sons moved to Phoenix, staked out a homestead at the northeast corner of McDowell Road and Thirty-Fifth Avenue and began raising crops. By the next year, they had grown enough, according to the May 24, 1878 edition of the *Arizona Citizen*, to be awarded a contract to sell 200,000 pounds of barley to Fort McDowell.

The family first lived in a large adobe house on the corner of Seventh Avenue and Jackson Street. Later they built one of the first houses in Phoenix of any size constructed entirely of lumber, which had to be freighted by wagon from Prescott. It was one story and had nine rooms. It burned to the ground ten years after it was built.

On April 19, 1886, Isaac "proved up" his homestead and testified that he had made improvements worth $2,000, including a large house forty feet by forty feet, corrals, an orchard and 150 acres under cultivation in alfalfa. His sons William, John and Eli also filed homestead proofs, and together they homesteaded approximately 450 acres under the Homestead Act of 1862. William and John also acquired 475 acres under the Land Act. All told, the family amassed over 900 acres. Descendants of the Isaac family lived on part of the original homestead until the 1970s.

In 1878, the Maricopa County Board of Supervisors established Isaac School District #5 to educate the children of the surrounding area. In 1894, a permanent schoolhouse was erected for $3,000 on the northwest corner of Thirty-Fifth Avenue and McDowell Road on land homesteaded by the Isaac family. The Isaac Middle School occupies the original site today.

Until railroads arrived in Phoenix in 1887, goods were hauled in and out of the valley by wagons. After the spring and fall harvests, the Isaacs made trips to Yuma, an early terminus of the Southern Pacific Railroad, to haul

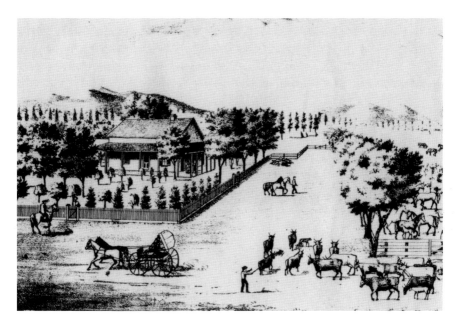

The Isaac Farm. *Courtesy Dean Isaac.*

William and Jennie Isaac. *Courtesy Dean Isaac.*

The headstone for the Isaacs in 1902. The trees on the left line the original cemetery entrance called Peppertree Lane. *Courtesy Dean Isaac.*

freight back to Phoenix. The wagons would be loaded with enough feed for the trip down and back. On the way to Yuma, they would leave feed for the return. They used two wagons coupled together and pulled by ten horses. The load back to Phoenix could weigh twelve thousand pounds, and it took about twenty-five days to make the trip.

Contemporaries described Isaac as a man who was goodnatured and genial.[81] He was active in Republican politics and was a candidate on the 1880 Republican ticket for the Maricopa County Council. The civic positions he held included road overseer for District 1 (1878), county surveyor (1881–82) and court commissioner for the Second Judicial District Court, where he assisted Judge DeForest Porter. He was involved as a surveyor or trustee in many of the early canal companies.

William and Jennie were devout Baptists. On March 23, 1900, they completed their nightly ritual of reading several chapters from the Bible and saying family prayers before retiring. Shortly after 4:00 a.m. the next morning, William called to his wife to get a light. When Jennie returned, William was dead from a heart attack at the age of seventy-two. The *Arizona Republican* wrote that William was one of the best-known residents of the

valley, whose labors and ambitions helped contribute to the prosperity and development that exists in this treasure land of the Southwest.[82] Jennie died almost two years later, on February 10, 1902, from influenza. Both rest in the Masons Cemetery, while two of their daughters and four grandchildren are buried in the Knights of Pythias Cemetery.

George Loring (Contributing Author Derek Horn)

George Loring and his wife, Aggie, were among the earliest settlers in the new town of Phoenix. Relocating to the hardscrabble frontier from the comforts of the East, they experienced both success and tragedy. Loring was born in June 1854 in Saco, Maine, to Samuel and Elizabeth Loring. Later, the family relocated to Boston, Massachusetts, where, in July 1874, he married Margaret "Aggie" Roby.

Loring opened a watch store in Marblehead, near Boston and his family. Unfortunately, his business suffered in the economic depression that occurred after the Panic of 1873. Loring wrote to his mother, Elizabeth, early in 1875 that "business is awful dull. I think I can do a good deal better in some other town."[83]

Inspired by lectures and stories about Arizona by Samuel Cozzens, a former Tucson judge, Loring followed through on his idea and joined a group called the Arizona Colonization Company or Boston Colony. He left his wife, pregnant with their first child, with family and, in February 1876, headed west.

The journey was both arduous and disappointing. The company planned to settle along the Lower Colorado River in northern Arizona, but Mormons had beaten them to it. The company broke up, and Loring went to Prescott, the territorial capital. Prescott already had several watchmakers, so Loring decided to investigate the prospects in Phoenix.

Phoenix did not have a watchmaker, so Loring set up shop on the south side of Washington Street between First Street and Central Avenue. He soon expanded and added other commodities. Aggie and their new baby, George, arrived in Phoenix in October 1876.

The store on Washington became Loring's Bazar [sic]. It prospered and soon housed the post office and the telegraph office, along with a Wells Fargo agency. Loring's advertisements in the *Salt River Herald* called it a "News Depot," with fruits, candy, nuts, stationery, blank books and schoolbooks, jewelry, silverware and tobacco, along with watch, clock and jewelry repair.

In 1879, he imported a soda fountain, which likely made his store popular on a Phoenix summer day.

In 1877, Aggie became pregnant again, but her health deteriorated during the last few months of her pregnancy. She gave birth to a baby boy, Madison, on July 8. Shortly after the delivery, Aggie came down with a fever and her condition worsened. She died on August 12, 1878, at the age of twenty-five.

With two small children to raise and a business to run, Loring convinced his parents to move to Phoenix. They arrived in October 1878, and the family developed a successful real estate business. Loring married Jennie Clark in 1881. They had five children together, although two girls died very young.

By the 1890s, Loring had turned his energies to successfully raising blooded trotting horses. Active in Republican Party politics, in November 1896 he bet one Thomas Bryan that Republican William McKinley would win the presidential election over Democrat William Jennings Bryan. He put up some property on Washington Street as a stake and won the bet, along with four houses owned by Bryan on Van Buren Street.

By 1900, Loring had suffered some financial reverses, and he sold many of his belongings at auction. He and Jennie no longer lived together. Sometime after 1906, George moved to Los Angeles, where he ran a grocery store for many years. He died in February 1932 at the age of nearly seventy-eight.

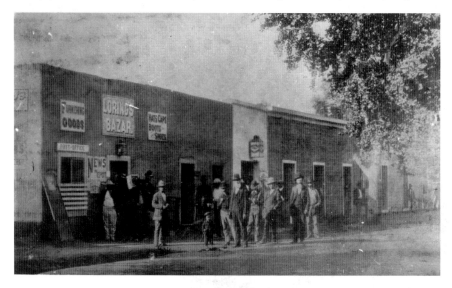

Loring's Bazar. George Loring is the man in the white hat under the sign for "Hats, Caps, Boots." *Courtesy Arizona State Libraries, Archives and Public Records, History and Archives Division, Phoenix, No. 95-2859.*

Right: George Loring. *Courtesy Arizona State Libraries, Archives and Public Records, History and Archives Division, Phoenix, No. 97-7127.*

Below: The Loring Vault during its 1989 examination. *PCA files.*

During the early 1900s, Loring constructed a vault in the Rosedale Cemetery, which was also known for a time as the Loring Cemetery. Aggie; Loring's father, Samuel; and the two girls from Loring's second marriage who died in infancy were interred there. Later, after their deaths, Loring's and his son George's cremains were placed there as well. In April 1989, the vault was opened for examination and inventory of its contents before being resealed and restored. A child's burial dress and shoes taken from the vault are on display at the Smurthwaite House at the PMMP.

Samuel Calvin McElhaney
(Contributing Authors Donna Carr and Debe Branning)

Samuel Calvin McElhaney was born on October 9, 1861, probably in York County, South Carolina. He was the son of Randolph McElhaney and his second wife, Catherine Black. Most accounts say that Randolph died fighting for the Confederacy on July 1, 1862, in Mississippi, leaving Catherine to raise Samuel and his younger sister Clorinda.

As a young man, McElhaney made his way to Texas and then later drove a herd of cattle and horses to Phoenix and settled near the Salt River. On January 10, 1889, Sam was among six men who incorporated the Fairmount Water Storage Company to sell water for irrigation and mining purposes in Maricopa County. Later that year, on April 10, McElhaney married Sarah Hill. They had seven children.

The newlyweds moved to Holbrook, where they ranched. They enjoyed a few years of success before drought forced them to return to the Salt River Valley in the early 1890s. McElhaney then established a farm at the northeast corner of Camelback Road and Fifty-First Avenue. Son Lucius died in January 1897 and was buried in Loosley Cemetery.

From an early age, son Randolph was his father's right-hand man. Back then, the ranchers used brush weirs (barriers) to divert water from the Salt River into irrigation ditches on their property. One of Randolph's jobs was to stand guard with a shotgun to make sure that no one came along and removed the weirs.[84]

On November 28, 1905, tragedy struck the family. Samuel and Randolph were loading some hogs to be taken to market into a wagon. While running one of the hogs up the chute, Sam smashed his thumb, causing him agonizing pain. Although he repeatedly assured his son that he was hurt in no place but the thumb, the pain was so unbearable that he fainted twice while

attempting to walk the short distance to the house. A doctor was summoned, but McElhaney, vomiting and fainting several more times, died from shock before help could arrive. He was forty-four years old. After a service at the First Baptist Church, McElhaney was buried in Loosley Cemetery. Sarah gave birth to their last child, Samuel Jr., a few months later.

The task of raising the children and managing the family farm fell on Sarah and Randolph. In 1908, she purchased a lot at the southwest corner of Seventh and Oak Streets and built a house for the family. Sarah died of pulmonary tuberculosis on March 25, 1911, at age thirty-nine and was interred in the family plot in the Loosley Cemetery.

The orphaned McElhaney children were fortunate their maternal grandparents were in Phoenix and able to help raise them to adulthood. Both Randolph and Samuel Jr. went on to establish large ranches of their own. During the 1930s, Randolph acquired a ranch in Chino Valley, and in 1940, Samuel established the McElhaney Cattle Company in Wellton. Samuel even started a small museum on his ranch where he exhibited buggies, carriages, a popcorn wagon, an old hearse, stagecoaches and antique cars dating back to 1911.

John Osborn (Contributing Author Mark Lamm)

John Preston Osborn and his family were early and influential settlers in the Salt River Valley. Their name remains on a school district and major street in midtown Phoenix. Osborn was born in Tennessee in 1815, the son of John Osborn and Elizabeth Flannery. In 1841, he married Perlina Swetnam, a native Kentuckian. They went to Iowa about 1850 and had six children together.

The family eventually moved to Colorado in 1863 and then on to Prescott in 1864, where Osborn established the Osborn House hotel, one of the first in that pioneer town. He assisted in the exploration of the Del Rio and Verde Valleys. Osborn also ranched and farmed in the area but suffered losses of both stock and structures to raiders. In 1866, his daughter Louisa married John Alsap. Sadly, Louisa died the following year, and Alsap, along with Osborn's son John, moved to the Salt River Valley in 1869. Alsap and John may have convinced Osborn of the opportunities of the new settlement in the Salt River Valley. In January 1870, the Osborns made the arduous journey from Prescott to the valley and soon established a homestead at the southeast corner of McDowell Road and Seventh Street.

Son William had another homestead on neighboring land to the east.

Osborn quickly became an influential member of the new community. As a member of the Salt River Valley Town Association, he took a lead role in establishing the Phoenix town site and assisted with its survey and the layout of the streets, blocks and lots. After a land patent was issued for the town site, Osborn chaired the Phoenix Townsite Commission, which determined the ownership and value of lots sold in the town site before it received its land patent in 1874. Alsap, the Maricopa County superintendent of schools, appointed Osborn as a trustee of the first school district in 1871.

John P. Osborn. *Courtesy Arizona State Libraries, Archives and Public Records, History and Archives Division, Phoenix, No. 97-7801.*

In 1874, the Osborns suffered financial reverses and lost their land. Some was sold to Mary Woolsey, King Woolsey's wife, and to Michael Wormser.[85] Osborn left the Salt River Valley for a few years, but undaunted, in 1878, he and sons Neri and William filed claims on lands north and south of Phoenix. They subsequently received their patents. Neri accumulated land along the east side of Central Avenue south of Campbell Avenue and a 320-acre tract along Southern Avenue between Seventh Avenue and Seventh Street. Osborn had 160 acres at the southeast corner of Indian School Road and Seventh Street. William had a 160-acre tract at the northeast corner of Fifteenth Avenue and Thomas Road, the present location of Phoenix College. Because the Osborns were among the first residents of the area, both Osborn Road and the Osborn School District are named for them.

Osborn continued farming until his health failed in his last years. He died on January 19, 1900, at the age of eighty-five and was buried in the Workmen Cemetery. Perlina joined him there in 1912 at the age of ninety-one. Many of the Osborn family remained in the Phoenix area. Neri served several terms as Maricopa County recorder. Neri's son Sidney became the first secretary of state of the state of Arizona in 1912. Sidney was later elected the state's seventh governor in 1940 and went on to be elected to three more consecutive two-year terms before dying of Lou Gehrig's disease in 1948.

Abraham Peeples (Contributing Author Derek Horn)

When Abraham Peeples died, he was remembered for being the proprietor of well-appointed saloons as much as for his adventures and accomplishments as an early Arizona explorer and pioneer. Born in June 1822 in Guilford County, North Carolina, he moved to Texas at the age of twenty-four. At the outbreak of the Mexican-American War in 1846, he enlisted in the Second Texas Rangers as a private and participated in the Battle of Monterrey. For some unknown reason, he was discharged after the battle.

In 1849, Peeples made his way to Gold Rush California and for the next fourteen years mined in the Sierra Nevada. Attracted by the lure of gold in the new Arizona Territory, he and three partners went to Yuma in 1863. They joined up with other prospectors, including Henry Wickenburg, and formed what became known as the Peeples Party. Led by famed mountain man Pauline Weaver, they journeyed up the Colorado River and then turned east. Their journey took them to Rich Hill in the Weaver Mountains. In that area, they found gold. For a few months, they extracted an average of nearly $7,500 per month per man (over $140,000 in today's currency). Jack Swilling joined the party. When the surface gold ran low in November 1863, Peeples moved east and settled in an area that became known as Peeples's Valley.

Peeples ranched while still mining but was plagued by raids on his stock by Apache Indians. He joined up with one of the expeditions led by King Woolsey to pursue and punish the raiders and was at the controversial Battle of Bloody Tanks.

Peeples soon gave up ranching. Described by one biographer as "anxious and restless," he helped found the town of Aubrey, set up a livery stable and corral in Prescott and then moved to the town founded by and named for his friend Henry Wickenburg, where he set up a brewery and saloon.[86] He became a justice of the peace. On December 28, 1864, he married Rebecca Cavaness. Little is known about their life together, and they had no children.

Having established himself in Wickenburg, Peeples branched out. In July 1871, he, along with Thomas Graves, purchased three lots, including a saloon and brewery, on the north side of Washington Street between First and Second Streets in Phoenix.

During the 1870s and into the 1880s, Peeples continued to live in Wickenburg, where he was the proprietor of several businesses that included the Arizona Hotel and Magnolia Saloon as well as the Mechanics' Exchange saloon in Prescott and the Hayes & Peeples Saloon in Phoenix.

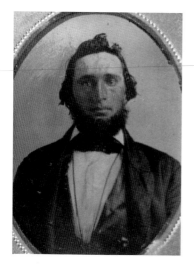

Abraham Peeples. *PCA files.*

In 1883, Peeples's Wickenburg businesses were destroyed by fire. He sold his property there and moved to Phoenix. Peeples engaged in Democratic Party politics and ran for his party's nomination for Maricopa County sheriff in 1884, but he withdrew from the contest when party delegates deadlocked among several candidates. A fire destroyed a large part of the Phoenix business district on May 27, 1885, and Peeples lost buildings valued at $4,500. He had no insurance.

This was a devastating loss, and little is known about his life for the next five years. He received a land patent on 160 acres at the southeast corner of Van Buren and Sixteenth Streets, but it is unknown if he farmed this parcel, rented it out or held it for appreciation. By 1890, Peeples had reestablished himself in his old profession as the proprietor of the Bowling Alley Saloon on Washington Street. Its advertisement stated that it was the only bowling alley in Phoenix.

Abraham Peeples died on January 28, 1892, at the age of sixty-nine and was buried in the Loosley Cemetery. In an interesting coincidence, fellow pioneer "Lord" Duppa died two days later in Phoenix.

John Y. T. Smith (Contributing Author Donna Carr)

While Jack Swilling and his party of canal builders and farmers established the first permanent Anglo settlement of the Salt River Valley in 1867, they were not the first non-Indian residents of the area. That distinction belongs to another man with an unusual name: John Yours Truly Smith.

John Smith was born on September 16, 1831, near Buffalo, New York. At the age of ten, he became a cabin boy on a riverboat and traveled up and down the Mississippi, Missouri and Ohio Rivers for the next three years. Smith left that occupation in 1845 and spent the next eight years farming in Macoupin County, Illinois.

In the spring of 1853, Smith set out with a party of young men to drive a herd of cattle from St. Joseph, Missouri, up the Platte River and across the plains to California. They made the trip in six months. From 1853 to 1860,

he engaged in mining and prospecting on the Pacific coast, broken only by an expedition to British Columbia in 1858 at the time of the Fraser Canyon gold rush.[87]

At the outbreak of the Civil War, he enlisted in Company H, Fourth California Infantry. The regiment was stationed at Yuma for a year before moving to Camp Latham near Los Angeles. In 1864, he was stationed at San Luis Obispo and later at Dunn barracks near San Pedro, where he was promoted to second lieutenant and then first lieutenant of his company. At the end of the war, the Fourteenth U.S. Infantry was sent to garrison Fort McDowell, and Smith went along as a civilian employee.

In July 1866, Smith was working as a wagon master at the army depot in Tucson.[88] Following his discharge from the army, he is believed to have gone to the Salt River Valley in 1866 or 1867 to harvest the hay that grew wild along the river and supply it to Fort McDowell. Smith set up his camp on land now near Fortieth Street and the Salt River in Phoenix.[89] It is possible Jack Swilling may have visited Smith's hay camp briefly in September 1867 and on this occasion conceived the notion of excavating the old Indian canals to irrigate the area.[90] Given his familiarity with the Salt River, Smith also saw the potential for diverting its water for agricultural purposes, and that money could be made selling hay to the miners at Vulture Mine near Wickenburg, as well as to Fort McDowell.[91]

By 1868, Smith was the ferryman at McDowell Crossing on the Salt River near present-day Mesa, about twenty miles upriver from his hay camp of the previous summer.[92] For the next few years, he was also the post trader at Fort McDowell.

About 1872, Smith opened a store in Phoenix, freighted in goods through the Gulf of California to Yuma and then hauled them overland by wagon.[93] In 1874, Prescott merchant Michael Goldwater, who also owned a store in Phoenix, sold his Phoenix store to Smith, King Woolsey and one other partner.[94]

The first building erected as a schoolhouse in Phoenix opened in 1872. It was a one-room adobe building with a mud-thatched roof, but it did have a wooden floor. Twenty children from the new town attended, and the teacher was Ellen Shaver. Smith and Ellen became acquainted. Even though he was about twice her age, on October 3, 1875, they were married in Prescott and eventually had four children.

In 1876, Smith built the second flour mill in the Salt River Valley at the northwest corner of First and Jefferson Streets in Phoenix.[95] He operated it until 1889 and then built a new mill near present-day Ninth and Jackson

Streets, which he sold in 1899. Over the years, Smith acquired extensive real estate and other interests, including a gold mine in Yavapai County.[96]

As his milling business prospered, John Smith decided that he needed a more distinctive name. During the course of his business dealings, he came across other men who called themselves "John Smith," some of whom were undoubtedly using it as an alias for shady purposes. Accordingly, he petitioned the Tenth Territorial Legislature for a legal name change. Successful, he became John Yours Truly Smith.

Like many of his fellow pioneers, Smith engaged in politics and served the community in elected and appointed offices. He was a member of the Arizona Territorial House of Representatives in 1868 and again in 1887 to 1889, when he represented Phoenix. He served as the Speaker in the second session and was instrumental in moving the territorial capital to Phoenix. Smith also served as the territorial treasurer from 1889 to 1891.[97] His appointment as treasurer by the territorial governor Lewis Wolfley was challenged by C. Burton Foster, the previous treasurer, who maintained his term had not officially expired and he still held the post. A judge disagreed, and Smith assumed his new office.

Smith became a member of the GAR post in Phoenix. He was also a Mason. On February 5, 1880, Smith was raised to the sublime degree of master mason in Arizona Lodge Number 2. He was elected master of the lodge in December 1887. In November 1888, he became junior grand warden, the following year senior grand warden and in 1890 deputy grand master of the Grand Lodge of Arizona.[98]

Later in life, Smith took to spending summers in cooler parts of Arizona or in California. He died at the age of seventy-two of heart failure on July 15, 1903, while visiting Los Angeles. His body was returned to the community where he had harvested hay so many years before and was interred July 20 in the Masons Cemetery. Three years after he was laid to rest, he was joined by his daughter and son-in-law, who had lost their lives in the great San Francisco earthquake in 1906. In 1914, John's widow, Ellen, had all the remains moved to Greenwood Cemetery.

King S. Woolsey (Contributing Author Donna Carr)

King S. Woolsey was born around 1832 in Alabama, although he grew up in Louisiana. A Roman Catholic, he was preparing to become a priest when he rebelled. Woolsey may have been involved in an unsuccessful

filibustering expedition to Cuba.[99] About 1850, he sailed to California, then in the throes of the gold rush. In 1855, Woolsey was again a member of a filibustering expedition—this time to Nicaragua. It, too, was unsuccessful. Returning to California, he took up mining and remained there until 1860.[100] That year, with $5 (about $120 in today's currency), three horses, a rifle and a pistol, he left California for Arizona and found work as a mule driver for Fort Yuma.

Going into partnership with a pharmacist named George Martin, Woolsey acquired the Agua Caliente Ranch on the Gila River about eighty miles east of Yuma for $1,800. The ranch had a good water supply, and there he raised cattle and horses along with wheat, barley and potatoes. The partnership dissolved in 1865, but Woolsey continued to operate the ranch until 1871.[101]

Because Woolsey was a Southerner, it has been assumed he favored the Confederacy during the Civil War. Indeed, legend has it that in 1861, he planned to join a group of volunteers that crossed Arizona heading east to join Confederate army colonel Albert Sidney Johnston but was prevented from doing so by illness. Perhaps the opportunity to make money also triumphed over his political beliefs. Whatever the reason, when a group of Union army soldiers and volunteers, known as the California Column, marched through Arizona during 1862, Woolsey, despite his reputation as a secessionist, made a substantial profit selling supplies to the U.S. Army.[102]

Notwithstanding this success, the lure of gold still beckoned. In 1863, Woolsey joined the Walker Expedition to explore northern Arizona. They discovered gold at Lynx Creek, where he set up a mining claim. Finding the climate of central Arizona more congenial than that of Yuma, Woolsey soon bought another ranch, the Agua Fria, on the Agua Fria River near present-day Dewey.

At the Agua Fria Ranch, Woolsey built the first ranch house in northern Arizona. It became an outpost where travelers could obtain food and shelter. It was also well fortified, and for good reason.[103] The Apache Indians in the Prescott area conducted raids against the settlers encroaching on that region, and the ranch offered some shelter. In response to these raids, Woolsey led several punitive expeditions against the Indians in 1864. One culminated in the Battle of Bloody Tanks, near present-day Globe, Arizona. In this raid, Woolsey is said to have shot and killed an Indian leader during a parley, and then, as if by pre-arrangement, the other members of his party started shooting and took the Indians by surprise. The resulting battle left twenty-four Apaches dead. This action was controversial, even in its time, and

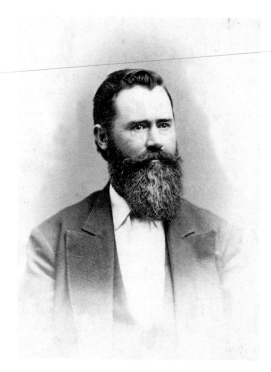

Left: King Woolsey. *Courtesy Sharlot Hall Museum Library and Archives, Sharlot Hall Museum Collection, Call no. PO-1507P.*

Below: The ruins of King Woolsey's ranch at Agua Caliente in the 1920s. *Courtesy Arizona State Libraries, Archives and Public Records, History and Archives Division, Phoenix, No. 97-1658.*

historians have noted that it likely led to other battles between the pioneers and the Native Americans in the territory.[104]

On another expedition, Woolsey invited Apache leaders to parley, having hidden a sack of pinole laced with strychnine nearby. As expected, the other warriors found and ate the pinole. Poisoned, the fleeing Indians were gunned down by Woolsey and his men. Despite Woolsey's efforts, raids continued on his ranch.

Arizona became a territory in February 1863. Its first governor, John Goodwin, appointed Woolsey his military aide with the rank of lieutenant colonel in the Arizona Volunteers. Woolsey was also elected to the Council (the Senate) of the First Arizona Territorial Legislature in late 1864.[105] By this time well-known throughout the territory, he served another term before stepping down.

At the end of the Civil War, Woolsey acquired Stanwix Station, a stopping point for mail and passenger service on the Butterfield stage route between San Diego and Tucson near the Agua Fria ranch. Between 1864 and 1872, Woolsey operated several mines near Prescott and even built a stamp mill to extract gold from ore-bearing quartz. His mining schemes failed, however, and he had to sell his Agua Fria Ranch to pay his creditors. He married Mary Taylor on May 27, 1871. Mary took on running the Stanwix Station.

In 1872, Woolsey was elected to the council of the Seventh Arizona Territorial Legislature and served two more consecutive terms. In the early territorial days, the capital alternated between Prescott and Tucson. In January 1873, when Tucson was the capital, Woolsey introduced legislation to permanently relocate the capital to Phoenix. This motion was tabled, but he continued his efforts during the next few years to make Phoenix the capital city before acceding to Prescott as the permanent capital in 1877, when he was president of the council.

Despite this setback, Woolsey's political career gave him access to other influential businessmen in the territory. He saw opportunity in Phoenix, and as soon as the Phoenix town site was laid out, Woolsey began acquiring property there. In 1876, he partnered with John Y.T. Smith and C.W. Stearns to build a flour mill.

In May 1878, Woolsey announced in Phoenix his candidacy for territorial delegate to Congress. Used to winning elections, he soon ran into some serious headwinds. Some voters from Tucson and Prescott may have remembered his efforts to move the capital to Phoenix. He was also attacked by the *Arizona Sentinel* newspaper of Yuma for his southern roots and sympathies, political ambitions, conduct during the Indian expeditions, the fact that he borrowed

Stanwix Station. Mary Woolsey stands behind the fence. *Courtesy Arizona State Libraries, Archives and Public Records, History and Archives Division, Phoenix, No. 97-0401.*

money for his campaign at little interest and the fact that he had neglected his children.[106]

Between 1865 and 1871, before he married Mary, Woolsey kept a Yaqui girl, Lucy or Lulee Martinez, as his mistress at his Agua Caliente Ranch. Their cohabitation was not legal at the time. He had two daughters and a son with Lucy, but he never acknowledged his half-Indian children, nor did he provide any support until he ran for Congress. Lucy eventually moved to Yuma, where the girls entered a convent school run by the Sisters of St. Joseph. Since Woolsey and his wife, Mary, never had children, Woolsey's line was carried on only through the descendants of Lucy.

Woolsey lost the election, coming in last in a field of four. Not one to remain idle, he turned his energies to new enterprises. He served as director in several water companies aimed at more equitable distribution of water privileges. While continuing to operate his Agua Caliente properties, Woolsey expanded his business interests and landholdings in Phoenix and became one of its most prominent citizens. Always an innovator, Woolsey

Conception Woolsey, King Woolsey's daughter with Lucy Martinez. *PCA files*.

opened the first roller-skating rink in Phoenix at the Woolsey and Wentworth Hall in June 1878.

On June 29, 1879, having been in Phoenix all day, Woolsey returned late to his home. Around 3:00 a.m., his cook heard a groan and, going to Woolsey's bedroom, found him lying on the floor. A doctor was summoned, but it was too late. Woolsey died on June 30, 1879, of apoplexy at the age of forty-seven.

Woolsey was interred in the first city cemetery. His remains were later moved to their current location in Loosley Cemetery. At the time of his death, Woolsey's wealth was valued at about $40,000 (almost $1 million in today's currency). He died intestate, and his estate was not settled until 1893. There was no provision for Lucy or their children. Mary survived Woolsey by almost fifty years and remarried twice. When she died in 1928, Governor George W.P. Hunt ordered the state flags to be flown at half-staff in honor of Mary's contributions as a pioneer, the first time a woman had been so honored in Arizona.

King Woolsey was not forgotten. In 1942, Arizona held a contest to name a Liberty ship. Schoolchildren who collected scrap metal for the war effort

The SS *King Woolsey. Courtesy Frank Barrios.*

provided suggestions, and the name of King S. Woolsey came out on top. Three children from the schools that collected the most scrap attended the launching. Woolsey's granddaughter Helen Woolsey Marron christened the SS *King S. Woolsey* as it slipped into the water and sailed off to war.

FROM FARAWAY PLACES

The Holland Family (Contributing Author Donna Carr)

Even though they had an Anglicized name, the Holland family were Chinese merchants who were among the earliest settlers in Phoenix. The man who would eventually become William Holland was born around 1827 in China, most likely in Zhongshan in the Guangdong Province. According to an account in the *Arizona Republican* on September 8, 1890, he worked as a cook on ships for years and subsequently "embraced the customs of the white man."

By about 1860, Holland was living in New York, where he met and married Ellen Holland. Since New York had never enacted the anti-miscegenation laws common to states in the American South and West, it was legal for those of Chinese descent to marry outside their race. He adopted the name William Holland. Their son, Joseph Henry, was born about 1861.

About ten years later, the Hollands headed west and may have spent about five years in Yuma before moving to Phoenix in the mid-1870s. They established a restaurant and lodging house and acquired property at the southwest corner of Second and Adams Streets, in the city's first Chinatown, and at the northwest corner of Second Avenue and Jefferson Street. Interestingly, the 1880 federal census for Phoenix lists William Holland as living in a bachelor household with several other Chinese laundrymen. There is no mention of Ellen. Joseph, by that time nearly twenty years old, appears to have been living in La Mesilla, New Mexico, where he worked as a waiter. Although Ellen is not listed in the census, she was very much present, as her name appears shortly thereafter on a legal document recorded in Phoenix in November 1880.

In the late 1880s, the Holland family departed for China, where William and Ellen planned to retire. Arrangements had also been made for Joseph to marry a girl named Yit Sen, born in Zhongshan in either 1864 or 1867. Although Joseph probably returned to Arizona after the wedding to look

after the family's business interests, Yit Sen remained behind in China with William and Ellen until 1890. It was customary for a young Chinese wife to serve her in-laws, and it would have been an opportunity for Ellen to teach Yit Sen some English.

When Yit Sen arrived in the United States in 1890, she was likely accompanied by her mother-in-law, Ellen, who had decided living in China did not suit her. It is also likely that William intended to return as well, but he fell ill and had to remain behind. It was reported in the *Mohave County Miner* on August 20, 1892, that William, the "whitest Chinaman ever in Arizona," tried to arrange his return but omitted some "necessary formalities." It is unknown what those formalities were, but apparently with no hope of succeeding, he remained in China to grow coffee. He died soon after.

In 1891, the Holland family resided on Adams Street between First and Second Streets. Joseph worked as a waiter. That same year, Yit Sen gave birth to twin daughters, Elizabeth and Lena.

By the time Yit Sen was expecting their third child, in mid-1893, Joseph's financial resources were becoming strained. In October 1893, he offered F.M. Czarnowski a commission of 5 percent if Czarnowski would find a buyer willing to pay $5,000 (over $130,000 in today's currency) for his Adams Street property, which consisted of three lots. Apparently, Joseph planned to use the money to return to China, where he claimed he "could live like a king." Czarnowski produced a buyer only two days later. The alacrity with which a buyer was found may have caused Joseph to realize that he had seriously undervalued the property. He withdrew his offer to sell, telling Czarnowski that he wanted $5,000 for each *individual* lot, not all three together. When Joseph refused to pay the agreed-upon commission of $250, Czarnowski sued him.[107] The Hollands' third daughter, Cecilia, was born on October 14, 1893.

Ellen died in Phoenix on December 6, 1894, and her remains were shipped to San Francisco for burial. A few days later, Joseph filed a deed with the county recorder's office. Ellen had sold their family home on Adams Street directly to Yit Sen, possibly to secure it should Joseph lose his court case.

Joseph and Yit Sen became the parents of Joseph William, born on August 4, 1895, and a daughter, later known as Dora, born on August 30, 1897. By that time, Joseph was employed in a restaurant and occasionally supplemented his income by acting as a court interpreter in cases involving Chinese litigants.

The federal census of 1900 does not list a Joseph Holland in Phoenix. There is evidence he journeyed to Alaska to try his luck in the Klondike gold rush. The *Arizona Republican*, on September 15, 1900, reported that he had returned from Nome with no big strike. Nevertheless, Yit Sen and the five Holland children still lived on Adams Street. The Hollands owned their own dwelling and reported a net worth of $1,830 (about $52,000 in today's currency).

In December 1900, the Hollands attended a parade in downtown Phoenix that celebrated the opening of the Second Phoenix Indian and Cowboy Carnival. Yit Sen and three of their children rode in a carriage with the parade's Chinese contingent. A studio photograph taken that same day shows Yit Sen and her youngest daughter, Dora, wearing Chinese attire, while the rest of the children are in school uniforms.

The Holland family continued to grow when Yit Sen had another set of twins born in November 1901. Tragically, infant Theodore died on December 18, 1901, of marasmus. The other infant, Harold, died on May 10, 1902, of gastroenteritis. The twins share a headstone in Rosedale Cemetery.

The Holland family in 1900. *Courtesy Irving Chew.*

As the Holland girls entered their teens, Joseph found it increasingly difficult to support the family on his earnings as a waiter. He had already mortgaged and sold off most of his real estate holdings to meet his financial obligations. In January 1906, Joseph sold the last of their property, the family home on East Adams Street. One of the few remaining adobe structures in Phoenix, it was demolished that August for redevelopment.

Due no doubt to Ellen's influence, the Hollands were practicing Catholics and regularly attended Mass at St. Mary's Catholic Church in downtown Phoenix. A family portrait taken on May 14, 1906, the day of Cecilia Holland's first communion, shows Joseph William in the garb of an altar boy. In addition to Joseph William and his four sisters, there is a small boy in the photograph. This suggests that Joseph and Yit Sen had another son born around 1904. He must have died in early childhood, since nothing about him is known today, not even his name.

Soon after, for some unknown reason, the Holland family broke apart. Yit Sen, along with her four daughters, left in June 1906 and sailed for China. Joseph stayed behind with Joseph William, who was about to enter junior high school.

During the next several years, Joseph continued working as a waiter. In 1914, he and a partner purchased a café on South Mill Avenue in Tempe. During this time, Joseph's health began to fail, possibly due to heart disease, and he left the area on occasion to seek rest or treatment. Joseph William graduated from Tempe High School in 1914 with high marks. He enrolled in the University of Arizona but left in December 1917 for officers' training camp. In May 1918, he was sent to France and, after serving fifteen months overseas, returned to Arizona, where he secured a position as an electrical engineer in the Salt River Project power plant. Sadly, he was electrocuted in a power plant accident on November 20, 1919. He died of his burns on December 3 and was buried with military honors in St. Francis Catholic Cemetery.

During the 1920s, Joseph remained the proprietor of the Richmond Café on South Mill Avenue in Tempe. He was well known to the students from the nearby university who frequented his restaurant. He died in February 1927 of heart disease and was buried in St. Francis Cemetery near his son.

Life in China was not good for the Holland girls. They were of mixed race, taller than most Chinese and did not have the bound feet that were still the norm in Chinese society. Considered unsuitable as "first wives," their only recourse was to enter arranged marriages with widowers and become much less prestigious "second wives." Elizabeth married a widower and moved to

Hawaii. Lena ran up debts that forced her into what was essentially slavery. Although family members purchased her release in 1948, she never returned to the country of her birth.[108]

Sometime in the 1920s, Cecilia returned to the United States. She worked in her father's restaurant and then left Tempe in 1935 for San Francisco's Chinatown where she married and assisted her husband with his business affairs. Upon his death, she went back to work before retiring in 1948. By 1930, Dora had also returned and worked as a server in the Phoenix area. She made her way to San Francisco, where she married. Their older sister Elizabeth visited occasionally from Hawaii. Dora died in 1975. Cecilia passed away in 1980, and Elizabeth, the last surviving Holland child, died in 1983.[109]

Jacob Waltz (Contributing Author Donna Carr)

One of the most intriguing and enduring legends of the old West is the mystery of the Lost Dutchman Mine. Over the decades, many books and articles have been written and tales told about a rich gold mine located in the Superstition Mountains east of Phoenix, so much so that it is difficult to separate fact from fiction and pure speculation. Despite many attempts, the mine, if it exists, has yet to be discovered or revealed, yet the legend persists.

The legend started with Jacob Waltz, the "Old Dutchman," who got the nickname from the American term for Germans, or Deutschmen. He was born around 1810 near Wurttemberg, Germany. It is believed he immigrated to the United States in November 1839 and arrived in New Orleans.[110]

What Waltz was doing between 1839 and 1848 is a matter of conjecture, as no documentary evidence of his whereabouts has been found. Some believe he spent time in the gold fields of North Carolina and Georgia learning the miner's trade. It is known, however, that Waltz was in Natchez, Mississippi, when he filed his letter of intent to become a U.S. citizen on November 12, 1848. It seems likely news of the California gold rush drew him west the following year.[111]

Waltz may have spent the next decade panning for gold in California. The 1860 federal census shows a Jacob *Walls*, age fifty, living in the camp of one Ruben Blakney on the banks of the San Gabriel River in Los Angeles County, California. Since he became a naturalized citizen in Los Angeles on July 19, 1861, this could well have been Waltz.

With the outbreak of the Civil War in the East, there was an increase in travel from California east through Arizona. Waltz may have joined one of those parties, as the first territorial census of Arizona, taken in 1864, places him in the Prescott area. Historian Tom Kollenborn writes that Waltz was actively mining in the Bradshaw Mountains between 1863 and 1868. In 1868, he moved to the Salt River Valley.[112] That this is "our" Jacob Waltz is attested to by the fact that the same man who was naturalized in Los Angeles appears in many Arizona government documents.[113]

With his move to the Salt River Valley, Waltz seems to have changed the focus of his prospecting trips to the Superstition Mountains east of Phoenix. Stories were told of Waltz showing up at Phoenix saloons with enough gold to buy rounds of drinks. When drunk, he claimed that the gold came from the Superstition Mountains. Some believed Waltz about the rich mine in the Superstitions. Other researchers have remarked that there was another source of gold close to Phoenix—the fabulously rich Vulture Mine near Wickenburg. Could Waltz have been taking ore from the Vulture Mine while leading everyone to believe that the gold came from the Superstitions? If Waltz *had* found gold in the Superstitions, his lifestyle certainly did not reflect it. He was recorded in the 1880 federal census as a farmer living in Phoenix, Arizona. By then seventy years old, he was eking out a living raising cattle and chickens.

Around 1885, Julia Thomas arrived in Phoenix. Mrs. Thomas, who had worked for a German family in Louisiana, spoke German. It is said she struck up a friendship with Waltz, and he advanced her the money to open an ice cream parlor and bakery. Their business arrangement included regular deliveries of milk and eggs from Waltz's farm.[114]

When the Salt River flooded in February 1891, the entire area from the river to downtown Phoenix was inundated. To escape the rising water, Waltz climbed a tree on his property. Though rescued a day later, he developed pneumonia and never fully recovered. Thomas cared for him in a room at the back of her business establishment, but Waltz died on October 25, 1891, at the age of about eighty-one. Although a box containing about forty-eight pounds of high-grade gold nuggets worth about $4,000 (over $105,000 in today's currency) was reportedly found under Waltz's bed, his obituary, published the following day, makes no mention of any mineral wealth.[115] An old man without family, he was buried in the far southwest corner of the Loosley Cemetery.

There is little doubt that Waltz told Julia Thomas about the existence of a secret gold mine in the Superstitions, for she and her friends Rhinehart and

Herman Petrasch began searching for it almost immediately upon Waltz's death. All else about the mine, however, is conjecture. After several weeks in the rugged mountains, Thomas and the Petrasches returned to Phoenix empty-handed and broke. Although Julia Thomas never found the fabled mine, she did make a certain amount of money selling maps she said were based on details related to her by Waltz.

So how did the legend of the Lost Dutchman Mine begin? Julia Thomas may have sold the story to P.C. Bicknell, who published it in the *San Francisco Chronicle* on January 13, 1895. Some historians attribute the legend's origin to this article.[116]

Several adventurous people set off to find the mine. After a few years and with no known discoveries, however, interest in the mine waned until 1931, when an amateur sleuth named Adolph Ruth became interested in the legend and went looking for the mine. He did not return, and later that year, his skull was discovered with two bullet holes in it. The national wire services picked up the story, and interest in the mine revived. In 1934, the Phoenix Dons Club (now the Dons of Arizona) began a series of annual treks into

The Lost Dutchman Monument in the Loosley Cemetery built with stones from the Superstition Mountains. *Photograph by Derek Horn.*

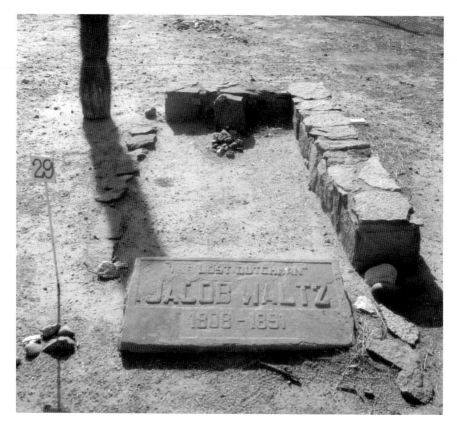

Jacob Waltz's grave site. *Photograph by Derek Horn.*

the Superstition Mountains to commemorate the legend of the mine. They constructed the Lost Dutchman Monument in Apache Junction in 1938.

The Lost Dutchman Mine and the idea of a fortune in lost gold waiting to be found still intrigues today, but the only person who knew the real story rests at peace in the Loosley Cemetery.

Ong Sing Yuen (Contributing Author Donna Carr)

In the middle of the Loosley Cemetery stands a solitary marble headstone bearing an inscription in Chinese. It is testimony to the fact that, for a brief time, Chinese immigrants made up nearly 10 percent of the population of early Phoenix. Some were railroad workers who had been laid off

Ong Sing Yuen's headstone.
Photograph by Derek Horn.

after construction on local rail lines was completed. Others came because the political climate for Chinese was better in sparsely populated Arizona than it was in the gold-mining towns of California and Nevada. They worked in small, family-run businesses such as restaurants, grocery stores, hand laundries and vegetable farms.[117] Although many of Phoenix's early Chinese residents eventually returned to China, about fifty were buried in the PMMP.

In 1993, archaeologist K.J. Schroeder asked William Tang, an associate professor at Arizona State University, to translate the inscription on the marble headstone. Tang, a Mandarin speaker from northern China, translated it as that of Tang Xian Yuan, born in Canton province, Hoiping district, Da Lou village.[118]

Years later, PCA researchers discovered the death certificate of Ong Sing Yuen, age about fifty-one, who died on June 8, 1913, and was buried in the Loosley Cemetery. Since the man buried in Loosley had been born in Hoiping, he would almost certainly have been a speaker of Cantonese, and "Ong Sing Yuen" is, in fact, the Cantonese equivalent of the Mandarin "Tang Xian Yuan."

At the time of his death from esophageal cancer, Ong was a merchant living at 529 South Seventh Avenue. Although opium smoking was listed as a contributory cause of death, it is probable that Ong was simply using opium to dull the pain of the malignancy that was taking his life.

In 1997, K.C. Tang of Phoenix produced a family tree that identified Ong Sing Yuen as a collateral relative of Tang Shing.[119] It is even possible that Ong Sing Yuen invited Tang Shing to Phoenix to take over his business when his health began to fail. Tang Shing became one of Phoenix's foremost Chinese American businessmen. In 1929, he built the Sun Mercantile Building in downtown Phoenix. He and his wife, Lucy Sing, were the parents of eleven children, including Father Emery Tang and Judge Thomas Tang.

The present-day Ong family, also prominent Phoenicians, has since revived its practice of honoring Ong Sing Yuen as one of its family members with a short ceremony on Ching Ming, a Chinese holiday that occurs in early April.

EARLY PROFESSIONALS AND ARTISTS

James M. Creighton (Contributing Author Derek Horn)

While James Creighton is not buried in the PMMP, he has two very important connections to it: Smurthwaite House and the grave of his young son. Born in 1856 in New Brunswick, Canada, Creighton moved in 1879 to Denver, where he apprenticed to a building contractor and studied architecture at night. He soon moved to Tombstone and Tucson, where he worked on some of the first buildings at Fort Huachuca. In 1882, he moved to Phoenix.

Unable to win the bid to construct the first Maricopa County Courthouse in Phoenix, he partnered with Samuel Patton, the successful bidder, and formed the firm Patton and Creighton about 1884. Creighton concentrated on design, and the partnership produced two important early Phoenix buildings: the Fry Building at 146 East Washington Street (now Majerle's Sports Grill) and the first building (now demolished) of the Insane Asylum of Arizona (now Arizona State Hospital) at 2500 East Van Buren Street.

The partnership lasted until 1887, when Creighton began to practice on his own. For the next several years, he designed some of Phoenix's most significant buildings, including the first Phoenix City Hall, on the south side of Washington Street between First and Second Streets, and the Osborn School at the northeast corner of Central Avenue and Osborn Road. In the early 1890s, he designed several buildings at the new Phoenix Indian School at the northeast corner of Central Avenue and Indian School Road. All these buildings were eventually demolished.

As his career progressed, he designed other significant buildings in Phoenix and nearby communities. In partnership with Denslow Millard, he designed the original Adams Hotel, located at the northeast corner of Central Avenue and Adams Street, in 1896. The hotel burned down in a spectacular fire in 1910. He also designed the Phoenix Carnegie Public Library located in Library Park on the south side of Washington Street between Tenth and

Twelfth Streets in 1906. Located just northeast of the PMMP, it is now part of the Arizona State Library.

In 1897, his firm designed a house for Dr. Darius and Mary Purman at the northwest corner of Seventh and Fillmore Streets. Intended as a boardinghouse, it was purchased by Trustim and Anne Connell. Their daughter Caroline Smurthwaite inherited the house in 1938, and it became her home, along with that of her daughter Carolann.

Tragedy struck the Creighton family in 1906. In February of that year, their eleven-year-old son James M. Creighton Jr. contracted diphtheria. Out of concern for spreading the disease, the Creighton house was quarantined and the school that the Creighton children attended was closed temporarily. James succumbed on February 12 and was buried in the Masons Cemetery.

Creighton continued to practice architecture well into the twentieth century. He partnered with Henry Trost to form Trost and Creighton in 1907 and designed the President's House at Arizona State University.

Creighton maintained an office until he was about seventy, but as his practice slowed down, he remained active in the community. A founding member of the First Presbyterian Church in Phoenix, he taught classes at the Phoenix Indian School, promoted missionary work and was the superintendent of the Railroad Mission in South Phoenix. Creighton became an American citizen in 1922 and traveled extensively in retirement until his death in Phoenix in 1946. In 1994, the Smurthwaite House was moved from its original location on Seventh Street to the PMMP, where it is now a visitors' and research center.

Czar J. Dyer (Contributing Author Mark Lamm)

Although he was an authentic Arizona pioneer, the gentleman with an unusual first name, Czar, was born in Jackson, Michigan, on February 2, 1846. At the age of eighteen, Dyer enlisted in the United States Navy. He served during the Civil War from August 1864 to July 1865 as a powder monkey on board a gunboat. Upon discharge, he received a small pension because of an injury to his eyes. After his year in the Union navy, Dyer eventually moved to California. The federal census of 1880 has C.J. Dyer residing in Oakland. He listed his age as thirty-one and occupation as artist.

The booming mining industry near Prescott, Arizona, captured his attention, and a few years later, he moved there, where he practiced his profession as an artist and cartographer. The July 4, 1884 edition of the

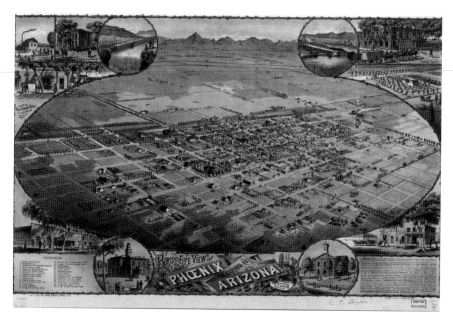

C.J. Dyer's painting of Phoenix in 1885. The view looks to the northeast. *PCA files*.

Weekly Arizona Miner mentions Dyer's "beautiful picture of Prescott" and contains an advertisement by Dyer marketing sketches, drawings and lithographs for reasonable rates and satisfaction guaranteed. In 1885, Dyer completed a painting titled *Bird's Eye View of Phoenix, Maricopa Co. Arizona*, an aerial perspective of the city viewed from the southwest to the northeast.

It is not known exactly when Dyer came to Phoenix, but an early reference to him as a city resident occurs in mid-1890. A personable fellow, "C.J.," as he was popularly known, quickly established himself in the community and became involved in local commerce and government affairs. He was active in Republican Party politics and avidly collected Native American artifacts from the various Hohokam village ruins and digs throughout the Salt River Valley.[120]

Despite his affability and profile in the Phoenix community, Dyer did experience occasional difficulties, such as obtaining payment for his mapping commissions or issues with other individuals. On April 24, 1893, H.C. King, a local electrician, filed a complaint against Dyer, alleging he was insane and dangerous. A warrant was issued for Dyer's arrest so he could be examined by the Maricopa County probate court judge for insanity and confinement to the Insane Asylum of Arizona in Phoenix.[121] It is

Dyer's headstone with the incorrect middle initial. *Photograph by Derek Horn.*

unknown what generated this action—perhaps a quarrel or misunderstanding. The record does not indicate Dyer was declared insane or served any time in the asylum. Indeed, three months after this matter, the July 30, 1893 edition of the *Arizona Republican* reported that Dyer went to the aid of an Indian who was robbed near Dyer's home.

These issues did not diminish Dyer's stature in the community. He became a Phoenix city councilman during the late 1890s and served into the early 1900s. He functioned as interim mayor from January through April 1899 and as acting mayor in July 1900. The April 5, 1901 edition of the *Arizona Republican* has this to say about Dyer's popularity: "C.J. Dyer is a mighty popular man in his ward. He is a looloo as a vote getter."

Even though he was deeply involved in both the political and business communities, no photograph, sketch or likeness of him has been found. He is the only Phoenix mayor for whom no known image exists. Dyer also never married and is not known to have fathered any children. He had his office and home in a small run-down adobe building at 27 East Van Buren Street.

Dyer's health began to fail in the early 1900s. In March 1903, he was hospitalized and died of paresis on March 28 at the age of fifty-two. Those in the community turned out en masse and honored their friend with an elaborate funeral. According to the March 31, 1903 edition of the *Arizona Daily Gazette*:

> *The civic bodies of Phoenix united with the citizens in doing honor to the late Czar J. Dyer at his funeral services yesterday. The fire department, of which he has for many years been an honorary member, the city officials, the G.A.R., and hundreds of citizens joined in the long funeral cortege of the man who in his long life in the city, had made many friends and no enemies.... The casket was well night [sic] with floral tributes, people from all stations in life having contributed to the weath [sic] of flowers—tokens of the esteem in which Mr. Dyer was held.*

C.J. Dyer is buried in the Rosedale Cemetery. The grave marker is a standard military marble stone sculpted in relief but, incorrectly, with an "A" for Dyer's middle initial.

Scott Helm (Contributing Author Donna Carr)

Dr. Scott Helm, for five years the surgeon general of territorial Arizona, had a brilliant career but died tragically young. He was born about 1862 in Kentucky and was a graduate of Princeton College, Rush Medical College in Chicago and Heidelberg University in Germany. After serving for several years in the Marine Hospital Service, Helm moved to Chicago, where he began a successful practice.

In 1887, Helm nicked his hand during surgery and contracted blood poisoning. He was very ill by the time he traveled to Arizona in 1888 in hopes of regaining his health in the desert air. A special train had to be chartered to take him on the last leg of his journey to Phoenix.

Helm did recover and quickly became known as one of the best educated and most respected physicians in Arizona. He set up his office and residence on the east side of Second Street south of Washington Street. In 1891, he joined the National Guard of Arizona and was appointed the territory's first surgeon general, with the rank of colonel. During that time, he tirelessly promoted Arizona in medical journals as a destination for sufferers of tuberculosis, arthritis and other ailments. He became active in several fraternal organizations. In 1889, he met Norma Jackson, who had come to Arizona from Washington, D.C., for her health. They were married on February 12, 1890.

The year 1891 proved very hard on Helm. In February, the Helms celebrated their first wedding anniversary. Unfortunately, it was also their last. Norma died on April 30 at the age of twenty-eight and was buried in Porter Cemetery. Later that year, in July, Alice White, the granddaughter of Ira Stroud, a prominent Phoenix businessman, died of septicemia following a botched abortion. Helm was arrested and accused of both performing the abortion on Alice and being responsible for her death. The case caused a sensation in the community, and verbatim testimony from the coroner's inquest became front-page news. Emotions ran high, and there was saloon talk—never acted upon—of lynching Helm. In court testimony, much was made of a professional rivalry between Helm and Dr. H.A. Hughes, who treated Alice when she became ill after her abortion. During the inquest, one

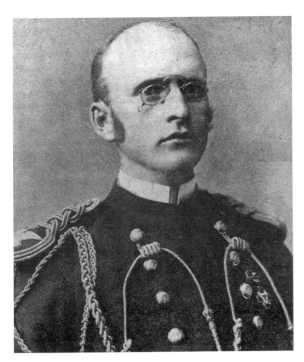

Left: Dr. Scott Helm. *Courtesy Arizona State Libraries, Archives and Public Records, History and Archives Division, Phoenix, No. 97-8764.*

Below: Scott Helm's prominent headstone with his first wife Norma's much smaller marker on its left. *Photograph by Derek Horn.*

defense attorney even accused Hughes of deliberately withholding treatment from Alice so Helm would be implicated in murder. The grand jury indicted Helm for Alice's murder in November 1891. The case went to trial, but in March 1892, Helm was acquitted of any wrongdoing.

The notoriety and trials of the murder case did not diminish Helm's profile in the community. In 1892, he married Jane Beeler of Louisville, Kentucky. Helm's practice flourished, and he became active in Republican Party politics. In May 1894, the Phoenix City Council appointed him the city's health commissioner. He promptly turned down the appointment because of his busy practice and the paltry twenty-five-dollars-per-month compensation. Despite refusing the position, he deplored the state of sanitation in the town and advised the council that the many cesspools should be filled in and the horse corrals should be closed. In March 1895, Helm became the surgeon in chief for the Santa Fe, Phoenix and Prescott Railroad and was also put in charge of the new Sisters of Charity hospital, the forerunner of St. Joseph's Hospital.

The busy practice and Helm's other community activities must have taken their toll. In April 1896, at thirty-four years old, he obtained a disability certificate and resigned his post of surgeon general, complaining of "old soldiers infirmities."[122]

Helm loved horses, but he told friends that he would probably meet his death in a horse-related accident. His premonition came true on October 8, 1897. He was at the train station in downtown Phoenix when his horse reared and fell, throwing Helm to the pavement and causing a fatal head injury. He died two hours later of intracranial bleeding. Helm's funeral was attended by many Phoenix residents and members of fraternal organizations. He was buried in Porter Cemetery next to his first wife, Norma. An impressive obelisk of polished red granite marks his grave.

TRAGIC AND MYSTERIOUS ENDS

The Mysterious Death of Wong Fong (Contributing Author Donna Carr)

Around 1909, young Wong Fong left his village in China and moved to Arizona. Originally, he settled in Globe, converted to Christianity and joined the Lutheran church. Early in 1913, he moved to Phoenix to work in a barbershop belonging to a cousin, Wong Fie.

Wong Fie, age about fifty, had a beautiful young wife named Quock Young whom he had acquired through a Chinese marriage broker based in Tucson. Since Wong Fong slept on the screened porch of his cousin's home at 220 East Madison Street and shared their meals, he became acquainted with Quock Young. They fell in love.

Chinese women of any age were very rare in the Old West, and men who were both fortunate and wealthy enough to obtain wives guarded them jealously. Imagine Wong Fie's feelings when, one day in February 1914, his wife gave him some papers written in Chinese, as well as a couple of coins, including one broken in half. Since Wong Fie could not read the Chinese characters, he took the papers to a friend who read them to him. He discovered that Quock Young did not want to live with him anymore and was asking for a divorce.

Quock Young was no ordinary Chinese woman. She had been a resident of Miss Donaldina Cameron's Presbyterian Rescue Mission in San Francisco. Miss Cameron is well known in history for rescuing hundreds of young Chinese girls from San Francisco brothels and bringing them up as Christian young ladies. Girls in her charge learned to speak, read and write English, cook and sew and manage a household. Because of these accomplishments, they were much sought after by Chinese bachelors throughout the American West. That Quock Young even knew that such a thing as divorce was possible was undoubtedly due to her time spent at the mission.

Wong Fie may have suspected his young wife preferred the company of another. He withdrew $1,000 from his Valley Bank account and took a train out of town, supposedly to consult with the broker who had arranged his marriage.

Fearing for his life, Wong Fong absented himself from the barbershop and went into hiding. As a precaution, he even wrote a message to his friend, Lutheran minister Reverend Immanuel Frey, that read, "When I am killed, have Wong Fie arrested!"

Between midnight and 1:00 a.m. on the morning of February 13, 1914, Wong Fong's body was discovered on the porch where he usually slept. He was dead from a gunshot wound to the head. On the floor beside him was a pistol with one spent bullet. Suicide? Maybe not. Policeman John McGrath, who investigated the incident, found several cartridges on the ground just outside the porch, as well as a screwdriver used to force the door. Not knowing who might have committed the crime, the police arrested both Wong Fie and Quock Young.

At first, Quock Young spun a fanciful tale about having been engaged to Wong Fong years ago before meeting and marrying Wong Fie. They had been separated but had found each other again in Arizona. She claimed she and her lover had made a pact to kill themselves if Wong Fie refused to grant her a divorce. Initially, she maintained that Wong Fong must have carried out his part of the bargain and committed suicide. The police, however, discounted this theory. From the angle of the bullet, it would have been very difficult for Wong Fong to have shot himself. The physical evidence pointed to someone entering the room and murdering him as he slept.

Upon hearing this, Quock Young revealed her husband had withdrawn $1,000 from his bank account and may have left town to hire someone to eliminate his rival. Wong Fie, for his part, insisted he had been on a legitimate business trip. Returning to Phoenix very late on February 12, he went directly to a friend's house, arriving at about 11:40 p.m. He, therefore, could not be the murderer because he was with his friend at the exact time of Wong Fong's death.

Since all the evidence was circumstantial and Wong Fie's friend had provided him with an alibi, the police declined to charge either Wong Fie or Quock Young, and they were released. The police then immediately rearrested Quock Young and charged her with entering the country illegally. She was taken to Tucson to face deportation proceedings.

No matter the outcome of the affair, Quock Young knew she could no longer remain in Arizona. She made a telephone call to Donaldina Cameron and described her plight, and Miss Cameron went to Tucson at once to identify and assist her former student. In her opinion, it was highly unlikely that Quock Young and Wong Fong had ever been engaged, as they would have been mere teenagers at the time. Nevertheless, she took Quock Young back to San Francisco with her.

Wong Fie paid Quock Young's bail while her case made its way through the courts. It was alleged in the hearings that she had married a Chinese American citizen in Hong Kong, gained admission to the United States and then quickly left him to engage in prostitution. She must have made her way to Miss Cameron's establishment before marrying Wong Fie in 1912. She was either deported or returned to China voluntarily. In April 1915, Wong Fie filed for divorce on the grounds that his wife had deserted him.

After the coroner's inquest was inconclusive on the question of suicide or murder, Wong Fong's body was laid to rest on March 10 in the Chinese section of the Loosley Cemetery. His murder was never solved.

Thomas Graham (Contributing Author Val Wilson)

Thomas Graham, a young Arizona rancher, became a major player and final victim in one of the most infamous feuds of the Old West: the Pleasant Valley War. The son of Samuel and Jane Graham, he was born in Boone County, Iowa, in 1854. Graham left home in the 1870s and went to Arizona with his brother John in the early 1880s. They met Ed Tewksbury, a rancher in Pleasant Valley northeast of Phoenix. Tewksbury invited the Grahams to Pleasant Valley to start their ranch, and for a while, the families were friends and business partners.[123]

During this time, another rancher named Jim Stinson also lived in Pleasant Valley. He acquired cattle and established his ranch there around 1880.[124] In 1883, Stinson's large ranch started to encroach on the ranches of the Tewksburys and Grahams, and he started accusing both families of rustling his cattle. Tempers escalated when John Gilliland, a cowboy from Stinson's ranch, went with several other Stinson hands to the Tewksbury cabin to arrest them for cattle rustling. The Grahams were also present at the cabin that day. The Tewksburys fought the cowboys, and Gilliland was wounded.

In 1884, Stinson proposed a deal to the Grahams. If they turned in evidence against the Tewksburys, he would pay them in cattle and make sure they never went to jail for the cattle rustling. The Grahams took the deal. Stinson then filed a complaint with the district attorney, but the case was thrown out due to lack of evidence.[125]

The incident started a bloody feud between the Tewksburys and Grahams that lasted for years and nearly wiped out both families. There were many mysterious deaths and shootings, killing family members on both sides, as well as some of their friends and business acquaintances. By the time 1892 rolled around, Tom Graham and Ed Tewksbury were the only ones left. That year would mark the final blow.

Tom Graham left Pleasant Valley in the late 1880s and moved to Tempe. He maintained his interests in his ranch but decided to start a new life. He married Annie Melton on October 8, 1887, and established a business. They had two children, Arvilla and Estella. Arvilla died shortly before her first birthday in 1888.

On August 2, 1892, while Graham drove a wagon loaded with goods past the Double Butte schoolhouse near Broadway Road and Priest Drive in Tempe, two assassins shot him in the back. Conscious throughout the whole ordeal, Graham was able to make a statement identifying his killers. He claimed that he heard horses riding up behind him, and when he turned

to see who it was, he saw the faces of Ed Tewksbury and John Rhodes, Tewksbury's brother-in-law. They then shot him in the back. Unarmed and paralyzed from the wound, Graham lay defenseless as Tewksbury rode up and aimed his gun at the dying man to finish him off. He and Rhodes, however, instead rode away into a thicket on the side of the road. Graham died a few hours later and was buried in the Workmen Cemetery.[126]

Rhodes was quickly arrested. During his preliminary examination, Annie Graham, Tom's widow, walked up to him in the courtroom, put the muzzle of a pistol against his back and pulled the trigger. The hammer caught in the cloth of her purse, however, and the gun did not fire. Disarmed, Annie was removed from the court by family members while begging them to let her shoot.[127]

It took longer to capture Tewksbury. Located by the Pima County sheriff, he was taken to Tucson and held there, possibly to avoid mob action against him.[128] On August 16, the Maricopa County sheriff boarded a train with Tewksbury to take him to Phoenix for trial. At a prearranged location south of Tempe, the train slowed, and Tewksbury was dropped off the train and into the custody of lawman Henry Garfias, who slipped him into a Phoenix jail.[129]

It was Tewksbury who was tried for the murder after Rhodes successfully produced an alibi. At least one hundred witnesses were called during the entire ordeal. The trial drew many interested spectators, sympathetic and hostile alike. At his first trial, Tewksbury was granted a new one because of a legal technicality. During his second trial, the case was dismissed because of a hung jury. Tewksbury was released and died in 1904 in Globe of natural causes.

Rose Gregory (Contributing Author Patricia Gault)

Remembered today as the "benevolent madam," Rose Gregory was one of Phoenix's more colorful pioneers and known for her many charitable deeds. She was born in England and arrived in the United States in 1870 with her extended family as part of the Mormon migration to the Territory of Utah.[130] They settled in Salt Lake City, and Rose bore a daughter about 1871. Three years later, Rose took her daughter to California to be educated. She then left her daughter with her sister and headed for Arizona, although she returned to California on occasion to see her child.[131] Prior to leaving California, Rose began using the name Minnie Powers. It is unknown if

this was her married name or a name adopted to conceal her identify and protect her family in California.

In May 1879, Rose, as Minnie, boarded a train headed for Maricopa, Arizona. She was part of a larger group of passengers that were going to Maricopa to buy land and establish businesses. It does not appear, however, that Rose's purpose for going to Maricopa was to buy property. Almost immediately, she headed to the bustling and often rowdy town of Tucson, a place that probably offered more opportunity for a single woman.

By 1880, Rose was living with two other women on Cemetery Street in Tucson. On the census, she listed her occupation as "housekeeper," while the other two women were "courtesans." Although Rose was living north of what was considered the red-light district of the time, the fact that the two ladies living with her were described as courtesans suggests that the women catered to wealthier men. Courtesans were typically more sophisticated, beautiful and accomplished than the average prostitute.[132]

Rose first appeared in Phoenix in 1886 when she opened a business on the southwest corner of Van Buren and First Streets. She was described as a beautiful and kindhearted woman who often took care of the less fortunate, sometimes giving away large sums of money. Possibly some of the unfortunate women she rescued became habitués of her lodging house.

Rose's business brought her to the attention of law enforcement officials more than once. In 1893, some of her female "employees" were arrested for riding their horses astride on Van Buren Street while clad only in their "Mother Hubbards."[133] Women riding astride in that time was considered very immoral. They were each fined $1.00 "for the disgrace heaped upon the horses they rode" and another $5.35 for the "wear and tear on Van Buren Street."[134]

The tragic death of Letitia Rice, a resident of Rose's establishment, on May 20, 1893, also brought unwanted attention to Rose's operation. It soon became apparent to the citizenry that Rose was operating a brothel in the heart of town, and her neighbors were not pleased. Increased pressure from the community as well as a sheriff's sale of her establishment forced Rose to temporarily relocate.[135]

Undaunted, by March 1895, Rose had moved back into the property on First and Van Buren Streets, taken over the business and renamed it Louvre Gardens. Although she described her establishment as having a garden room where guests could relax, others objected to "the noisy hilarity and beer-inspired jollity which floats from the windows, doors and gateways of the Louvre to the annoyance of the neighbors." Once again, the sheriff charged

Rose with operating a brothel, but she was cleared because no witnesses could be found who were willing to testify to that fact.[136]

By 1896, community pressure once more forced Rose to move, this time to 720 East Jackson Street at the edge of town, where she opened the Villa Road House Saloon. In the past, Rose's establishments were elegantly furnished and the girls relatively genteel, but by this time, at age forty-two, Rose was in much reduced circumstances and in a downward spiral. She sealed her fate when she hired William Belcher as her barkeeper.

William "The Cockney" Belcher was a watchmaker in Missoula, Montana. His fondness for alcohol, however, caused his steady decline, and he eventually wound up in Phoenix. Upon the death of his mother, he came into some money but spent most of it on drink. Rose offered him a job and financial advice, and she soon became his mistress.

Their relationship was turbulent. Belcher was violently jealous and was occasionally arrested for drunken outbursts. When he was in jail, Rose would entertain other male visitors, and William would threaten to kill her. On the morning of September 17, 1898, Belcher was released from jail and stopped at McNamara's Saloon to have a few drinks for breakfast. After obtaining a .44-caliber pistol, he went over to the Villa Road House Saloon, where, finding Rose asleep in bed, he shot her twice. He then turned the gun on himself, falling across Rose on the bed. The bodies were discovered later that day.[137]

While Rose's will stipulated that she wanted to be buried in Oakland, California, near her family, her assets and debts turned out to be about

Rose Gregory's headstone. Note the coins and medallion left by visitors. *Photograph by Derek Horn.*

equal, with nothing much left over for an out-of-state burial. So Rose was buried in Rosedale Cemetery in Phoenix. The plot cost a mere ten dollars, but her casket was lined with copper and had silver-plated handles. The words "At Rest" were inscribed on a plate attached to the lid.[138] Her grave went unmarked for many years, but a wrought-iron cross now adorns it, and her grave is one of the most popular for visitors.

John T. McCarty (Contributing Authors Vivia Strang and Derek Horn)

On June 6, 1901, John McCarty, the Arizona game and fish commissioner, set off from his remote camp near Clear Creek on the Mogollon Rim to hunt for some rare pigeons and squirrels. He was never seen alive again. A few weeks later, a body was discovered and identified as McCarty's, but was it really his?

Little is known about McCarty's past. Census records indicate he was born in 1855 in Scott, Virginia, to James and Mary McCarty. By 1880, he was living in Globe as a laborer. About 1890, he became a professional hunter and took on J.K. Day as his business partner. For the next ten years, the territory's newspapers related his adventures as he roamed the state hunting bears, mountain lions, lynx and other game. He would turn in skins of the animals he shot for bounty payments by county governments. One time in October 1893, he turned in enough animal skins to Coconino County to receive a bounty of $160, worth over $4,000 in today's currency. He also collected specimens for museums and universities, both as a hunter and as an agent. Because of his knowledge of the territory and its wildlife, in the fall of 1898, he became its game and fish commissioner.

On April 15, 1900, he married Lillie Sparks, the young granddaughter of Peter and Susan Cosgray, who had a ranch near Florence. When McCarty set off on his last hunting trip, he left his wife, pregnant with their first child, with her grandparents. Shortly before he departed, he took out six separate life insurance policies that totaled $27,000, nearly $750,000 in today's currency.[139]

When McCarty did not return to camp, his companions began searching for him, believing he may have lost his way or been injured. On August 19, searchers discovered a body, about seven miles from the campsite, thought to be McCarty's. The August 28, 1901 *Arizona Weekly Journal Miner* reported the discovery:

The circumstances and conditions led the searchers to the following conclusions: That McCarty had killed a bear…and it is believed he was on his way to camp when he encountered the second bear and the fight to the death occurred. It is supposed that he shot at the second bear, failing to kill it, and that his gun exploded, as it was found laying by his side, the barrel burst about two feet from the breech. Both of his legs were broken below the knees, and his clothes were torn to shreds, which, the searchers believed were indications of a terrible struggle between an enraged bear and an unarmed and defenseless human being.

Mutilated and badly decomposed, the body was transported to Flagstaff for a coroner's inquest, identification and examination by physicians and attorneys representing Lillie and some of the insurance companies. With the widow and friends satisfied that the body was indeed McCarty's, it was transported to Phoenix and buried in the Masonic Cemetery.

Suspecting fraud, the insurance companies refused to honor their policies, and Lillie's grandmother, representing her underage granddaughter, sued for payment. The trial began on April 13, 1903, in Flagstaff. Attorneys for the insurance companies were certain McCarty was still alive, maybe in Mexico or British Columbia. It was alleged that the body in McCarty's grave was one stolen from a Phoenix graveyard a few days before he left on his last trip. The defendants promised to produce McCarty alive in court. They never did, and the insurance claims were eventually paid.

Rumors persisted for years that McCarty was still alive. Was his insurance-buying spree shortly before his final hunt part of an elaborate and successful fraud? Or, since he was engaged in a dangerous profession, could it be he was making provision for his young wife and unborn child? The debate continues to this day.

Jay Miller (Contributing Authors Diane Sumrall and Derek Horn)

In the Knights of Pythias Cemetery lies a headstone inscribed "In Adoring Memory of Jay." It is not a typical grave marker but a large granite boulder with the inscription barely visible. For many years, members of the PCA examined the stone and searched the records for some clue as to who "Jay" was. There were several candidates: J. Roe Young, an eleven-year-old boy who was killed in a train accident in 1896; his brother John, who died in a mining accident in 1899; and J.H. Miller, who died of a gunshot in 1895.

Through some detective work and a stroke of luck, PCA member Diane Sumrall unearthed the story behind the mysterious headstone.[140]

At the time of his death in 1895, Jay H. Miller had lived in the Phoenix area for about eight years. Little is known of Miller's life before he moved to Arizona. He was born in California about 1865. His mother was Susan Sawyer Miller. No information on his father has been located other than his birthplace was Tennessee. According to the 1870 census, Susan, a seamstress, and her son lived in California. By 1880, Susan was living with her husband, John Hayes, and teenage son in Sacramento.[141]

Miller moved about 1887 to Phoenix, where he began work at the newly established Maricopa and Phoenix Railroad. In February 1891, the free-flowing Salt and Gila Rivers flooded severely. The tracks of the Maricopa and Phoenix Railroad, the city's connection to the Southern Pacific transcontinental rail line at Maricopa, were damaged, and rail access to the city was halted for repairs. Freight and passenger service transportation reverted to the days of mule teams and stagecoaches. Miller went to Maricopa to assist in moving freight between Maricopa and Phoenix.

Miller continued his service with the railroad into the 1890s and eventually became its commercial agent. About 1892, he acquired a large lot at the southeast corner of Seventh and Pierce Streets. He hired C.J. Dyer to create a plat and subdivided the lot into ten individual smaller residential lots. By 1895, the growing Phoenix Street Railway system had expanded along Pierce Street in front of Miller's property and must have increased its value and potential for development.

On September 7, 1895, Miller's life came to a sudden and tragic end. That evening, he spent some time drinking in a saloon near his workplace at the northwest corner of Central Avenue and Washington Street. About 10:00 p.m., in the alley behind his office, he was shot in the head. Was it murder or suicide? A man was arrested for the killing and a coroner's jury summoned. The *Arizona Republican* reported the trial in ghastly detail. The jury took testimony from nearly fifty individuals who testified about Miller's activities that night, the nature of his wounds and possible attempts at or threats of suicide in the past. After several days of work, the jury was unable to reach a verdict as to who fired the gun, Miller or an unknown murderer. Later that year, a grand jury was also unable to establish blame or indict someone for the shooting. The case remains unsolved.

Miller was buried in the Knights of Pythias Cemetery. He died intestate, and his mother became his sole heir. Likely it was she who had the unusual headstone placed on his grave. Over the years, records of many burials did

Two views of Jay Miller's headstone that show the whole inscription. *Photographs by Derek Horn.*

not survive, and information about who was buried under the stone was lost. The mystery intrigued PCA member Diane Sumrall, and she began her search for an answer. She found the aforementioned candidates but could not pinpoint a specific person. Then on November 25, 2006, as she was cleaning trash in the cemetery and telling a friend about the mystery, she glanced at the stone as the sun was setting in the southeast sky. The light at that angle revealed another inscription on the underside of the stone that had been hidden from view. It read "H. Miller." The words carved into the stone, when put together, become "In Adoring Memory of Jay H. Miller." Mystery solved![142]

Leticia Rice (Contributing Authors Debe Branning and Donna Carr)

"Burned to a Crisp. The Sad End of a Sad Life" went the headline of an article in the *Arizona Daily Gazette* of May 21, 1893, that described the last hours and gruesome death of an unnamed "young woman" who met her end after a night out with friends. The young woman acquired a name in the May 23, 1893 edition of the *Arizona Republican* in a judgmental banner that read, "It can only be known that Tessie Murray's Awful Fate Came of Drunken Carelessness."

Tessie's real name is believed to be Letitia Rice, but she was also known as Blanche Russell and Mrs. C.W. Wright. Born on March 25, 1876, Letitia was already a "working girl" by the time she was seventeen. Little is known about her life, but by May 1893, she was a resident of the boardinghouse and saloon operated by Rose Gregory located at the corner of Van Buren and First Streets. Unlike at other boardinghouses in the Phoenix business district, its residents were young women exclusively, giving rise to community concerns that it was actually a brothel.

On the evening of Saturday, May 19, while Rose attended the theater, Letitia and another girl named Ruth Reed were entertaining two young gentleman callers named Hilier and Dowe. They all went out for drinks, returning inebriated after a wild buggy ride through the streets of Phoenix. Apparently, Letitia did not want her night out to end, for Hilier was obliged to carry her, kicking and protesting, into her room at the boardinghouse.[143]

According to the accounts at the time, Letitia was laid on the floor as Ruth started to ready the bed for her. It is unclear what happened next. Perhaps Letitia, struggling with her friends, knocked over a coal oil lamp that was sitting on a small stand beside her bed. Perhaps one of her three friends in

Letitia Rice's headstone. *Photograph by Derek Horn.*

the room accidentally hit the table with the lamp and it fell off. However it happened, after hitting the floor, the lamp broke, may have exploded and spilled burning coal oil over Letitia from head to knees. Ruth may also have been splashed with oil but was not injured.

As Letitia was engulfed in flames, "the brave young men, whose names were not obtained, ran out when the explosion occurred, probably desiring not to be found in that kind of house and did not return, though one of them sent around later to see how the girl was getting along."[144]

The other girls in the house quickly extinguished the flames by rolling Letitia in a rug. Others turned a hose on the fire and quickly dowsed it. Doctors were sent for, but Letitia died about 11:00 a.m. on Sunday from the shock of her burns. When it became known that she was about to be buried without a formal inquest, a coroner's jury was hastily convened. Dr. Scott Helm examined Letitia's remains and affirmed that death was due solely to her burns, not poison or any other injury. The witnesses, including the two young men, were questioned. The jury "believed there had been terrible drunken carelessness, but was unable to define it and accordingly returned a verdict of accidental death, without either implicating or excusing anyone."[145] Letitia was buried in the Loosley Cemetery, where she rests under a cream marble headstone atop a granite base. Considering her age and profession, her monument is an unusually fancy one. Maybe an unknown admirer paid for it, or perhaps her landlady and employer Rose Gregory did so.

RENEWAL, RECOGNITION AND PRESERVATION

THE FIRST PIONEERS' CEMETERY ASSOCIATION

By 1914, when the seven pioneer cemeteries were closed, they were in poor shape. They were still privately owned, and the owners no longer cared for them. Even though the city had forbidden burials within its limits in 1914, some interments continued in the cemeteries. John Loosley continued to sell lots in the Loosley Cemetery as late as 1917. Almost two hundred sets of remains, however, were disinterred and relocated. These included such notables as "Lord" Duppa, DeForest Porter, Charles Poston and John Y.T. Smith.

During the 1920s, the City of Phoenix improved the streets around the cemeteries and assessed their owners for the projects. The owners were likely still the original developers—Loosley, the fraternal societies, Lulu Porter and J.W. Walker—but they or their heirs evidently had abandoned or forgotten about their properties. In any case, the assessments were not paid, so between 1924 and 1930, the city acquired rights to the cemeteries through certificates of sale for the delinquent assessments, which totaled $28,897.23 with interest. Deeds were not issued, however, on these certificates until years later.[146]

Up to 1939, the cemeteries were in a serious state of neglect. No one tended or watered the landscape, and what was there went wild. The cemeteries were frequently vandalized and desecrated by grave robbing, vagrant camping and prostitution. Headstones were knocked down or stolen

Charles Poston's grave site (*left*) and Frank Poste's grave site (*right*) in the early 1900s show the condition of the cemeteries. *PCA files.*

to be used as flagstones and other decoration. Transients who camped out in the cemeteries likely used wooden headboards for campfires. Per City of Phoenix records, in the early 1930s, the city engineer investigated the idea of turning the cemeteries into a park. He did an inventory of the remains interred there and prepared some cost estimates for their relocation. The idea was not pursued.[147]

The Pioneers' Cemetery Association, or PCA, has its roots in the Arizona Pioneers Association. In 1920, Dwight Heard, publisher of the *Arizona Republican* newspaper, initiated an annual gathering of Arizona Pioneers and formed the Arizona Pioneers Association. The association gathered in Phoenix each April for a convention where pioneers, their families and

others would celebrate Arizona's past with stories, musical events and, of course, speeches. This event drew thousands each year and, with Heard as its patron and sponsor, was front-page news. After Heard's death in 1929, the annual conventions continued to be sponsored by the *Republican* (now the *Arizona Republic*).

Preservation and beautification of the seven cemeteries just west of downtown Phoenix interested the Pioneers Association during the 1930s. Many members had family buried there. By the late 1930s, the condition of the seven cemeteries generated a great deal of concern in the community. In 1936, association member Lin Orme began raising money and making plans for restoring the cemeteries. The Pioneers Association elected him its president in April 1939.

By 1939, Orme had accomplished a great deal. He was president of the Salt River Valley Water Users Association (now Salt River Project) and a past secretary and member of the Arizona State Board of Appeals. Well known and respected in the community, he had the passion and the

A 1930s view of the Rosedale Cemetery. Both the Loring and Wooldridge Vaults are visible. *Courtesy Arizona State Libraries, Archives and Public Records, History and Archives Division, Phoenix, No. 96-4233.*

connections to get things done. Ably assisted by Thomas Hayden, an engineer and chief surveyor at the Water Users Association, he set to work on restoring the old cemeteries.

Shortly after his election, Orme began discussions with city officials about what could be done. They discussed enclosing the cemeteries with a fence, installing irrigation, landscape and hiring a caretaker. One hundred palm trees were donated for the cemeteries. Most burial records had been either lost or destroyed many years before, so Hayden was given a year off from the Water Users Association to review old records and interview families and anyone else who had memories of the cemeteries. He reestablished the original corners and boundaries of the cemetery sites originally laid out by William Hancock, documented the surviving grave markers and reconstructed records of interments and their locations.[148]

Orme and Hayden formed the Pioneers' Cemetery Association. The list of organizers on the association stationery included members of many pioneer families, as well as community leaders. Charles and Abe Korrick, along with John Gardiner's widow, Laurabel, shared billing with banker Walter Bimson; Maie Bartlett Heard; Senator Carl Hayden; and businessman, future senator and presidential candidate Barry Goldwater.

The Pioneers Association and PCA enjoyed some initial success. Working in partnership with the City of Phoenix, by January 1940, they had installed a steel fence and oleander hedge around the southern cemeteries, and funds were available for a fence and hedge for the northern cemeteries. Trees and bushes were trimmed. The PCA brought in artisans to restore the headstones and petitioned Senator Hayden to assist in replacing the rotting headboards of Millard Raymond and Clarence Proctor with headstones furnished by the War Department. Momentum, however, stopped soon after. Thomas Hayden, a driving force in the efforts, died unexpectedly in December 1940. Curiously, his ashes were never claimed, so they remained at the J.T. Whitney Funeral Home for over forty years before finding a final resting place in the PMMP.

Orme carried on with the restoration work and fundraising, but when the United States entered World War II on December 8, 1941, war priorities stopped work at the cemeteries. He continued his work with the Arizona Pioneers Association and remained president of the PCA into the 1950s, but there was little done after the war. In November 1945, he requested the city assume administration and upkeep of the cemeteries.

On December 27, 1950, in response to an inquiry by a council member, Phoenix city manager Ray Wilson requested that planning director John

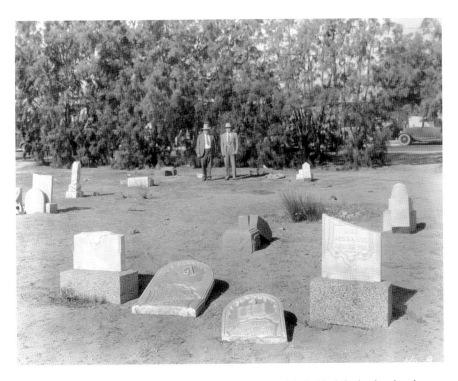

Two men identified as Lin Orme, *left*, and Tom Hayden, *right*, behind the broken headstones of King Woolsey and Mary Armstrong in 1940. *Courtesy Arizona State Libraries, Archives and Public Records, History and Archives Division, Phoenix, No. 96-4257.*

Beatty conduct a study on whether the cemetery sites could be reused for a "constructive purpose."[149] He received the report in July the following year. It noted that other uses, such as a municipal stadium or a park with tennis, basketball and volleyball courts along with miniature golf and shuffleboard, should be considered. The report also stated that state statutes contained provisions for relocating interred human remains from cemeteries, and in the opinion of the city attorney, state law mandated that decommissioned cemeteries could only be used as public parks. The report concluded that the expense and difficulty of moving the bodies coupled with religious concerns did not make reuse practical.[150]

When Lin Orme died on March 26, 1953, the PCA died with him. The city provided some cemetery maintenance by occasionally clearing weeds and watering the hedges. On May 23, 1956, it recorded a series of deeds where it officially took ownership of all seven cemeteries for nonpayment of the street improvement assessments in the 1920s. It considered resetting

The Woolsey and Armstrong headstones after repairs. *Courtesy Arizona State Libraries, Archives and Public Records, History and Archives Division, Phoenix, No. 96-4656.*

headstones, installing irrigation and some landscape in the early 1960s, but over the decades, the condition of the cemeteries relapsed.[151] Children rode their bicycles through them, drinking parties occurred on their grounds and others used the headstones for target practice. Veterans' organizations held Memorial Day commemorations, but for the most part, the cemeteries lay forgotten and abandoned again.

During the country's bicentennial preparations and celebration, interest in the cemeteries revived for a short time. The Phoenix Chamber of Commerce and the Luke and Williams Air Force Bases sponsored a project that proposed using the cemeteries as an educational and historic center located close to the state capitol. A complete re-landscape of the cemeteries was planned that would include repairing and replacing headstones, setting up a visitors' center and creating a pavilion of flags to commemorate all fifty states. While getting attention and support of the business community, it was never implemented.[152]

Above: Revolutionary War reenactors march through the PMMP during the bicentennial. *Photograph by Algona Winslow.*

Left: Algona Winslow. *PCA files.*

In 1975, Phoenix resident Algona Winslow became interested in the cemeteries. She began researching burials and interviewing descendants of those buried there. Also during the 1970s, a boy named Daniel Craig, venturing about on his bicycle near the old cemeteries, became intrigued by glimpses of headstones through the oleander hedges.

THE PIONEERS' CEMETERY ASSOCIATION REBORN

Around Memorial Day 1982, Craig, now grown up, was having his car serviced at a shop near the cemeteries. While waiting, he wondered if a cemetery was still there, so he walked over to check. Finding the Porter Cemetery open, he spoke with a man who was trimming weeds and getting it ready for a Memorial Day ceremony that the Veterans of Foreign Wars held every year. Craig talked with the man briefly and came away from the encounter with a renewed interest in the cemeteries and the idea to do something about documenting their history and arresting their destruction. He attended the ceremony, and afterward, seeing the gates of the Loosely Cemetery open, went in and explored. There he met Darton Harris, who was tending a grave site. Craig engaged Harris in conversation about the cemeteries and discovered that a small group met at the Arizona Museum on Saturdays to do what it could about them. Craig attended the next meeting, which was hosted by the museum's curator, Bill Soderman. The meeting included Soderman, Craig, Philip and Algona Winslow and Darton Harris. They all had a purpose: save the pioneer cemeteries and other old cemeteries in the area.[153]

Their first tasks were to form an organization, incorporate and prevent a proposal that would eliminate the Porter and Rosedale Cemeteries for a new "Capitol Corridor," a planned redevelopment of the area to place more state buildings along Jefferson Street. They chose to name their organization after Lin Orme's and Tom Hayden's 1940s group. Craig prepared the incorporation documents and worked with the federal and state agencies to obtain nonprofit status. He designed a logo that his co-worker Jay Casmirri then developed into the first brochure and business cards. In August 1983, thirty years after the death of Lin Orme, the Pioneers' Cemetery Association came alive again.[154]

Craig became the first PCA president. Charter members included his wife, Coleen; Philip and Algona Winslow; Darton Harris; George and

Gladys Loring; and Loraine Noland. Others who later joined included Jose Villela, Jay and Robin Casmirri, Dave and Catherine Loring Butcher, Bill Soderman, Rudy and Lucy Flores, Ed Korrick and Marge West.[155] Like its predecessor, the association was dedicated to the protection and preservation of the seven cemeteries and the memory of the pioneers.

After formation, the PCA set to work. Members collected broken headstones before they could be stolen, planted trees and cacti, installed irrigation and used cobblestones to define burial blocks in the Porter Cemetery. The cemeteries were featured in a televised public service announcement. These were humble beginnings, but the members persevered as their work and accomplishments gave them the experience and confidence to continue.

The PCA soon gained the support of the City of Phoenix. Phoenix city councilman Ed Korrick, who had relatives in the cemeteries, along with council members Calvin Goode, Mary Rose Wilcox and Howard Adams, were early supporters. So was the city's Parks, Recreation and Library (PRL) department director James Colley. In October 1984, the department proposed a multiphase improvement plan for the cemeteries that incorporated elements of the 1976 scheme. The city's plan included a visitors' center, avenue of flags, botanical mall and desert garden, as well as general cleanup

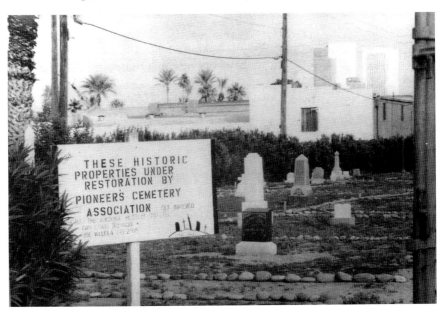

A sign by Daniel Craig about restoration efforts begun by the new PCA. *Photograph by Daniel Craig.*

and landscape. Initially, $65,000 was budgeted for some cleanup and authorization for city staff to seek public and private contributions. Mark Lamm, a supervisor in the city's PRL department, became the city's liaison to the PCA and helped coordinate support. Phoenix eventually included funds in its 1988 bond program for improving the cemeteries and became a partner with the PCA for maintenance and improvements.

By 1987, the overgrown oleander hedge around the southern cemeteries had been cut down, and a new wrought-iron and stucco fence replaced the 1940 chain-link fence. An irrigation system was installed for the newly planted trees and cacti. The PCA engaged the assistance and support of other businesses and organizations. Boy Scout and Girl Scout troops participated on cleanup days. Craig's employer, Salt River Project, the successor to the Salt River Valley Water Users Association, became a major contributor to the PCA's efforts. On special occasions, such as Memorial Day, the cemeteries were opened to the public, and the Arizona Civil War Council provided military reenactments during the ceremonials. The seven cemeteries became the Phoenix Pioneer Military and Memorial Park in 1988.

Girl Scouts place flags on veterans' graves in the PMMP for Memorial Day. *PCA files.*

An early Memorial Day commemoration with Civil War reenactors. *PCA files.*

Spanish-American War reenactors. *Photograph by Daniel Craig.*

As more resources became available, the PCA and the city began work on other improvements to the park. For some reason, the segment of Fourteenth Avenue between Jefferson and Madison Streets was never improved like other streets that bordered the cemeteries. It remained a tract of dirt and weeds between Rosedale and Porter for decades. In 1988, the PCA and city installed paving brick, landscaping, a fountain and six flagpoles for a flag representing each nation that governed the Arizona Territory. On May 7, 1988, Phoenix mayor Terry Goddard and other officials dedicated the Avenue of the Flags. Tom Hayden's ashes, long abandoned in the Whitney & Murphy Funeral Home, soon rested under the Avenue of Flags among the cemeteries he cared so much about.

Between 1990 and 1992, Phoenix sponsored an archaeological exploration of the PMMP. Starting with archaeological records from the Pueblo Grande Museum, the archaeologists discovered pit houses, artifacts, a canal and human remains from the La Villa Indian village. They also discovered artifacts that provided insight into the life of early Phoenix.

At the start of the 1990s, one major task from the ambitious development plans remained: a visitors' center. That was about to change. By 1994, the Smurthwaite House at the northeast corner of Seventh and Fillmore Streets had seen better days. An 1897 Shingle-style structure designed by

Phoenix mayor Terry Goddard at the dedication of the Avenue of the Flags. *Photograph by Daniel Craig.*

Right: The Avenue of Flags. *Photograph by Diane Sumrall.*

Below: The interment of Tom Hayden's ashes in the Avenue of the Flags in 1988. *Standing from left to right*: Jose Villela, Robert Villela, unidentified, unidentified, Daniel Craig, Darton Harris, Bill Soderman, Algona Winslow, Reverend John Linsley, Mark Lamm and Marge West. *Seated*: Philip Winslow. *PCA files*.

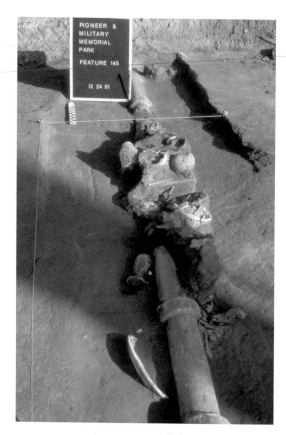

Left: The La Villa excavation in 1991. A sewer line and artifact cluster were uncovered. *Courtesy Pueblo Grande Museum, City of Phoenix.*

Below: The Smurthwaite House prepared for its move to the PMMP. *Photograph by Algona Winslow.*

James Creighton and occupied by members of the Smurthwaite family for decades, it was in the way of redevelopment. When Carolann Smurthwaite died in 1982, she willed the house to the Heard Museum, Museum of Northern Arizona and the Phoenix Art Museum with the wish the house be preserved and opened to the public. The museums donated the house to the City of Phoenix in 1991, after the city committed to move it to the PMMP and preserve it. Supported by city historic preservation bonds and private donations, on May 21, 1994, the Smurthwaite House began its laborious eight-hour, twenty-six-block journey to its new home on West Jefferson Street north of the Porter Cemetery. Restoration work commenced, and the PCA began turning it into a visitors' center.

For its age, Smurthwaite House was in good shape. Most of the original interior fixtures and features were intact. The Arizona Heritage Fund provided a $50,000 grant for exterior renovation, and over the years, the City of Phoenix and the PCA have restored both the exterior and interior. Now a visitors' and research center, it is the home of the PCA and one of the few remaining pre-1900 structures in Phoenix. The Smurthwaite House is in the Phoenix Historic Property Register and National Register of Historic Places.

The Smurthwaite House today. *Photograph by Derek Horn.*

The interior of the Smurthwaite House reflects the dedication of PCA members to restore it with period furnishings. *PCA files.*

Construction of the Loosley Cemetery sign. *Photograph by Mark Lamm.*

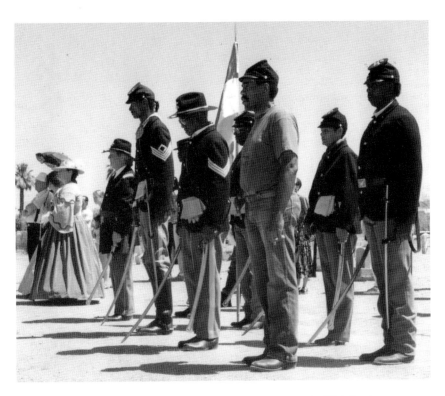

This page: Reenactments continued into the 1990s and 2000s. *Top: PCA files*; *bottom*: *photograph by Mark Lamm.*

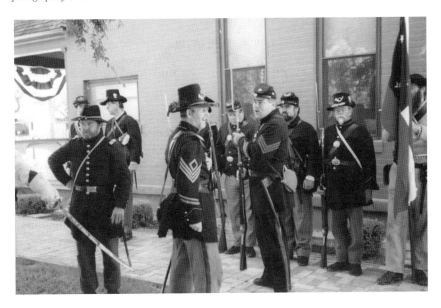

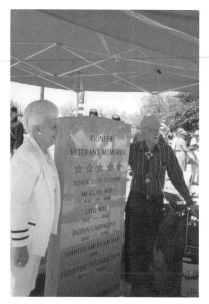 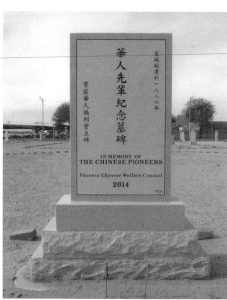

Left: Former Arizona governor Rose Mofford dedicates the Pioneer Veterans Memorial in the Porter Cemetery. *Photograph by Mark Lamm.*

Right: The Chinese Pioneer Memorial. *Photograph by Derek Horn.*

Throughout the 1990s and into the 2000s, the PCA continued working on projects that improved the PMMP and honored the heritage of those buried there. It placed location signs at each cemetery, continued to conduct Memorial Day ceremonies and reenactments and placed monuments to honor veterans and other groups. Lin Orme would have been proud.

THE PCA TODAY

The PCA continues its work on preserving and improving the cemeteries of the Phoenix Military and Memorial Park. It strives to promote education and understanding by engaging the public with cemetery tours, periodic open houses, special events and exhibits. PCA members continuously research and discover new information about the PMMP and those interred there. Period furnishings and artifact displays in the Smurthwaite House illustrate life in late 1800s Phoenix. Dining Among the Dead banquets and the annual Memorial Day observances draw hundreds of visitors to the park.

Above: Memorial Day celebrations at the PMMP draw diverse gatherings to honor the departed. *PCA files*.

Right: Dining Among the Dead. *PCA files*.

Above: A PCA team conserving a headstone. *Right*: Patricia Gault; *center foreground*: Sterling Foster, in hat. *Photograph by Mark Lamm.*

Opposite, top: PCA members periodically find and reset grave markers. *Photograph by Diane Sumrall.*

Opposite, bottom: Deterioration of grave markers is an ongoing issue. *Photograph by Derek Horn.*

In addition to their research and maintenance activities, PCA members periodically locate and reset headstones that have fallen over or are found in other locations. Deterioration of grave markers is an ongoing concern. Over the years, many original headboards and markers have been replaced. Recently, members received extensive training in headstone conservation, which is now being applied to selected stones throughout the park.

The PCA continues its partnership with the City of Phoenix in maintaining and improving the PMMP. The PCA also maintains close ties with other organizations that promote history and preservation. These include both the city and state historic preservation offices, Heritage Square, the First Families of Arizona, Daughters of the American Revolution, Phoenix Police Museum, Arizona Capitol Museum, the Arizona State Questors and others. The PCA invites the public to visit the PMMP for its special events and on Thursdays for tours of the Smurthwaite House and the cemeteries. Maps showing specific grave sites are available for those who visit and take advantage of the opportunity to learn about Phoenix's first residents whose stories emerge from beneath the headstones.

CEMENTERIO LINDO

CONTRIBUTING AUTHOR DONNA CARR

In 1890, the Maricopa County Board of Supervisors authorized funds to purchase a ten-acre potter's field at Fifteenth Avenue and Durango Street. Although several small cemeteries were already in existence in Phoenix, they were privately owned, and the county had to bear the cost of burying indigents in them. It was thought more cost-effective for the county to have its own cemetery, a no-frills, low-maintenance one located in one of Phoenix's Hispanic barrios. It was known variously as the Salt River Cemetery and the County Cemetery, and burials began in 1891. The last documented burial occurred in late November 1951.

From the first, burials were those of indigents, stillborns and infants, tuberculosis patients, prisoners who died in custody and John Does who couldn't be identified. Interments spiked during the influenza epidemic of 1918 and the Great Depression, when thousands of Dust Bowlers headed west in search of jobs. Some never made it to California.

Poverty was the only criterion for burial in the county cemetery, but it was inevitable that minorities would be disproportionately represented. Of the 8,145-plus documented burials, 46 percent were Hispanic, 9 percent were African American and the remaining 45 percent were mostly of European descent.

In 1951, the caretaker's shack burned, taking with it the county's records of names and plot locations. In 1952, Maricopa County closed the cemetery because it was full and opened a new one at Twin Buttes in Tempe. By the time the Maricopa County government deeded the cemetery to the City of Phoenix in 1961, lack of maintenance left the cemetery in bad shape.

In 1967, construction of the I-17 freeway was underway directly south of the cemetery. Although the people buried there may have died poor, they were not forgotten. Over the years, families continued to visit their loved ones' graves, decorating them for Dia de Los Muertos, Christmas and Mother's Day. With their growing political clout, the residents of the neighborhood insisted that their ancestors' resting place be accorded the care and respect due a cemetery. The city agreed, and in 1967, the old cemetery became Cementerio Lindo, or beautiful cemetery.

Using federal funds, the City of Phoenix launched a beautification project. The work was overseen by a city program that hired local unemployed youth. Work began to clean up the derelict cemetery, now overgrown with

Left and below: Handmade and decorated grave markers can be found in Cementerio Lindo. *Photographs by Derek Horn.*

weeds and trash. Workers installed an irrigation system, put up a fence and planted trees and grass. They laid down the upright grave markers, many of which had been broken, and engraved names on about two hundred bricks to replace old markers that were past salvaging. There was even talk of laying turf over the grave markers and repurposing the cemetery as a community park. That plan, however, was eventually abandoned.

Until at least 1991, the cemetery had grass and trees. Community memorial events, complete with a priest, mariachi bands and folk dancers, were held there in 1990, 1991 and 1993. Shifting demographic patterns, however, eventually led to the cemetery's decline. Old barrio inhabitants with personal ties to the cemetery died or moved away. The irrigation system failed and was not replaced, so the trees and grass died. By 2000, the cemetery was once again a parcel of bare dirt where local youth rode their dirt bikes amid scattered headstones.

In 2004, volunteers from the PCA began the daunting task of reconstructing the cemetery's burial list from death certificates that were accessible online. By its conclusion, they had 8,145 names. In 2007, Carter-Burgess Engineering, Inc., made an aerial map of the cemetery, and a field crew from Logan Simpson Design, Inc., identified 632 grave markers that were still visible. Additional input from the neighborhood and the

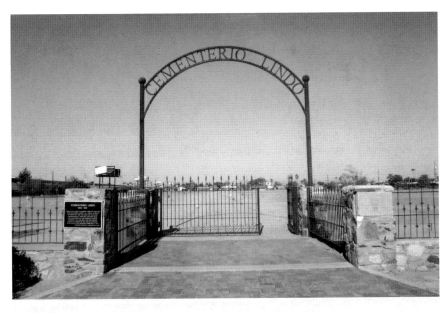

The entrance gate and archway at Cementerio Lindo. *Photograph by Derek Horn.*

families of the deceased resulted in some of the crumbling old markers being replaced with new ones.

The City of Phoenix enclosed the cemetery with a wrought-iron fence and constructed a decorative arch and gate in 2010. Cementerio Lindo was rededicated on October 25, 2012, with remarks by such local notables as Phoenix city councilman Michael Johnson and Maricopa County supervisor Mary Rose Wilcox. Since then, work crews show up periodically to cut weeds and pick up trash. The PCA has designated a spot near the gate for a memorial garden to commemorate the many individuals whose grave locations are no longer known.

A RELIABLE SUPPLY OF WATER

CONTRIBUTING AUTHOR DEREK HORN

The Salt River Valley is in the Sonoran Desert. While the winters are moderate, the summers are blistering-hot, with temperatures that can reach 120 degrees Fahrenheit or more. The average annual rainfall is about seven inches and usually occurs during the summer monsoon season and in winter. From the time the Swilling Party first settled in the valley, the community has depended heavily on the Salt River. The early pioneers realized, just as their Hohokam predecessors did, that a steady, reliable supply of water was crucial for successful agriculture and, indeed, their very existence.

After Swilling dug his first canal, known as "Swilling's Ditch," over the following decades more canals were dug to tap the river and deliver water to the growing number of farms and ranches in the valley. Most were constructed by private concerns, and they often did not cooperate with one another. Canals built upstream on the Salt could take water intended for canals downstream. In drought years, a downstream farmer might find he had no water for his crops. Even in years with normal water flow, there might not have been enough to meet the demand. This led to litigation to establish or reassert water rights.

The free-flowing Salt could be capricious, and the reliability of the water supply depended a great deal on the weather. Some archaeologists and historians theorize that the Hohokam were eventually driven from their land by long-term drought that starved their canals or by a river so swollen by flood that it wrecked them. The river flooded periodically in the 1880s, but the most severe occurred in 1891, when floodwaters reached

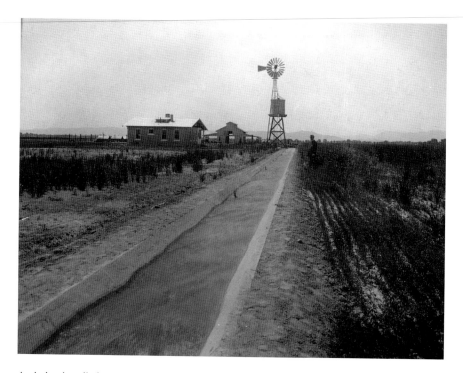

An irrigation ditch serving a Salt River Valley farm. *Courtesy of Salt River Project; photograph by Walter J. Lubken.*

into the Phoenix town site. Later, in the 1890s, the river went into a severe drought. Flows slowed to a trickle, and thousands of acres of farmland went out of production. Many farmers gave up and left the area.

These events convinced community leaders that a dam on the river was necessary. The reservoir behind it could accumulate water in wet years and protect the valley from floods. Water could be drawn out of the reservoir during dry years. In August 1889, a surveying party located a suitable dam site at the confluence of the Salt River and Tonto Creek northeast of Phoenix. Community interest in constructing a dam increased during the 1890s' drought. After a series of public meetings on the topic, local landowners organized the Salt River Valley Water Users Association in 1903 and pledged their lands as collateral to construct a dam at the Tonto Creek site. Taking advantage of the National Reclamation Act of 1902, they obtained a loan from the federal government, and construction on the dam commenced in September 1906. The dam was finished almost six years later, and former president Theodore Roosevelt journeyed to the valley to dedicate it.

A work crew deepening the Arizona Canal shows how early Salt River Valley canals were dug. *Courtesy of Salt River Project; photograph by Walter J. Lubken.*

Since 1911, Roosevelt Dam has supplied both water and electric power to the customers in the valley. While the river still flooded and dried up, the dam, and other dams constructed in later years, stabilized the water supply and guaranteed the future of the Phoenix metropolitan area. The Water Users Association eventually became present-day Salt River Project.

Places and Definitions

Over the decades, the names of some Phoenix streets and of some cities and towns around the state have changed. The contemporary names of these locations are used to assist the reader in orientation to the events related in this book. Also, unless otherwise noted, the locations mentioned in the text are in Arizona.

The Salt River Valley lies along the Salt River in central Arizona and is the location of the Phoenix metropolitan area. It is known locally as the "valley."

Up to 1848, Arizona was part of Mexico. It then became part of the New Mexico Territory of the United States after the Mexican-American War of 1848 and the Gadsden Purchase of 1853. Both the Confederacy and the Union claimed it at the beginning of the Civil War. Arizona became a territory in 1863 and the forty-eighth state in 1912. For simplicity, it is referred to as "Arizona."

Seven historic cemeteries make up the Phoenix Pioneer and Military Memorial Park, or PMMP, established in 1988. They are

- Loosley, or City, Cemetery
- Masons Cemetery
- Knights of Pythias Cemetery
- Independent Order of Odd Fellows Cemetery

- Ancient Order of United Workmen Cemetery
- Rosedale Cemetery
- Porter Cemetery

Collectively, they are referenced as the PMMP throughout the text and noted individually where appropriate. The Pioneers' Cemetery Association, which oversees the park in partnership with the City of Phoenix, is referenced as the PCA.

"Land patents" refers to land grants made by the United States government to individuals willing to move to and establish themselves in unsettled territory. Many pioneers utilized patents to establish farms and ranches in Arizona. Perhaps the most famous land grant program was the Homestead Act of 1862. To establish a land patent, a person first filed a "claim" or "pre-emption" with the federal land office and then "proved up" by making improvements to establish a permanent land patent.

GAR stands for the Grand Army of the Republic, a fraternal organization for veterans of the Union army, navy and marines who served in the American Civil War.

Notes

Chapter 2

1. Schroeder, *PMMP Archaeological Project*, 35.
2. John Alsap, undated account in the Arizona State Library.
3. Grady, *Out of the Ruins*, 63–6; Luckingham, *Phoenix*, 18.
4. Alsap.
5. Grady, *Out of the Ruins*, 84.
6. Ibid., 12–13.
7. Ibid., 165–71.

Chapter 3

8. *Phoenix Herald*, "The Cemetery Meeting," March 4, 1881. Clipping in possession of PCA.
9. James M. Barney, "Historic Phoenix Cemeteries Hold Many Pioneer Characters," *Arizona Independent Republican*, April 9, 1941, 7.

Chapter 4

10. Goff, *Arizona Biographical Dictionary*, 3.
11. "Alsap, John Taber," accessed June 2, 2017, www.asu.edu/lib/archives/ azbio/bios/ALSAP.PDF.

12. Luckingham, *Phoenix*, 16.
13. *Chickasha Daily Express*, "The Game Editor," April 24, 1901, 7.
14. The "Jamison Raid" was an unsuccessful attempt by British colonial official Leander Starr Jameson and his troops to trigger an uprising of British expatriate workers in the South African Republic, or Transvaal, which was governed by the Boers led by Paul Kruger. It occurred between December 29, 1895, and January 2, 1896, and was a factor in starting the Second Boer War.
15. Goff, *Arizona Territorial Officials*, 152–61.
16. Goff, *Arizona Biographical Dictionary*, 35.
17. Goff, *Arizona Territorial Officials*, 153.
18. U.S. IRS Tax Assessment Lists, 1862–1918, Provo: Ancestry.com Operations Inc., 2008. Original data from National Archives (NARA) microfilm.
19. Eric Schmitt, Missouri State Treasurer, "Past Treasurers, Alfred William Morrison," accessed January 2, 2013, www.treasurer.mo.gov/content/about-the-office/1alfred-william-morrison.
20. Goff, *Arizona Territorial Officials*, 156.
21. Ibid., 152.
22. Ibid., 155–60.
23. Goff, *Arizona Biographical Dictionary*, 34.
24. The judge's verdict and account of the case are quoted verbatim in the *Arizona Weekly Gazette*, July 1, 1899, 2, copy in possession of PCA.
25. Earl Zarbin, "Henry Garfias, Phoenix's First City Marshal," July 21, 2004, 3, paper in possession of PCA.
26. Ibid., 8.
27. *Weekly Phoenix Herald*, January 1, 1885, 4.
28. *Arizona Republican*, "Tewksbury," August 17, 1892, 1.
29. Richardson, *Dogged Pursuit*, 291–331.
30. *Arizona Republican*, "A Brave Officer Gone," May 9, 1896, 8.
31. Peplow, *Taming of the Salt*, 27.
32. Ibid., 28.
33. Ibid., 29.
34. Grady, *Out of the Ruins*, 68–73.
35. Ibid., 155.
36. Goff, *Charles D. Poston*, foreword.
37. Ibid., 20.
38. Ibid., 36.
39. Ibid., 36–37.

40. The Burlingame Treaty between the United States and China stipulated that either nation would be open to immigration from the other; that the citizens of one nation could travel freely in the other; and that the United States would not interfere with internal China affairs.

41. Goff, *Charles D. Poston*, 57.

42. *Colorado Weekly Chieftain*, March 6, 1879, 3

43. Find a Grave, "L.B. Putney," accessed November 14, 2017, www.findagrave.com/memorial/9799641.

44. Richard B. Goldberg, "Michael Wormser, Capitalist," *American Jewish Archives*, November 1973, 162, accessed September 10, 2017, americanjewisharchives.org/publications/journal/PDF/1973_25_02_00_goldberg.pdf.

45. Ibid., 167.

46. Ibid., 178.

47. Ibid., 186.

48. Ibid., 198.

49. Kippen, "Diary, 1854–1862."

50. *Arizona Republican*, "Death and Burial of Sisto Lizarraga," March 25, 1912, 1.

51. Barney, "Historic Phoenix Cemeteries Hold Many Pioneer Characters."

52. Military pension file on James Broomell, copy in possession of the PCA.

53. Ibid.

54. *Friends' Intelligencer and Journal*, First Month 4, 1896, 631, accessed June 27, 2012, Google Books books.google.com.

55. "The Broomells in Arizona," written by a grandchild of Charles Albert Broomell, copy in possession of the PCA.

56. The National Farmers' Alliance and Industrial Union assisted its members in selling crops and obtaining supplies on advantageous terms. It was instrumental in the Populist third party movement in the early 1890s.

57. The Territorial Normal School is now Arizona State University in Tempe.

58. Carl Ploense III, "Ready and Forward Again...A Unit History of the 10th Cavalry Regiment," the Spanish American War Centennial Website, accessed October 30, 2004, www.spanamwar.com/10thcavhist.htm.

59. Ibid.

60. Ibid.

61. Ibid.

62. Gilbert D. Gray, report of the coroner's inquest held March 28, 1900. and filed July 6, 1900.

63. *Arizona Republican*, "It Came Too Late," April 3, 1900, 4.

64. Roosevelt, *Rough Riders*, appendix.

65. Maricopa County, "Sheriff," 7–8, manuscript in Arizona Room, Burton Barr Central Library, Phoenix, Arizona.

66. David John Taylor, "The Killing of Frank Fox," accessed August 15, 2017, www.authorsden.com/visit/viewarticle.asp?AuthorID=3199.

67. Thomas A. Hayden, "Salt River Project, Arizona," *Western Construction News*, June 25, 1930, 294, copy in possession of PCA.

68. Block 41 is bounded by Madison, Jackson, Fifth and Sixth Streets.

69. Jacquemart and Reiner, *Tovrea Castle*, 81.

70. Burke, *Genealogical and Heraldic Dictionary*, 364.

71. Farish, *History of Arizona*, vol. VI, 80.

72. Luckingham, *Phoenix*, 15.

73. Farish, *History of Arizona*, vol. VI, 78.

74. Bourke, *On the Border with Crook*, 173.

75. Farish, *History of Arizona*, vol. VI, 80–81.

76. Elwyn Ll. Evans and Stanley R. Mathews, "The Father of Phoenix," *Journal of Arizona History* (Autumn 1988): 241.

77. Sources differ on Duppa's first burial location.

78. The Land Act of 1820 enabled the purchase of federal lands for $1.25 per acre in minimum tracts of eighty acres.

79. *Arizona Weekly Miner*, July 23, 1875, 3. John C. Frémont, the territorial governor, lived in this house from 1878 through 1881. It is known as the Fremont House and is now located on the grounds of the Sharlot Hall Museum in Prescott, Arizona.

80. *Arizona Weekly Miner*, November 5, 1875, 2–3.

81. *Arizona Republican*, "A Pioneer Gone Sudden Death of William Isaac Yesterday Morning," March 24, 1900, 4, copy of article in possession of the PCA.

82. Ibid.

83. Grady, *Out of the Ruins*, 105.

84. "Pioneer and Military Memorial Cemetery, Archaeological Project, Biographical Research on Samuel Calvin McElhaney and his wife Sarah Ella (Hill) McElhaney," 1992, research paper in possession of PCA.

85. Grady, *Out of the Ruins*, 39.

86. "Yavapai County Peeples' Valley," biography by unknown author in possession of PCA.

87. Goff, *Arizona Biographical Dictionary*, 91.

88. Zarbin, *Swilling Legacy*, 8.

89. Goff, *Arizona Biographical Dictionary*, 91.

90. Farish, *History of Arizona*, vol. VI, 70.

91. Richard Nilson, "Phoenix Had Humble Start," *Arizona Republic*, June 24, 2011, accessed January 14, 2018, www.azcentral.com/centennial/ent/articles/2011/06/24/20110624architecture-phoenix-buildings-ramadas-canals-farming.html.

92. Zarbin, *Swilling Legacy*, 8.

93. Masonic Lodge records in possession of PCA.

94. Farish, *History of Arizona*, vol. II, 287.

95. The Hayden Flour Mills on the Salt River and Mill Avenue in Tempe were the first. Charles Trumbull Hayden founded them in May 1874.

96. Peplow, *Taming of the Salt*, 23.

97. Goff, *Arizona Biographical Dictionary*, 91.

98. Masonic Lodge records in possession of the PCA.

99. "Filibustering" is participating in a private military action in a foreign country.

100. Arizona Historical Foundation, "King Woolsey, 1832–1879," accessed May 31, 2017, files.usgwarchives.net/az/statewide/bios/Woolsey.txt.

101. Goff, *King S. Woolsey*, 13.

102. Ibid., 6–10; *Phoenix Herald*, "Dust to Dust: King S. Woolsey Crosses the Shining River," July 2, 1879, 2.

103. Goff, *King S. Woolsey*, 24.

104. Ibid., 33–37

105. The upper house of the territorial legislature was the Council and the lower was the House of Representatives.

106. Goff, *King S. Woolsey*, 70–72.

107. *Czarnowski v. Holland*, 5 Arizona 119, accessed August 28, 2011, books.google.com, citing vol. 78, page 890, of the *Pacific Reporter*.

108. E-mail correspondence between Irving Chew and Donna Carr, June 3, 2011, to June 9, 2011.

109. Ibid.

110. Tom Kollenborn, "The Legend of Jacob Waltz," Tom Kollenborn Chronicles, February 7, 2011, accessed June 19, 2017, superstitionmountaintomkollenborn.blogspot.com/2011/02/legend-of-jacob-waltz.html.

111. Ibid.

112. Ibid.

113. Tom Kollenborn, "Jacob Waltz 'Lost Dutchman' Exhibit," Superstition Mountain Museum, accessed November 24, 2017, superstition mountainmuseum.org/exhibits/the-jacob-waltz-lost-dutchman-exhibit.

114. *Phoenix Daily Herald*, May 28, 1891, 3.

115. *Weekly Phoenix Herald*, October 26, 1891, 3.

116. Kollenborn, "Jacob Waltz 'Lost Dutchman' Exhibit."

117. Keane, *Chinese in Arizona*.

118. K.J. Schroeder, "An Historic Reconstruction of the Life of Tang Xian Gyuan," document in possession of the PCA, 2–3.

119. K.C. Tang, Ong Shiang Family Tree, document in possession of the PCA.

120. *Arizona Republican*, "A Loss to the Territory," February 12, 1893, 1.

121. Probate court documents in the matter of C.J. Dyer dated April 24, 1893, in possession of Arizona State Libraries.

122. *The Argus*, "Glory, Glorious, Glorissimo," 1, no. 18 (April 9, 1896): 4.

123. Hanchett, *Arizona's Graham-Tewksbury Feud*.

124. Marshall Trimble, "Pleasant Valley War," *True West Magazine*, February 3, 2017, accessed on July 28, 2017, truewestmagazine.com/pleasant-valley-war-2.

125. Hanchett, *Arizona's Graham-Tewksbury Feud*.

126. *Arizona Weekly Journal-Miner*, "Assassinated," August 10, 1892, 4.

127. *Arizona Republican*, "The Avenger," August 10, 1892, 1.

128. Richardson, *Dogged Pursuit*, 285.

129. *Arizona Republican*, "Tewksbury. The Noted Prisoner Brought in at Last," August 17, 1892, 1.

130. *Mormon Migration*, "Liverpool to New York 13 Jul 1870–26 Jul 1870, Ship *Manhattan*," Mormon Immigration Index CD by Intellectual Reserve, Inc. and Brigham Young University, 2010–17, accessed November 17, 2017, www.mormanmigration.lib.byu.edu.

131. Rose Gregory Family Tree, PCA files.

132. Bernard J. Wilson and Zaellotious A. Wilson, "From Maiden Lane to Gay Alley, Prostitutes and Prostitution in Tucson 1880–1912," *Journal of Arizona History* (Summer 2014): 167.

133. A "Mother Hubbard' is a long, loose-fitting gown designed to cover as much skin as possible.

134. *Arizona Republican*, "Modern Godivas," February 5, 1893, 1.

135. *Arizona Republican*, "Going, Gone," April 30, 1893, 1.

136. *Arizona Republican*, "A Moral Joint," March 10, 1895, 5.

137. *Arizona Republican*, "Murder and Suicide: Minnie Powers Shot to Death in Her Sleep," September 18, 1898, 4.

138. *Arizona Republican*, "The Cockney's Burial," September 20, 1898, 5.

139. Vivia Strang, "Fish and Game Chief's Death Caused Insurance Dustup," *Arizona Republic*, January 22, 2016.

140. Diane Sumrall, "Finding Jay," November 2006, document in possession of the PCA.

141. Ibid.

142. Ibid.

143. Debe Branning, "Ghost of Letitia Rice: Gone but Not Forgotten," August 17, 2009, accessed May 14, 2014, www.examiner.com/article/ghost-of-letitia-rice-gone-but-not-forgotten.

144. *Arizona Daily Gazette*, "Burned to a Crisp," May 21, 1893, 8.

145. *Arizona Republican*, "The Inquest," May 23, 1893, 8.

Chapter 5

146. City of Phoenix Assessor to City Manager, memo dated February 2, 1956, supplemental information 1, digital copy in possession of the PCA.

147. Ibid., 1.

148. Daniel Craig, "The Story of PCA Founding," recollections of Craig in possession of author and PCA.

149. Ray Wilson to John Beatty, City of Phoenix memo, December 27, 1950, digital copy in possession of the PCA.

150. John Beatty to Ray Wilson, City of Phoenix memo, July 10, 1951, digital copy in possession of the PCA.

151. James Stokely, City of Phoenix memo, March 30, 1961, digital copy in possession of the PCA.

152. Jason O'Neil, research and unpublished article, revised June 10, 2016.

153. Craig, "PCA Founding."

154. Ibid.

155. Schroeder, *PMMP Archaeological Project*, vol. 2, 44.

BIBLIOGRAPHY

Bourke, John G. *On the Border with Crook*. New York: Charles Scribner's Sons, 1892.

Burke, Sir J. Bernard. *A Genealogical and Heraldic Dictionary of the Landed Gentry of Great Britain & Ireland for 1852*. London: Colburn & Co., Publishers, 1852.

Farish, Thomas Edwin. *History of Arizona*. Vols. II and VI. Phoenix, AZ: Filmer Brothers Electrotype Company, 1918.

George, G.G., and Leigh Conrad. *Phoenix's Greater Encanto-Palmcroft Neighborhood*. Charleston, SC: Arcadia Publishing, 2013.

Goff, John S. *Arizona Biographical Dictionary*. Cave Creek, AZ: Black Mountain Press, 1983.

———. *Arizona Territorial Officials*. Vol. II: *The Governors 1863–1912*. Cave Creek, AZ: Black Mountain Press, 1978.

———. *Charles D. Poston*. Cave Creek, AZ: Black Mountain Press, 1995.

———. *King S. Woolsey*. Cave Creek, AZ: Black Mountain Press, 1981.

Grady, Patrick. *Out of the Ruins*. Cave Creek, AZ: Arizona Pioneer Press, 2012.

Hanchett, Leland J., Jr. *Arizona's Graham-Tewkesbury Feud*. Phoenix, AZ: Pine Rim Publishing, 1994.

Jacquemart, John L., and Donna J. Reiner. Images of America: *Tovrea Castle*. Charleston, SC: Arcadia Publishing, 2010.

Keane, Melissa. *The Chinese in Arizona, 1870–1950*. Phoenix: Arizona State Historic Preservation Office, 1992.

Kippen, George. "Diary, 1854–1862." Microfilm reel in the Arizona Collection of the Arizona State Library, History and Archives Division.

Luckingham, Bradford. *Phoenix: The History of a Southwestern Metropolis.* Tucson: University of Arizona Press, 1989.

Maricopa County. "Sheriff." Phoenix: Maricopa County, Arizona, 2005.

Peplow, Edward H., Jr. *The Taming of the Salt.* Phoenix, AZ: Salt River Project, n.d.

Richardson, Jeffrey R. *Dogged Pursuit: Tracking the Life of Enrique Garfias.* Tombstone, AZ: Goose Flats Publishing, 2017.

Roosevelt, Theodore. *The Rough Riders.* New York: Charles Scribner's Sons, 1899.

Schroeder, K.J., ed. *Phoenix & Military Memorial Park Archaeological Project in Phoenix, Arizona 1990–1992.* Vols. 1 and 2. Phoenix, AZ: Roadrunner Publications, 1994.

Zarbin, Earl. *The Swilling Legacy.* Phoenix, AZ: Salt River Project, n.d.

INDEX

ABOUT THE AUTHORS

The contributing authors are volunteers with the Pioneers' Cemetery Association. They have a variety of backgrounds as historians, librarians, government officials, engineers, designers and community activists. Some are retirees who remain active with their volunteer work with the PCA and other organizations. All are united in the same goals of preserving the historic cemeteries and the heritage of the early pioneers.

Visit us at
www.historypress.com